HISTORIC BARNS
OF
OHIO

ROBERT KROEGER

THE
History
PRESS

Published by The History Press
Charleston, SC
www.historypress.com

Copyright © 2021 by Robert Kroeger
All rights reserved

First published 2021

Manufactured in the United States

ISBN 9781467145626

Library of Congress Control Number: 2020948772

This book is dedicated to old barns everywhere…and to the hardy pioneers who built them. Let us never forget their legacy.

"Barns are the shrines of a good life, and ought to be remembered." —Eric Sloane

"Barns represent the heart of America, and the old ones are bleeding. So many barns, so little time." —Robert Kroeger

CONTENTS

FOREWORD

Ohio is known for its diversity, yet it seems that Ohioans from every corner of our state share an affinity for historic barns. And rightly so, since they have long been a common denominator in Ohio's varied landscape.

From the first days of European-American settlement of what would become the state of Ohio, barns were a required feature on every farmstead. Made from mighty trees cut from ancient forests that gave way to form Ohio's rich fields and pastures, a farmer's barn was where he or she stored surplus produce and seeds for the next season. Cattle and hogs typically sheltered in the lower reaches of most barns, yet they could forage outside in adjacent paddocks. Barns housed horses that powered planting and harvesting, as well as the farming equipment that grew in complexity, size and weight over many generations. The barn was indispensable.

Or at least it was until sometime in the twentieth century, when grain awaiting sale or processing would be held in commercial elevators and livestock would be raised for market in ways that made the Ohio barn obsolete.

Indeed, Ohioans have a love of their state's landscapes in all four seasons, and most cannot imagine it without barns around every turn—the focal points of so many vistas. During Ohio's bicentennial period, Scott Hagan—now celebrated nationally for his work—painted Ohio's red, white and blue bicentennial logo on a barn in each of our eighty-eight counties. The project, which cued the public to celebrate the state's history and culture, was embraced by Ohioans from urban and rural areas alike.

Likewise, Dr. Bob Kroeger has had his inspiration from Ohio barns, both those in good standing and those whose elements stand out like skeletons against the never-ending liveliness of our landscape. Like Hagan, he has painted at least one barn in each county. But instead of vast canvasses of the sides of a barn, Bob has used his skills with oil paint and palette knife and has also written about the barns' stories to help each of us, as viewers and readers, see the romance of these iconic structures.

<div align="right">

BURT LOGAN
Executive Director and CEO, Ohio History Connection
Columbus

</div>

I am proud to be a native Ohioan, but this wasn't always the case. In a roundabout way, I must credit barns with much of this change of heart. I grew up in the northwest part of the state, surrounded by all visible indicators of a thriving agricultural community to which I could not relate. Without any immediate connections to farming, and a strong ambition to seek out success in the big city, I didn't appreciate the significance of this landscape. During my adolescence, I resented what I now see as the tranquil beauty of rural Ohio for its general lack of "excitement."

Early adulthood never led me to New York City or Los Angeles. Instead, I made my way to the southern United States, where I stayed for the better part of a decade. While exploring the red dirt roads of Georgia, I grew to embrace the quintessential trademarks of the region: live oak trees heavily laden with Spanish moss and stately antebellum Greek Revival homes. My studies in historic preservation and architectural history at the Savannah College of Art and Design gave me a discerning eye to view my surroundings. While developing a growing appreciation for southern culture, I also acknowledged the absence of many staples from my midwestern upbringing. Among other things, the old barns, so ubiquitous in Ohio, were notably missing in southeastern Georgia.

Upon returning to my hometown in 2013 and taking the position of executive director at the Hancock Historical Museum in Findlay, Ohio, I brought with me a new appreciation for the culture and landscape of this great state. I developed a fascination with the vernacular architecture of Ohio, in particular the timber-framed barn.

In 2013, with the assistance of Hancock County farmer Gary Wilson, the Hancock Historical Museum set out to develop a Historic Barn Tour. I solicited

the expertise of a statewide preservation organization, Friends of Ohio Barns, to evaluate the properties selected for the tour. Its board members, some of the most knowledgeable timber framers in the country, gave their time to educate me about the importance of preserving Ohio's barns.

The inaugural Historic Barn Tour in September 2013 was the first of its kind in the region and exceeded every benchmark for success, with more than seven hundred people in attendance. The tour was designed to engage the rural community in the museum's programming and to highlight the county's rich agricultural heritage. In the years since, the Historic Barn Tour has become a family favorite in Hancock County. Nearly one thousand people attended the fifth Historic Barn Tour in 2019, with guests from across Ohio and neighboring states.

The success of the Hancock Historical Museum's Historic Barn Tour has snowballed into many additional projects and opportunities for the preservation of the area's farming heritage. The tour received the Ohio State Historic Preservation Office's Public Education and Awareness Award in 2014, and in 2018, the event was presented with the Scenic Ohio Award.

Most importantly, the tour has directly led to the preservation of historic barns in Hancock County. To be featured on the tour is a mark of prestige among area landowners and farmers, with many of them investing tens of thousands of dollars to prepare their properties for the showcase.

My own knowledge of barn architecture and interest in our region's agricultural history has grown exponentially. I have served on the Friends of Ohio Barns Board of Directors since 2016, and I help to plan the organization's annual state conference. I've come to recognize that every barn tells its own story.

Like Dr. Bob Kroeger, today I find myself relishing an opportunity to drive the rural backroads of Ohio. I soak up the idyllic image of a golden sun setting over a knee-high cornfield. I comb the landscape, searching for century-old barns and wondering what stories they hold. Dr. Kroeger's paintings of barns throughout the state have beautifully captured these icons, and his essays provide us with another opportunity to reflect on our surroundings. For me, the simple barn has fostered a love and pride for Ohio and its people.

SARAH SISSER
Executive Director, Hancock Historical Museum
Findlay, Ohio

Thanks to being a native of rural southeast Ohio, my love of barns grew from traveling our old country roads, many developed from livestock trails. There were the grand three-story bank barns, the lone "Chew Mail Pouch" barns and the long-forgotten ones, dilapidated and weathered. Once a year, while our Shenandoah High School lady Zeps basketball team would travel for an away game, we would pass my favorite barn. It was colorful with the Ohio State University logo and sometimes other cool designs on its side. Little did I know then that, just a decade later, the person who rendered that artwork, Scott Hagan, would go on to paint the Ohio bicentennial motif on a barn in each of the state's eighty-eight counties!

When Southeast Missouri State University sent me a letter asking, "Do you love history but you don't want to teach?," my love of barns transitioned into an appreciation of their architecture and the people who built them. Leaving Ohio, I embarked on a journey to Cape Girardeau, Missouri, to attend one of four colleges in the nation that offered historic preservation as an undergraduate major. For an assignment, I came back home and finally took the time to visit Noble County's oft-forgotten Gamary Farm, where a portion of the USS *Shenandoah*, a navy zeppelin dirigible, the first built in the United States, crashed yards away from the family barn in 1925. The barn was still standing. The axe and adz marks were evident on the massive beams, with wood peg construction and hand-cut joints that made me marvel at the maker's skill and had me fall in love with barns all over again.

I was homesick for "down home" after moving to Akron, the big city, but my forlornness dissipated as I went through the papers in my desk at a new job with the Summit County Historical Society. Unbelievable! Here were original drawings of the 1837 Perkins family barns and outhouse structures, completed by the author of one of my college architectural textbooks, Professor Allen G. Noble. Then I started to read and learn more about the history of the city and the formation of Summit County from portions of Portage, Medina and Stark Counties. Early settlers established gristmills using plentiful water supplies from streams, rivers and the canals (the Ohio and Erie and the Pennsylvania and Ohio) to power the grinding of the local farmers' products. One German immigrant, Ferdinand Schumacher, the "Cereal King," would create a way to cut oats for human consumption that would develop into the Quaker Oats Company. Another, Lewis Miller, invented the Buckeye Mower and Reaper, the prototype of the modern mower. Miller's company would transform into today's International Harvester.

When I started driving the roads of Akron and Summit County, I was pleasantly surprised that there was still evidence of those agricultural roots,

with numerous barns scattered across its landscape. This proved to be fortuitous, as when Dr. Bob Kroeger reached out to the society to find a contact to put him in touch with owners of vintage barns, I was ready to share what I had found.

I hope the reader can appreciate the aesthetics of Bob's paintings and revel in the nostalgia—artistic, historic and architectural. I also enjoy the stories that he's uncovered, often hidden behind old barn siding. Some of them surprise even lifelong Ohioans, like how barns and farmhouses that dotted pre–Civil War Ohio often provided refuge for escaped slaves. As they made their way on the Underground Railroad northward to freedom in Canada, the slaves were helped by farmers, including Akron's own John Brown, the famous abolitionist who tended a flock of Merino sheep and whose barn and house still stand on the grounds of Summit County's historical society.

LEIANNE NEFF HEPPNER
President and CEO
Summit County Historical Society of Akron, Ohio

Author's Note: I asked Sarah and Leianne to contribute to the foreword, proving that younger people, even in big cities and suburbia, can appreciate the legacy left behind by old barns and their stories. Sarah, from the Northwest, and Leianne, from the Northeast, complement the foreword, written by Ohio History Connection's Burt Logan, centrally located in Columbus, providing reasonable representation for our great state.

ACKNOWLEDGEMENTS

I owe thanks to many for contributing to this book, which began almost as spiritually as the Ohio Barn Project happened in 2012. Seven years later, in the summer of 2019, John Rodrigue, acquisitions editor for The History Press, sent an e-mail to me via the contact form on my barn art website. A newspaper article about my barn paintings raising funds for the Whitley County, Indiana agricultural museum was picked up by his Google Alert program and attracted his attention. Even though I wasn't planning to write a book until a few years down the road, after chatting with John and reviewing one of The History Press's books containing color images, I decided to forego the ego trip of a coffee table book and instead chose an affordable six-by-nine-inch paperback, the publisher's traditional format. I wanted to spread the gospel of Ohio's old barns to as many readers as possible.

I must acknowledge all the barn owners, who graciously allowed me to do paintings of their barns and write essays about their stories, most of which opened my eyes to the rich history of Ohio. Some supplied siding, which I used to make the painting's frame, hoping that it might add nostalgia.

I'd also like to thank the many historical societies, 4-H programs and other nonprofits for including my paintings in their annual fundraisers. In particular, the Hancock Historical Museum deserves recognition for including my paintings in its well-known biennial barn tour, which drew one thousand people in 2017 and 2019, and for allowing me to tell my barn stories during its brown bag lectures. I'm also indebted to the Highland County Historical

Society for connecting me with my first "barn scout," Sandy Shoemaker, without whose help this Ohio Barn Project may not have kept going.

My many other barn scouts should be recognized as well: Leianne Heppner of the Summit County Historical Society; Dave Reese, Gary Wilson and Sarah Sisser of the Hancock Historical Museum; Becky Keck and Doug Dennis of the SMARTS program in Youngstown; Jenny Clark of the Garst Museum in Darke County; Mary Spahr of Greene County; Nate Stitzlein and Tammy Drobina of the Fairfield County Heritage Association; Kristel of Brown County; Rheuben Gibson of Allen County; the late Floyd Reinhart of Crawford County; Larry Hall and Pam Gray of Knox County; Paul Stumpf of the Liberty Township Historical Society; Tom Cross of Adams County; Dr. Dave Poeppelman and Keith Sommer of Putnam County; Mel Poeppelman and the late Judy Miller of Bellevue and its four counties; Jody Lewis, Tom Mackall and Andy Varsho of Columbiana County; Heather Paisley of Mantua, Portage County; Raymond Friend of Highland County; Nyla Vollmer of Hocking County; Janel Donahue of the Loghurst Foundation in Mahoning County; Zonda Haase and Karry Snyder of the Springfield Township Historical Society of Mahoning County; and Carl Feathers and Jeff Scribben of Ashtabula County. These wonderful scouts not only provided leads but also drove me around their counties, allowing me to take notes, make compositions and see a fair number of barns in relatively short time.

One barn scout, whose story is outside of the realm of Ohio, is Ron Myer, who's on the board of the Whitley County Agricultural Museum, which is located thirty minutes west of Fort Wayne, Indiana. Ron has helped me to paint many barns in his county, raising funds for his museum, and he also wrote several newspaper articles about them, one of which caught the attention of The History Press, leading to this book being published.

Other writers, newspaper and journal editors and various media reporters and television and radio hosts have helped spread the word about my Ohio Barn Project. Matt Reese, editor of *Ohio's Country Journal*, not only made connections for me in Crawford and Hancock Counties but also wrote a nice piece about my work, which linked me with barn scouts in several counties. I must also thank my gifted son Rob for making the state map, which divides the counties into chapters. I'm glad he could be a part of this book.

Traveling to eighty-eight counties involves a lot of work, but thanks to these individuals and many others not named, I was able to accomplish my goal of finding at least one old historic barn in each county and then painting it and writing about it, preserving its memory for many years to come in the hopes that folks understand the role played by Ohio's old barns.

INTRODUCTION

They were the "money makers," the Ohio barns of the nineteenth century. When a pioneering family moved into Ohio in those early days, they encountered a vast virgin forest of hardwoods—chestnut, yellow poplar, black walnut, beech, maple, sycamore, elm, three varieties of oak— and initially built a log cabin for shelter. Next came clearing the land for planting and, after that, a barn, often made of logs. The barn served to protect both livestock and crops, and without it, the family would not have survived. If the farmer became prosperous, he would then build a brick farmhouse for the family, and in time, he would either add to the original barn or build a larger, timber-framed one. Today, with advances in farming, the "money makers" of the past have become non-functional. Despite being icons of a bygone age, they are disappearing rapidly.

For most of my life, I never noticed old barns. After having spent my childhood in a suburb of Youngstown and my college years in Columbus, I served four years of active duty in the U.S. Navy, eventually settling in 1977 in a suburb of Cincinnati, where my wife and I raised our five children. When my wife died, I remarried, as most widowers do, and started a new chapter in my life, part of which was an annual surprise anniversary trip—my new wife's idea. One year it was Laura's turn, and the next was mine. That was how my Ohio Barn Project began—mysteriously, almost spiritually.

In September 2012, Laura selected a rural bed-and-breakfast in Licking County several miles north of Granville, the county seat. As I turned the car down the road to the B&B, I noticed a small gray barn sitting on top of a

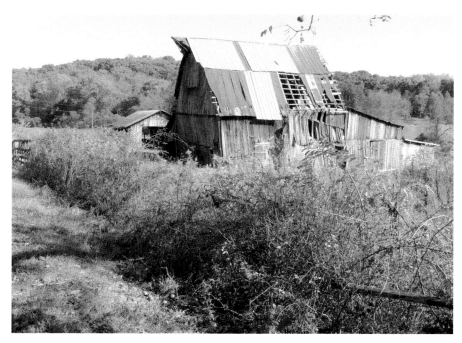

Hocking County. Barely surviving.

gentle rise, its roof sagging and its boards missing and warped. As I looked at it, it seemed to look back at me. Then it came: a strong message, almost as if a thunderbolt struck me between the eyes: *You're going to do an oil painting of this barn, write an essay about it and preserve early Ohio history*. Wow. Somewhat confused, Laura and I tossed ideas about it at dinner that evening.

The next morning, I drove back to the barn, parked next to the old (1830s) farmhouse and knocked on the door. An old man, unshaven and shoeless, came out. "Whadda want?" After explaining my epiphany and its purpose, he kindly told me about the Welsh settling here from Massachusetts, the land grants to Civil War veterans and the gunsmith shop across the street. Mr. Herbert Hall and his barn, one I affectionately call "Granville Gray," launched my project. *But how to begin*, I wondered.

The writing was not a problem. I'd written two books on dentistry, one on vitality and several on golf in the British Isles and Ireland. The painting was a concern. Even though my father was a university-degreed artist, he did not mentor me, although his work inspired me, as did the many visits we made to Youngstown's Butler Institute of American Art, a crown jewel of that city and the first museum in the United States to be dedicated solely

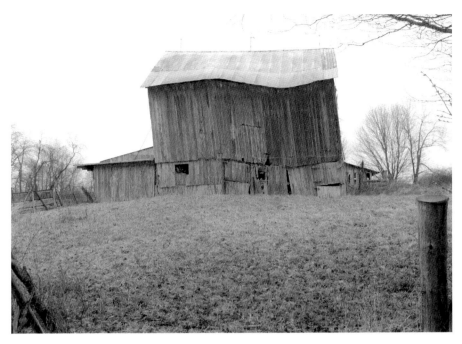

Licking County. *Granville Gray*, 2012.

to American art. I remember Winslow Homer's *Snap the Whip* as one of my favorite paintings.

I realized that drawing skills—perspective, proportion, value—must come before painting. So I studied, read books and took advantage of online tutorials. About that time, I also became interested in the impasto method of oil painting, especially when done with knives rather than brushes. I found two artists whose impasto work appealed to me: Joe Shell from Indiana and Ramon Vilanova from Catalonian Spain. As I studied painting and artists' work, I remembered my time in the navy, when, stationed in Spain, I had the chance to visit all the major art museums on mainland Europe. Finally, I jumped into the water and began painting. I took a workshop with a knife painter—and eventually with another one—and found a wonderful award-winning local artist, Nancy Achberger, who tutored me for years. I'd like to think some of her teaching has rubbed off.

So, armed with writing and rudimentary painting skills, I began searching for old barns, heading north of my home in Cincinnati into rural Warren County. I found a few good ones, met the owners and learned about their stories. A few weeks later, while on my own, I stopped at a nicely renovated old barn and knocked on the farmhouse door. When no one answered, I

began sketching and taking photos of the barn. Soon, I saw a small figure, about three hundred yards down the hill, approaching on an ATV. As he got closer, I noticed his long gray beard and then, a little closer, a rifle across his waist. "What do you think you're doing here? Taking photos? This is private property," he scolded. But after hearing my mission, he softened and told me all about the barn. However, I realized he was right. This was private property, and legally speaking, I was trespassing. Something had to change before I got shot or mauled by a hidden guard dog. I needed a barn scout.

After sending out queries to local historical societies and 4-H units, I hit pay dirt. The Highland County Historical Society referred me to Sandy Shoemaker, who, along with her husband, Tim, had recently retired and bought half interest in a farm with both an old barn and an old farmhouse. Sandy's local upbringing, along with her job approving waterways for the USDA, allowed her to know most of the farmers in the northern half of the county. And she knew where all the old barns were. We toured them on Mother's Day 2015. I put the paintings into a fundraiser for the Highland County 4-H in 2016 and again in 2017. Both times, my paintings raised about one-third of the total revenue. That fall, I put more paintings in the county historical society's annual fundraiser. The project had begun in earnest, thanks to my first barn scout, Sandy, and I began to branch out, although I may not have continued if I had not met Sandy and Tim.

Over the years, while continuously trying to improve my artistic skills, I sought out barns. Through sheer luck, I connected with Ron Myer, a wonderful barn scout in northern Indiana, where I did fundraisers for the agricultural museum. Again, through utter serendipity, I found a barn near Bardstown, Kentucky, that is now in its fifth generation of former-slave ownership. A few other states followed, including Massachusetts, where my former dental school roommate lives. Pat, not only a dentist but also a consummate carpenter, taught me how to make picture frames so that I could fashion them from old barn siding, adding a touch of nostalgia to the painting. I did two fundraisers for a local historical village and, over the years, connected with historical societies, 4-H units and other nonprofits throughout Ohio. My goal was to find at least one old barn in each of Ohio's eighty-eight counties. I knew it would take a long time.

Then, in the fall of 2018, I decided to try an experiment, realizing that, for one reason or another, all counties wouldn't be interested in doing a fundraiser through my barn project. After a trip north, first stopping in Akron and then in Youngstown, I drove south through Appalachian Ohio, covering eight counties—Columbiana, Carroll, Jefferson, Harrison,

Guernsey, Belmont, Monroe and Noble—some without and some with barn owner contacts. It was a long day but a successful one, even though driving up, down and around hills was challenging, and it encouraged me to finish all the counties sooner rather than later.

I continued with a Veterans Day weekend trip up Route 127 from Darke County through the counties of Ohio's western boundary and followed that with several trips throughout the state in 2019. I finished the final three counties—Wyandot, Marion and Union—in early 2020.

Even though many things fell into place nearly seamlessly, making me feel as if I were merely a puppet on strings, being pulled and pushed by the Big Guy Upstairs, it wasn't always easy finding a barn. Sometimes, when all else failed, I'd send a snail mail letter to the owner, tracking down his address from the county auditor. And sometimes even that didn't work, which meant that any stories connected to the county's barn, though old and photogenic, would largely remain unknown—at least in this book. Regardless, I captured it, along with a bit of the county's history.

As the project evolved, the press took notice. Matt Reese, editor of *Ohio's Country Journal*, wrote an article that led to barns in several counties, and being mentioned in *Growing Ohio*, the 2019 magazine of the Ohio Department of Agriculture, taught me that farmers treasure these old barns statewide. Articles in smaller newspapers unearthed historical barns, ones that would not have surfaced otherwise. Through *Growing Ohio*, I learned that Ohio has 75,462 farms, 320 farmers' markets and an agricultural economic impact of $124 billion, which translates into 1 million jobs in farming. One out of eight jobs in Ohio takes place on a farm.

Still, I wondered why a suburbanite like me would be doing this project. Of course, I knew how it started. But why did I keep going, as I did for years, without understanding why? I reasoned to myself that, if fifty to one hundred years from now, someone would see one of my barn paintings and read its essay, he or she might understand the role the old barn played and the sacrifices our forefathers made in developing our great state.

Then finally the "why" dawned on me. After purchasing my second book of Edward S. Curtis photographs, I read a quote from him regarding his purpose in recording the rituals and lives of Native American tribes from the 1890s to the 1920s. In Wayne L. Youngblood's *Portraits: The Many Faces of the Native American*, Curtis explained, "The passing of every old man or woman means the passing of some tradition, some knowledge of sacred rites possessed by no other… consequently the information that is to be gathered, for the benefit of future generations, respecting the mode of life of one of the great races of mankind,

must be collected at once or the opportunity will be lost for all time." It clicked: I, too, am trying to preserve a piece of our vanishing landscape.

I will cover some of the many architectural facets of Ohio barn construction, which many barn experts admire—the various types of joints, bents and purlins, scribe rule versus square rule construction and other such mechanical references. However, I won't go into detail, even though I respect the carpentry skills of the early barn builders who would chop down tall trees, use axes to convert these logs into square beams—called hand-hewn—and fit the pieces together to form a barn that might last more than two centuries. They knew which wood to use for the main beams and which to use in other applications. William Penn, founder of the original colony of Pennsylvania, once described wood as "a substance with soul." They fitted tenons (the male ends of a timber) into the mortise (the female end) with skill that would rival that of a university-trained mechanical engineer. They used wooden pegs, green with youth, that would swell as they aged, forming a locked joint that would last, without cement, for hundreds of years. Their legacy remains in many of Ohio's old barns and continues to amaze me every time I see hand-hewn beams and joints with wooden nails. Today's Amish and Mennonites carry on the tradition of building timber-framed barns, handed down from one generation to the next.

Most of the barns featured were built in the 1800s or before 1930, although occasionally there may be one built later if it has an exceptional story, which is another part of this project. I write about the history of the barn and its farm, about the family, the county, the region or, in some cases, about national pieces of early America if they are pertinent. Some stories, just like barns, are better than others, and unlike the barns of seventeenth- and eighteenth-century New England, most Ohio barn stories start only in the 1800s. However, unlike the old plain three-bay threshing barns of our northeastern coast, the barns of Ohio show an architectural flair quite different than their English barn cousins. Architectural gems still exist in Ohio, such as the three round barns of Perry County, all within five miles of one another; the German stonemason-built Kindelberger treasure in Monroe County; the wooden octagonal barn with Belgian blue glass in Ashtabula County; Harrison County's unique sixteen-sided barn; and Butler County's magnificently restored Muhlhauser barn, a look into Cincinnati's nineteenth-century beer brewing days.

Some of these old barns may have disappeared by the time this book is published, such as Trumbull County's Klondike and Allen County's elaborate Gothic marvel in the Welsh community of Gomer. Sadly, one of the most impressive old barns, the gigantic Pagoda barn of Henry County, an engineering

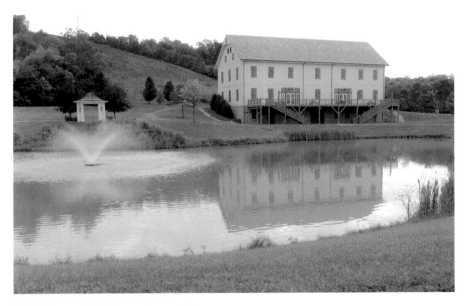

Butler County. Muhlhauser barn, 1881.

feat well ahead of its time, has been gone now for more than thirty years, although it survives in my painting and essay for future generations to admire.

I never criticize an owner for dismantling his or her barn; rather, I congratulate those who are clever and financially able to repurpose one. Wineries located in the Yellow Butterfly barn in Tuscarawas County and in the Blue Barn in Wayne County are thriving, providing new function for an old barn. Dave Wingenfeld's old dairy barn in Cuyahoga County plays host to the Lantern Theatre, a local theater group, and Butler County's Muhlhauser barn has held more than one thousand events in the last decade.

The sequence of eleven chapters begins in Ohio's northwest and heads south before moving into the north central, returning upward to the northeast and ending in Ohio's southeastern region. Each chapter contains an average of eight counties. Although I sometimes mention roads, I don't provide specific directions to reach these barns since I want to protect the privacy of the owners. Some of them are easily spotted on a main county or state road, but others aren't as easy to find. I've visited Monroe County's Kindelberger masterpiece twice and gotten lost both times, despite printed MapQuest directions and a car GPS. Regardless of the challenge, I always felt rewarded when I found the old barn and when I was allowed to do a painting of it and record its story in the hopes that others might find the old barn as fascinating

as I did and remember that, once a long time ago, it was indeed "the money maker," laying the groundwork for our great state's economic development.

When The History Press asked me to submit some images—paintings and photos—I sent a few dozen six months ago and decided to let them choose, knowing that their professional designers, notably Anna Renninger Burrous, are much better at this than I am. After a few tweaks, the result was significant in explaining the plight of old barns.

The front cover illustrates three different barns. First is Harrison County's hard-to-find round barn, the only sixteen-sided barn in Ohio, freshly painted and roofed securely by owners who love it so much that they built a miniature of it for their mailbox. Next is the magnificent pagoda barn of Henry County, one of America's most unique architectural monuments, which is now preserved only in a few random photos and this painting, showing what happens when owners can't save their old barn. The bottom photograph explains just the opposite: how a historic barn can be saved. This one, in Butler County's West Chester Township, features the Muhlhauser barn, which represents a municipality putting its money where its mouth is. The barn was dismantled, beam by beam, moved and then reassembled— expensive, yes, but one of the best restorations I've seen.

On the rear cover, there's a small insert of intricate slate-covered cupolas on a barn in Wood County, which I found thanks to the Hancock Museum's director, Sarah Sisser. I've seen only a few of these elaborate cupolas in the many hundreds of old barns I've visited—a throwback to the 1890s, when it was a way a farmer could show off a bit. Finally, the editors and designers decided to include a photo of Licking County's Granville Gray, which I took in 2012, the barn that inspired me to start this project. Although it's tilted a bit more, it's standing, as far as I know. It still seems to have a mystical aura around it, calling out to me to continue to capture old barns in paint and record their stories in words.

Three different architectural styles—a round, a pagoda and two rectangulars—each with a story to tell and a lesson to teach. They set the tone for this book, and hopefully they'll motivate others to maintain the old wooden "money makers" and preserve a part of early Ohio before they're gone.

Author's Note: Due to space limitations, some barn paintings are shown in black-and-white and inserted into the barn's essay. Other barn paintings can be found in the color insert section.

- The Chapters -

Ohio County Map. Designed by Robert F. Kroeger II.

Each region corresponds to a chapter in the book:
1. Northwest
2. West
3. Middle West
4. Southwest
5. North Central
6. Middle Central
7. South Central
8. South
9. Northeast
10. Middle East
11. Southeast

1

NORTHWEST

Ohio's northwestern region, bordering Michigan and Indiana, was originally mostly swampland and called the "Great Black Swamp." Due to Indian skirmishes, it was the last part of Ohio to be settled, as the native tribes successfully defended their lands against those immigrants brave enough to encroach. Ordered by President George Washington to make peace, early U.S. armies failed badly. The first, led by General Josiah Harmar, was defeated in the autumn of 1790. The second, another poorly trained group of soldiers and militia led in 1791 by Major General Arthur St. Clair, suffered the worst defeat ever of an American army at the hands of American Indians.

President Washington was furious and called on his friend, Major General Anthony Wayne, who came out of retirement. General Wayne, realizing the mistakes his predecessors had made, trained professional soldiers for years in a location near present-day Pittsburgh, and in August 1794, he led a force of well-prepared soldiers up Ohio's western flank to defeat the Indians in the Battle of Fallen Timbers. In 1795, he negotiated the Treaty of Greenville, which meant peace for this area of Ohio and encouraged settlers to move in.

After settlers began farming in this region, a clever local man invented a device to lay tile to drain the great swamp in the late nineteenth century, transforming it into some of the nation's most fertile farmland. Today, hundreds of old barns survive here.

WILLIAMS COUNTY

The Gunner's Pool

Many valiant soldiers and sailors of World War II don't like to talk about their experiences in the war, just as my father also avoided the topic. In hindsight, I wish I had found out more about his time in the Aleutian Islands, the only time since the War of 1812 that an enemy has occupied our land. Fortunately, one such veteran has told his: Richard Keough, former owner, along with his wife, Betty, of this barn and farm. Hardworking midwestern farmers, they raised children, worked long hours—sometimes at jobs outside the farm—and never complained, giving their children an appreciation for hard work and humility.

Richard's daughter Linda contacted me via e-mail to see if I'd be interested in coming to the extreme northwestern tip of Ohio to take a look at their barn. After her mother passed away in 2017, the farm was willed to Linda and her five siblings, who take pride in their family's heritage, which traces back to the mid-1960s, when her parents bought the farm. However, the original deed for the property, dated 1811, shows that her ancestors were among the first to settle in the Great Black Swamp. A year later, the War of 1812 began with activity in the area—Fort Wayne, Indiana; Fort Meigs; the Maumee River; and Fort Detroit. Linda's forefathers were there then, among the first to farm in Spencer Township in nearby Lucas County.

Although this old barn, built with massive hand-hewn timbers, traces back to a few years after Ohio became a state, the real story comes from Richard's service in the war, as related to me by his son Brad. Richard was drafted into the U.S. Army, began active duty in December 1943 and was eventually trained to be a gunner in the "ball turret," a small sphere fixed to the bottom of a bomber and barely big enough for one man and four .50-caliber machine guns. It was so small that the gunner couldn't wear a parachute. After flying a few combat missions in Germany, he volunteered to enter the "gunner's pool," where gunners could go when their crews were cut. They'd take assignments as needed. When Brad asked him why he did this, his dad said, "My job was to fly combat missions and I got the chance to fly a lot more in the pool." After the war, Richard met Betty Harmon at a dance at the Odd Fellows hall in Delta. They married in May 1947. Finally, Richard and Betty fulfilled their dream by buying their farm in May 1963.

Another ball turret gunner, Frank Mazikowski, who flew on sixty-two combat missions in Italy and Germany, enlisted in December 1941—aged

seventeen and still in high school. Wanting to be a pilot, he didn't handle it well when he didn't get his wings. Instead, he told his superiors, "I'd like to go to combat right away. What's the fastest way?" When he learned that aerial gunners were going down every nineteen seconds in combat, Mazikowski replied, "That's what I want to do." When asked why he chose such danger, he replied, "I don't know why. I was a kid and was angry. Also, there was the adventure of it. You had a gun mounted in a window and you'd press the button and blaze away at the enemy—125 rounds a minute, pretty fast."

Richard Keough was promoted to staff sergeant while in England—a country he loved so much that he had planned to apply for a second tour of combat. However, the war ended as he was on his way to serve in the Pacific. He received several medals, including four Air Medals for Valor and three Battle Stars. Thanks to Richard and thousands of brave and selfless men and women of the Greatest Generation, we aren't speaking German these days. And with this painting, a special thank-you goes to those who volunteered for the "gunner's pool."

Defiance County

North by Northwest

After driving for a few hours north on the ever-so-straight Route 127, I veered westward on Route 18, hoping to find a barn in the small section of Defiance County that I'd pass through. And I was lucky to spot this one—a red beauty, nicely maintained and just off the main road. It was built into a gentle rise and supported in the rear by sturdy stone walls, an example of a true bank barn, different from a barn on fairly flat land where dirt has been ramped up to form a bank leading into the top level of the barn. Although it was cold and windy, the snowfall had stopped, giving me a chance to do a sketch and take reference photos.

It's located west of the county seat, Defiance, which takes its name—as the county does—from a fort that General "Mad" Anthony Wayne built in August 1794. Although it was considered one of the strongest fortifications of that period, it took only nine days to build and was strategically placed in between two major rivers, the Maumee and the Auglaize.

Major General Charles Scott, who led one thousand Kentucky militiamen to support Wayne in this campaign, symbolized defiance when he remarked

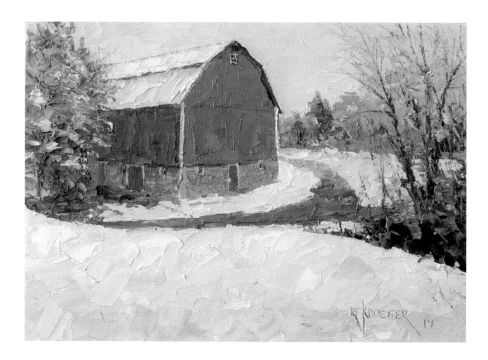

about the fort, "I defy the English, Indians, and all the devils of hell to take it." Scott, a veteran of the French and Indian War as well as the Revolutionary War, also served under Generals Harmar and St. Clair, who had failed in the western campaigns. After their defeats, President Washington called on his trusted veteran, who, he hoped, would not fail as well. Wayne spent two years in training troops.

Two weeks after the fort was completed, Generals Wayne and Scott defeated the Indian tribes in the Battle of the Fallen Timbers, just north of the fort on the Maumee River. This American victory, significant in the years of Washington's presidency, led to the famous treaty of Greenville one year later. The Northwest Territory had been conquered. It was 1795, only eight years before President Thomas Jefferson commissioned the Lewis and Clark Expedition, which led the way to western expansion. The United States was emerging from infancy.

FULTON COUNTY

Bean Creek

Every now and then, a name strikes me as being quintessential Americana, conjuring up times long ago, when horses were used instead of automobiles and reading encyclopedias gave us information instead of doing a search on the Internet. The Bean Creek Valley History Center, its name displayed in gold stenciling on the center's glass window, took me back to that era. And, of course, it was located on Main Street—West Main Street, to be exact—in Fayette, Ohio.

I stopped at the center to meet Colleen Rufenacht, president of the group, who kindly arranged for me to see the barn that represents Fulton County. Colleen and her fellow members were glad to see me and proudly showed off their conference table, which is made of reclaimed wood from historic buildings in the Bean Creek Valley. They've placed photos of the buildings on the wall and can identify which piece of wood is from which building—historical preservation at its best. As Colleen explained, the Bean Creek begins in Michigan at Devil's Lake, flows south through Fulton County and empties into the Maumee River.

After explaining my project, I followed Colleen to this old barn, owned by Austin and Jennifer Marihugh, who were out of town for the weekend but allowed me to tour the barn and take barn siding for framing. They acquired the farm in 2013 from a family who bought it from the Merillats, whose roots go back to David Merillat a Mennonite who moved here from Switzerland and established the farm in 1836, a date still displayed above the entrance.

The barn may have been built in that period, as evidenced by the forebay construction and large hand-hewn beams inside. David's son, Peter, continued to work the farm, as did Millard Merillat, born in 1916, whose name sits alongside the 1836 date. However, the Merillat family has moved on, and the Marihughs are now in charge, although they told

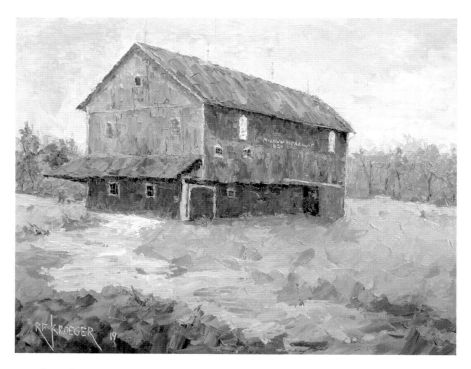

me that they won't be able to maintain the barn, used mainly for storage today. How long it will last depends on the battle between the whims of nature versus Swiss Mennonite construction. As many other families have discovered, old barns are no longer the money makers they used to be, and owners can't justify their upkeep, making me glad that I captured it and was able to use its own wood for the painting's frame, which will include a nineteenth-century cut nail that came out of the siding. Another piece of Americana and another memoir of the Bean Creek Valley's golden age.

HENRY COUNTY

George's Giant

It's been called a Chinese barn—and it does indeed resemble a Chinese pagoda—but it's a good old American barn, one that bit the dust many years ago—an American treasure that never got membership into the National Register of Historic Places.

This area of northwestern Ohio was formerly known as the Great Black Swamp, a huge wetland, thanks to the glaciers—stretching from Lake Erie east of Toledo and westward through Henry County and into Indiana, near present-day Fort Wayne. It was a land of forests, grasslands and wetlands, and not only did the swampy conditions affect travel, but the area was also a breeding ground for mosquitoes, causing malaria.

However, the swamp didn't stop General Anthony Wayne from marching troops northward from Cincinnati to quell the Indian uprising that other generals could not accomplish. General Wayne and his force of 5,000 marched north, building forts along the way. The Indians, numbering about 1,500, encouraged by recent victories over the Americans, were led by Little Turtle of the Miamis, Blue Jacket and his Shawnees, Buckongahelas's Delawares, Chief Roundhead's Wyandots, Ottawas led by Turkey Foot, Potawatomis, Mingos, Ojibwas and a British company of Canadian militiamen. A nearby British fort supplied them with provisions. The Battle of Fallen Timbers took place near Toledo and was a major victory for America, leading the way for the Treaty of Greenville and opening the black swamp for settlers.

But the swamp was still a swamp. The city of Napoleon, the county seat of Henry County, was not founded until 1832, illustrating the problem with the land. But a local, James Hill from Bowling Green, invented the Buckeye Traction Ditcher in the mid-1850s, allowing drainage tiles to be laid quickly. His invention helped drain the swamp, and the arrival of the railroad led to settlement.

One of those early settlers was George Hyslop, who built this barn in 1910. Not much is known about him, but he was mentioned in the local newspaper in 1894. According to the *Democratic Northwest* and *Henry County News*, "George Hyslop last Tuesday brought to Deshler 21 of the finest dressed turkeys ever brought into this market. George is a hustler in the turkey business."

Not only was George a hustler with turkeys, but he also had a vision to build one of America's most unusual barns. Unfortunately, it collapsed in 1984, long before I could take a look at it. However, after seeing old photos of this barn, I felt I had to include it in my project. Incredibly, it had ten thousand square feet of floor space. A barn owner in Putnam County gave me photos he took in 1970, showing the barn in a burnt sienna brown color.

George had to have been one of the most productive farmers of Ohio in those days, having enough money—$11,500—to build this five-story "cow palace," as it was also known. Although no one knows who the builder

was, George may have contributed his ideas to the design. The four silos stretched from the basement to the cupola, and chutes around them provided ventilation. A large cistern collected rainwater from the roof, allowing it to flow through pipes into seven tanks to water livestock. A system of carts on tracks carried feed to the animals, and another track, this one for hay, worked similarly.

The elaborate engineering allowed George to increase his production, using the barn to protect the livestock in the harsh winters of northern Ohio. At one time, the barn held 100 head of cattle, 14 horses, 600 chickens and 190 hogs. What an operation! But alas, the barn was neglected and eventually fell apart, a fate that other remarkable Ohio barns will succumb to in time. At least its memory will live on in these pages.

LUCAS COUNTY

All American

God smiled as I drove through the western part of Lucas County, another Ohio county whose rural scene has become engulfed by industry and suburbs. Without a local barn scout, I was on my own, hoping for a good find—like the one I had discovered earlier in Wood County. Driving up Route 64 and crossing the Maumee River into Lucas territory, I noticed a red barn across a field. But it didn't excite me, so I kept going, keeping it as a possibility, and turned onto Route 20, heading toward Swanton.

Then, all of a sudden, despite being surrounded by Toledo's suburbia and its nonstop traffic, a delightful little barn appeared, only twenty yards off this busy road. So I pulled in and asked Anne Grasser, who owns it with her husband, Chuck, if the barn was in Lucas County. "You're in luck," she said, "the county line is just down the road." Yes, I was fortunate: Anne was gracious enough to tell a stranger like me about her barn and to let me go through it. Their dog, Angel, a lab-greyhound mix with a disposition as heavenly as her name, kept me company.

This barn steps outside the normal since it's an example of how a farmer tried to preserve an old structure by covering it with a newer one. The original barn, a small one with plenty of hand-hewn beams, is covered by a larger barn with a gambrel roof and two dormers, suggesting construction sometime in the twentieth century. The house was built in the 1950s, which

may have been before or after the barn enclosure. In my later travels in northern Ohio, I saw another barn with two similar dormers. Rare birds.

However, the little barn probably dates to the 1870s or earlier and probably serviced a small farm. Or it may have been only one of other farm buildings, which are now gone. The silo—with its unusual multisided cap—hints that this was once a productive farm. Anne told me that the original family, the Najarians, farmed twenty acres and had a vegetable stand at the roadside.

What I liked about this was not only that a farmer long ago tried to protect an old timber-framed barn, possibly handed down through generations, but that an American flag stood tall in front, reminding me that this barn, even though it may not be around forever, is a symbol of America and its hardworking farmers. Yes, it's earned the title of "All American."

WOOD COUNTY

Spectacular

Since I had a hunch, I asked my friend Sarah Sisser, director of the Hancock Historical Museum, if she knew of any interesting barns in neighboring Wood County. Did she ever! After she helped me find the address of this barn on Jerry City Road, I sent a letter to the owners but got no response. I had my fingers crossed.

My friends Les and Rebecca, who came with me on Friday's barn tour of wetter-than-wet Hancock County, drove with me on a gorgeous April Saturday morning to look at this one, which, for want of a better word, looked spectacular. When we approached the barn from a distance, the three cupolas grabbed center stage and begged us to stop. They are probably the most ornate cupolas I've ever seen: a five-pointed roof (covered in octagonal slate), two portholes and eight louvered windows. I can visualize the architect designing them in 1896, a date that still survives in the barn, and deciding to leave his artistic mark. He did.

I tried to imagine the scene back then, a century ago. The farmer, in reviewing his options with the barn architect, might have said, "What are my options on making this barn a knockout?" Architect replied, "Well you could add a slate roof. More expensive but more durable." The farmer, "Well, I don't want ordinary slate." The architect, "OK, how do you like an

octagonal shape? That's different but more expensive." The farmer: "Money is no object. What else can we do?" The architect handed him a sketch of an ornate cupola, which the farmer liked. The farmer: "Three of those should do just fine. Make them big." The architect: "Anything else?" The farmer: "Cover them with slate."

After staring at this gem for a while, I knocked on the door of the house across the street, while Rebecca took about one hundred photos of the barn. No answer. *Try again*, I thought, as I knocked this time at the house just north of the barn. Nothing for a while, but then a young man, apparently still sleepy, came to the door. It was Levi Garner, son of the owners Mike and Sue Garner, who lived elsewhere. Levi, despite our early wakeup call, was kind enough to share information.

His parents bought the ten-acre farm in 2005 and raised beef cattle and hogs and farmed hay. The Kerr family owned the farm before the Garners, although the original owners, the barn builder and whatever farm stories happened here remain unknown. Levi, a recent Elmwood High School grad, had been involved in the 4-H, learning the business of raising livestock. He also works at another much larger dairy farm, one with 240 cows. He is used to hard work.

Levi took us on a tour of the barn, a large Pennsylvania bank barn with forebay, typical of many of Ohio's early barns and a reflection of its German heritage. He gave me siding to frame the painting. The barn's timber was saw-cut, confirming the date of 1896, and internally, the structure has been well preserved, still hinting that the original farmer was prosperous enough to hire a skilled architect and an equally talented barn builder. Were they one and the same? Even though some of the limestone support for the bank has crumbled, its weathered red paint is fading and boards in the windows are missing, the glory of this old barn shines on thanks to its three cupolas, which are simply spectacular.

OTTAWA COUNTY

The Tornado

With no results from my usual sources, I resorted to Plan B and consulted my Ohio bicentennial barn book to find a barn in Ottawa County. This county, like many in Ohio, is defenseless against the dreaded tornado, illustrated by

Scott Hagan's first attempt to paint Ohio's logo on a barn in this county, his sixth of the Ohio bicentennial series.

No sooner had Scott completed his Ohio painting on a barn owned by the Apling family than a tornado ripped through Ottawa County. With no siren warning then, Scott and the Aplings ran for shelter, leaving his scaffolding up, which was a wise move. Within minutes, the tornado leveled the barn and several others in the area, wiping out his work and pinning one of his ladders under the barn. But the painter and the barn owners were safe. That was 1998.

Three years later, after the committee found another willing owner, Scott returned and painted the Lowe family barn, a large one with eight thousand square feet, prominently displayed along the busy State Route 2. It was number sixty-eight in the series.

When I sent a letter to Brenda Lowe and her husband, the owners of this barn, she told me that James had passed away and that her sons worked the farm, still using the barn, built in 1936—a fairly new one by my standards—in raising hogs and cattle. Brenda told me that she owned a nearby restaurant,

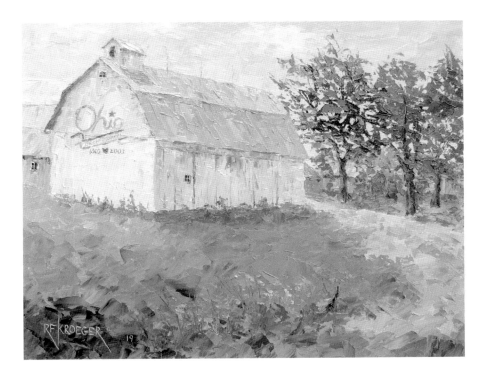

the Blackberry Corner Tavern, whose name intrigued me, as did the Ohio State Buckeye logo on the barn's reverse side.

Even though this barn goes back to Lowe's great-grandfather, a few hundred years ago this was Indian county, the Northwest Territory, declared off limits for settlers by the British in the mid-eighteenth century. Then, this county, named either for the Ottawa Indians or the word itself, which means "trader," was full of wild game—bears, panthers, deer and everything in between. So, yes, there was a lot of trading here in the 1700s.

The Ottawas, who lived originally on the East Coast, moved to southern Canada in the seventeenth century, then to Michigan and finally into northern Ohio. They called themselves Nishnaabe, meaning "Original People," and were known for their ability to barter. One of them, Chief Pontiac, born around 1720 on the Maumee River, was a great leader, organizing tribes to join the Ottawas to fight the British in what became known as Pontiac's War, lasting from 1763 to 1766. Eventually, the Ottawas were relocated to Kansas, as were other tribes in Ohio, but their name remains in Ohio in this county, as well as in Ottawa, Canada, the country's capital city.

On the other hand, the Lowes' barn still stands majestically, its logo fading, although Brenda wants to have it repainted soon. Long may it continue to survive. After all, a tornado doesn't strike twice in the same place, does it?

SANDUSKY COUNTY

Chickens Galore

This must have been some sight, back in the day, when this complex of barns produced thousands and thousands of chickens and their eggs. On the right side is a tall feed mill, which prepared food for the chickens. To the left are two barns—one a corncrib and one for hatchlings and storage. And behind them looms the giant chicken barn, all six stories of it, with its wooden-encased elevator shaft used to transport the feed to the various levels. A slate roof has protected it well over the centuries.

Yes, that's right: six stories. I can verify this because I hiked up ladders to see each one of them, courtesy of our guide, Betty Moyer, who owns the farm with her sister-in-law. Betty's husband, Robert, and his twin brother, Roger, have passed away, the fifth generation of the Moyer family to own this farm. And it's old. The farmhouse dates to 1840, and the barn may

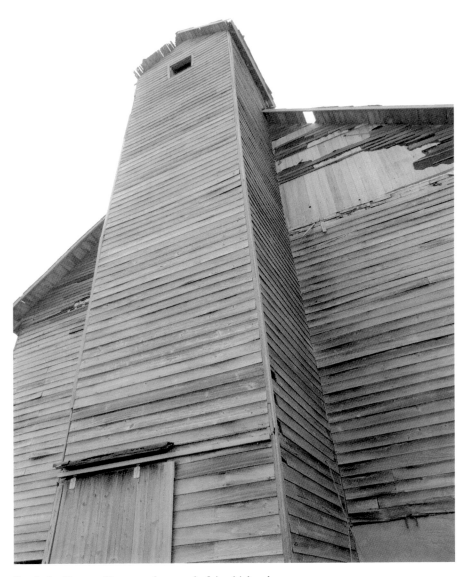

Sandusky County. Six-story elevator shaft in chicken barn.

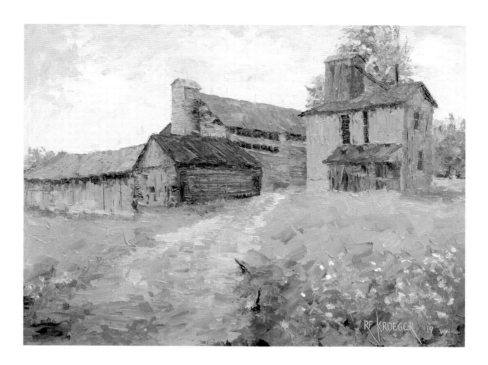

have been built around the same time, evidenced by its many rustic hand-hewn timbers.

Like its neighbor—the Schaeffer barn in adjacent Erie County—this barn benefited from the labor of the World War II POWs held at Camp Perry. On August 23, 1945, the date documented by an etching in cement, guards bused German and Italian prisoners to the farm for a work detail—leveling the ground at the entrance, changing it from a bank barn. This was nearly four months after the Allied victory in Europe and nearly three weeks after the atomic bombs were dropped in Japan. However, Japan didn't surrender until September 2, and the POWS weren't released until 1946. I wonder if they got to take any chickens with them.

2
WEST

According to the 2017 Agricultural Census, these eight counties of western Ohio have more than 7,400 farms, with Putnam County having the most at 1,335. Aside from the two largest cities, Lima and Findlay, the region is mostly farm country, and thanks to the drainage of the Great Black Swamp, it has some of the most fertile land in America. It's also home to many old and historic barns, built primarily by German and Swiss immigrants.

PAULDING COUNTY

Logistics

As I passed through Mercer and Van Wert Counties on Route 127—on my way to northern Indiana—I had to slow down, thanks to a virtual "whiteout," apparently the first snow of the season in these parts, not unusual on Veterans Day weekend. Undaunted, I was determined to find a barn in Paulding County, and after going by this complex, I stopped and walked back for a closer look. As I was figuring out a composition, snow persisting, a large truck approached, its two headlights reflecting off the road. I couldn't resist. I had to include this truck, barreling ahead despite the blizzard, and since our society seems addicted to ordering everything online and having it

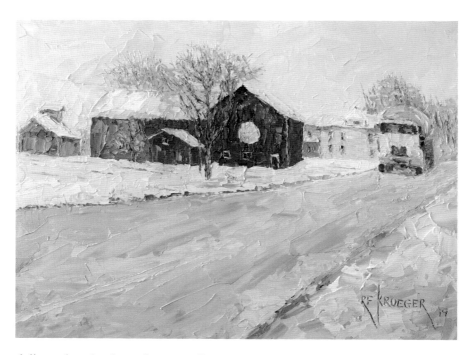

delivered to the front doorstep, I named the painting in honor of that hardy truck driver, intent on delivering his load, no matter what the weather had to offer.

The complex of barns was an interesting one, much more appealing since I didn't include the large cell tower in the background and a fleet of used cars in the foreground. One of the red barns, possibly the oldest, had an unusually large cupola, and another one featured a large white circle.

The county takes its name from John Paulding, a relatively poor farmer from the Hudson River region of New York who served as a volunteer militiaman during the Revolutionary War. One night in September 1780, he joined fellow volunteers David Williams and Isaac Van Wart, also poor farmers, as part of an armed patrol. When they came upon a British soldier, the three men seized Major John André near Tarrytown, now called Patriot's Park. Perhaps sensing trouble, they searched André and discovered, hidden inside his boots, the documents of a secret communication intended for Continental army officer General Benedict Arnold, one of General Washington's most trusted officers. He commanded the fortifications at West Point.

The militiamen, despite their poverty, refused André's substantial bribe and took the officer to army headquarters. Arnold's plans to surrender

West Point to the British—they offered a king's ransom—were revealed and foiled. André was hanged as a spy, with Williams in the audience, but Arnold escaped and switched sides to fight against the Americans. Even today, his name rings of being a traitor.

With George Washington's personal recommendation, the U.S. Congress awarded Williams, Paulding and Van Wart the first military decoration of the United States, the silver medal known as the Fidelity Medallion. In 1803, the year of Ohio's statehood, each man received the honor of having a county named after him—Williams, Paulding and Van Wert—all bordering Ohio's western boundary.

VAN WERT COUNTY

Courage

As I continued north on Route 127 through Mercer County and into Van Wert, I was lucky to have good driving conditions despite the winter blizzard. The asphalt roads still retained heat from prior warm days, preventing the snow from sticking or forming ice. However, finding a barn was more of a challenge. Again, luckily, I found one—nestled close to the road, sitting alone with two metal corncribs, their tops snow covered. It looked like an old one, not large and with an add-on. The red color stood out against the snowy background, and the telephone poles fading into the distance provided perspective.

As with its county neighbors Paulding and Williams, Van Wert County's name traces back to the Revolutionary War and the first military decoration, given by none other than George Washington. The county takes its name from Isaac Van Wart (this spelling is correct—the county's name was changed), a relatively poor farmer from New York who served as a volunteer militiaman during the Revolutionary War. Van Wart, as well as his two fellow militiamen, owned a small farm and worked it with family members, self-supporting and hardworking individuals (known today as yeomen farmers). These farmers represented the majority of small farmers in the Revolutionary War era, and along with the artisans of the towns—such as silversmith Paul Revere—they formed the nucleus of independent citizens, making the thought of freedom from mother England almost irresistible. After all, many had left the British Isles, Ireland and mainland Europe because of inequalities, whether religious or work-related.

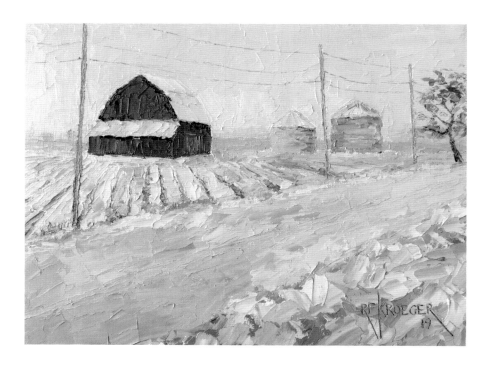

Even today in England, Scotland and Wales, landownership—including fishing rights on rivers—traces back to centuries of lairds, lords, dukes and earls. If you were born into a noble family, you had it made. If not, you were a tenant farmer, with little hope of landownership or emerging from poverty.

British officers of the eighteenth century, such as Major André, whom the three Patriots captured, often came from wealthy families since the commission of officer was expensive to purchase, costing £450, the equivalent of nearly £100,000 today. Many affluent families bought commissions for their sons. André may have come from one of these noble families, as his burial at Westminster Abbey suggests.

So, Major André, recognizing the plight of these farmers, may have offered a substantial bribe, hoping to tempt these three volunteer soldiers into releasing him. But it didn't work. Instead, the three turned him in, watched him hang and became legends in early America. Today, they're honored on a monument erected at the site of the capture in Tarrytown, commemorating their patriotism, their hope for a democratic society and, most of all, their courage.

MERCER COUNTY

Winter's First Blast

Early on a November morning, I headed north on Route 127, hoping to find a barn in four counties—Mercer, Van Wert, Paulding and Defiance. It was dawn, but there was no sun—just snow and lots of it.

By the time I crossed the county line into Mercer County, the snow had intensified. Fortunately, the ground was still warm enough that the roads remained clear, but visibility was not good. In hindsight, I was fortunate to spot this complex of a brick farmhouse and a barn with three cupolas. I did a sketch, took photos and hoped that I'd find some information about this old beauty, not far from Coldwater, a town appropriately named. Although I didn't find the owner, the name of the county was enough to justify an essay.

It took its name from Hugh Mercer, a Revolutionary War hero, as did the three counties north of Mercer. After all, Ohio was founded only thirty years after the Declaration of Independence. National patriotism was high.

Originally, Mercer, born in Scotland in 1726, became a physician at the ripe old age of nineteen, serving with the Jacobites for Bonnie Prince Charlie as an assistant surgeon in 1745. He also was in the Battle of Culloden, the last gasp of the Scottish Highlanders and a terrible loss for them. The English soldiers hunted down Prince Charlie's supporters, killing as many as they could, forcing Hugh Mercer to flee to America in 1747. He settled in Pennsylvania and practiced medicine for eight years. In 1755, he witnessed the French butchering the English army of Braddock when that army tried to take Fort Duquesne (in modern-day Pittsburgh), reminding him of the Battle of Culloden so much that he joined the British army, this time as a soldier. In 1756, he was commissioned a captain in a Pennsylvania regiment. After being badly wounded in a skirmish with Indians and separated from his unit, he found this way through one hundred miles of forest to Fort Shirley (near present-day Shirleysburg), where he was commended for his bravery and promoted to colonel.

British general John Forbes led another army, including both Colonel Mercer and Colonel George Washington—who would become close friends—to again try to capture Fort Duquesne. This time, the British succeeded, although Forbes became ill, leaving Mercer in charge of the fort, which he rebuilt since the French had burned it in their escape.

When the Seven Years' War ended in 1760, Mercer moved to Fredericksburg, Virginia, where he set up a medical office in this Scottish

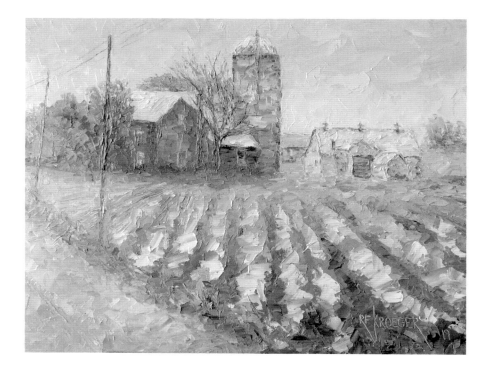

community and became active in the local Masonic lodge, to which his friend George Washington and future president James Monroe also belonged. In January 1776, he was appointed to what soon became the Third Virginia Regiment of the Virginia Line, a division of the future Continental army. In June, as tension escalated, he became brigadier general and reported for duty in New York.

In November 1776, when American forces were dwindling and losing hope, Generals Mercer and Washington led them across the Delaware River that December, earning a surprise victory and encouraging troops to stick with the fledgling army. On January 3, Mercer's brigade of 350 battled a superior British force, and as his horse was shot, he fell to the ground and was ordered to surrender. Instead, though outnumbered badly, he drew his sword and began to fight the same army that he had fought against thirty years earlier at Culloden. He was bayoneted seven times and left for dead by soldiers who thought he was Washington. Still, with a bayonet impaled in him, Mercer refused to leave his men, inspiring them and General Washington to rally the troops and defeat the British in the Battle of Princeton, which convinced the French to supply arms and supplies to the young army. The tide was turning.

Nine days after being wounded, Hugh Mercer died on January 12, 1777, and was reburied at Philadelphia's Laurel Hill Cemetery. He was an early American hero who was instrumental in the infancy of the revolution. So, even though it was snowing heavily when I visited this barn, any discomfort from winter's first snow paled when compared to Washington and Mercer's crossing the icy Delaware River en route to victories over the British, signaling the beginning of our country's quest for independence.

PUTNAM COUNTY

The Docent

Dr. Dave Poeppelman and Keith Sommer, owner of this barn and a walking encyclopedia on old barns and their construction, took me on a tour of Putnam County barns in May 2019. Throughout the day, Keith educated us on the finer points of barn architecture throughout the tour. His barn was a beauty.

The story began when his great-great-grandfather Johannes Geiger Jr. emigrated with his parents and siblings from Switzerland in 1835 to a Swiss settlement in Putnam County. First, they built a log house and then a log barn. Around 1847, the family built a water-powered reciprocating sawmill and probably did custom sawing for neighbors.

A few years later, Johannes built a commercial timber-framed shop, which still exists, for general woodworking, blacksmithing and gunsmithing, a business that must have flourished enough so that he could get married and begin raising a family. Accordingly, in 1854, he married Anna Steiner and built a well-insulated timber-framed home to replace the log house. Next he replaced the log barn with a timber-framed Pennsylvania-style bank barn, which is featured in this painting. Mennonites sought religious freedom, as did many of their fellow countrymen, leaving their homeland in those years. They also brought with them their barn building skills.

Between 1700 and 1776, about twenty-five thousand Swiss immigrants moved to the United States, and later in the nineteenth century, many Swiss farmers settled in eastern and northwestern Ohio. In fact, during the 1800s, German-speaking settlers were the largest group of immigrants in Ohio, and today, Swiss Americans in Ohio are second only to those in California in population. According to the U.S. Census of 2000, regarding

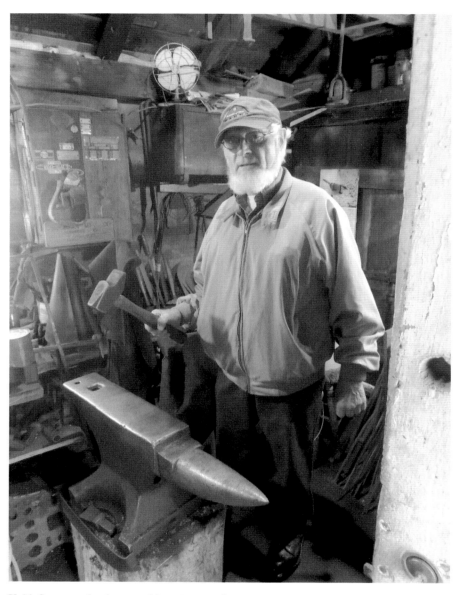

Keith Sommer, the docent, with antique anvil.

the highest percentage of Swiss Americans in any town, Pandora, where Keith's barn is located, came in sixth in the country, with nearly 20 percent having Swiss descent.

Keith took us through this Pennsylvania bank barn, showing us the hand-hewn timbers of white oak and the many mortise and tenon joints, expertly assembled more than 150 years ago, its longevity a testament to brilliant construction. The barn, forty by ninety feet, had owl holes in the siding of both gable ends. Keith explained that the builder employed a square rule, rather than a scribe rule, assembly. He also noted that the farmstead had other buildings: a hog house, a summer house with an exterior bake oven, a combination smokehouse/wash house, a dry house, a wood shed, a chicken house and a furniture shop supplied with wind power.

Later, Keith took us into a timber-framed shop, built by his ancestors around 1850, where today he stores antique anvils, circa 1870—one from England and one from France, each weighing hundreds of pounds. He uses these to teach the trade of a blacksmith, hoping to pass this knowledge down to younger generations. Keith, a history buff, also does reenacting work on timber framing, the wheelwright craft and stonecutting—work done on this farm by his ancestors.

He gave me some black walnut siding that was sawn on their reciprocating sawmill, located on a creek near the barn. The painting sits in this rare black walnut frame and reflects the Mennonite heritage of this farm as it approaches its 200th birthday. May it have many more.

ALLEN COUNTY

The Confederated Bachelor Union

This remarkable barn in Gomer was another reason I wanted to come to Allen County. I had seen a photo of it online and wanted to see it in person. Fortunately I did, thanks to Darlene Montooth, whose round barn Rheuben Gibson and I visited earlier that day. Darlene's great-grandfather, a Roberts, had emigrated from Wales, giving her a connection to this tiny village, just north of Lima. She gave us copies from a historical pamphlet that explained the barn owner's history, and she provided directions since the barn is somewhat hidden.

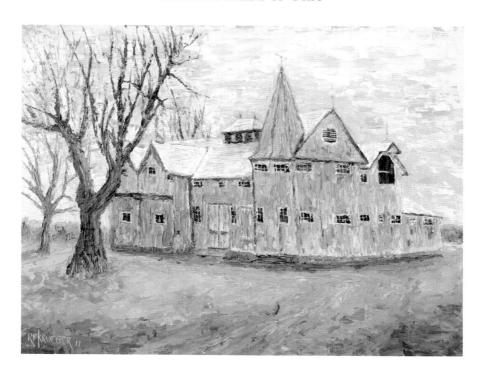

Allen County's Gomer has Welsh heritage. Families with names such as Roberts, Thomas, Williams, Nicholas and Jones were some of Gomer's early founders. These names, essentially first names—Robert, William, Nicholas and John (Jones)—stem back in history to when the English imposed taxation on the Welsh and demanded surnames to keep track of taxpayers. With no love for the English—which persists today among many Welsh nationalists—the Welsh cleverly used their first name as their surname. Hence Robert Roberts, William Williams and John Jones. This presented a problem for Welsh recruits in World War I. There were a lot of John Joneses and William Williamses. So the British government labeled them by numbers, such as John Jones no. 24.

This community sprang up in 1833 when three Welshmen traveled from the Welsh community of Paddy's Run to look at land in Sugar Creek Township. Formerly the home of the Shawnees and their famous leader Tecumseh, the wooded land was flat and good for farming and was sold for $1.25 per acre by the government in 1833. Satisfied with this prospect, Thomas Watkins, James Nicholas and David Roberts returned with their families six months later. They arrived in September and had to live in their wagons while they built log cabins. Presumably they finished them quickly since winters in northern Ohio can be harsh.

In November 1834, more Welsh settlers came here, notably Evan Jones, John Watkins and John R. Jones. By 1839, between forty and fifty Welsh families had set up homes. James Nicholas and Samuel Ramsey laid out the streets, but John W. Thomas, another Welshman, got permission to name the community. He chose the name Gomer.

Gomer's first physician and the builder of this barn, Richard E. Jones, was born in Llanbrynmair, Wales, in 1834. His father, William Jones, brought him to Gomer in 1848. About two years later, Richard boarded with the family of a Dr. Sanford in Lima, who may have encouraged the lad to pursue a career in medicine. He did, first apprenticing under Drs. Monroe and Robb in Vaughnsville and later graduating from Cincinnati's Miami Medical College. In 1856, fresh out of school at the age of twenty-two, he moved to Gomer and set up practice. Nowadays, most freshmen in medical school are this age but have many more years of education before they can practice.

In the mid-nineteenth century, epidemics were common in Ohio. In 1855, cholera took many lives, and in 1872, there was an epidemic of smallpox in Columbus Grove, a nearby village. One of the residents left a diary about this: "Our parents decided to have us vaccinated. Father took me to Gomer to Dr. R.E. Jones who told Father that as soon as my vaccination developed fully, he could vaccinate the rest of the family....Each case was a grand success....Dr. Jones also pulled my first tooth. He was a fine gentleman."

He was also a good businessman. For sixteen years, Dr. Jones was a director of the First National Bank of Lima, and for four years, he was president. He also entered politics and served two terms in the Ohio legislature. A historian, he founded the Elida Pioneer Society in 1895 and became its president. Oddly, he never married, was a confirmed bachelor and remained a stalwart in the town's Confederated Bachelor Union, which became the painting's title. If you look carefully, you'll see Dr. Jones, dressed in a green jacket with tails, a black top hat and a cane, headed to the barn for his horse-drawn carriage. Off to his bachelor's club. A popular man, Dr. Jones was honored by his many nephews and nieces, one of whom, Edith Jones, kept house for him. He died in 1911 at seventy-seven, an old age in those years.

Judging from the saw-cut wood inside the barn, it was built in the late 1800s, perhaps as late as 1890, but from a photo of Dr. Jones in front of his barn, he appears to be about fifty, which would date the barn to 1885. He used the barn to store crops from his small farm and to house his horses and buggies, which he used for travel, probably for making house calls. In

front of the barn stood his office, a slender two-story brick structure, now converted into a residence.

In November 2016, barn scout Rheuben and I had the chance to tour his 1870 home, also done in American Gothic, and view some of the memorabilia. The building next to the barn, Cathy Smith told us, was a granary and the doctor's farm office. Not far away and long since gone were two other buildings—a smokehouse and a spring house. Dr. Jones had quite an operation going.

But his masterpiece was the barn, an American Gothic marvel whose architect remains unknown. Even in those days, the architectural plans and construction must have cost dearly. An impressive tiled turret, the main attraction of the barn, rises high above the roof lines, which zig and zag in various directions. The many barn doors show off a fancy herringbone pattern, and three dormers sport circular slate tiles, a real statement of wealth. After all, anyone could use ordinary square tiles. Both sides of the barn feature protective eaves over the haymows. Even the adjacent farm

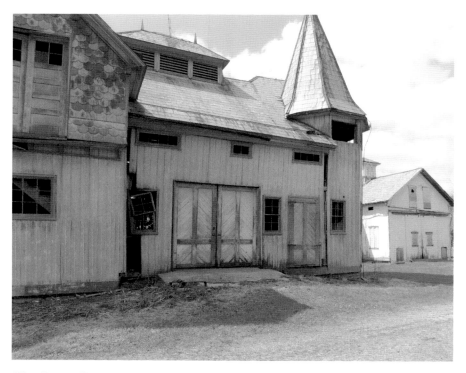

Allen County. Barn detail.

building is embellished with an ornate wooden cupola and a slate roof that matches the barn.

Slate for most American barn roofs came from Wales or New England. So it's easy to see why this Welshman wanted to bring some of the old country to Gomer. Many barns and homes in northeastern Ohio still have their original slate roofs, evidence of the material's durability.

However, the interior of the barn is deteriorating. The roof is damaged and leaks. Many windows are broken, allowing more water to penetrate the wood inside. Lightning rods, which dot the roof, may not do much good to stop the demise of this barn; the weight of the heavy slate roof, combined with its holes, may cause it to collapse. A strong wind could be the final blow. When I first saw it in the spring of 2016, I thought it could be saved, but after having seen further decline six months later, I have my doubts.

Regardless, I'm happy that the owner allowed me to do a painting of it and write about it. Yes, no one knows what will happen to this barn, unless a billionaire angel steps forward. Like the famous pagoda barn of Henry County, another national treasure that is no longer here, "Gomer's bachelor union" may face a similar fate.

Auglaize County

Magnificent Manchester

This iconic round barn is one of Ohio's most photographed and painted, and rightfully so. The dark roof, contrasting with deep-red siding and white trim, provides a striking composition that many have been drawn to capture, as evidenced by the hundreds of images found in a Google search.

Even though George Washington designed and built a sixteen-sided threshing barn at his farm in Virginia in 1793 and the Shakers built the first truly round barn in Massachusetts in 1826, this type of barn did not catch on until the late 1800s. An article, "The Economy of a Round Dairy Barn," written by Wilbur Frazer and published by the University of Illinois in 1908, described the benefits of a round barn: more efficient housing for cows, time savings in feeding, a protected silo and easier silage distribution. The article also inferred that construction of a round barn was less expensive than a rectangular one and that "progressive" farmers should consider such a barn. The opposite was true—circular barns were

more expensive than rectangular ones, and the "progressive" farmers were usually only the wealthy ones.

One of those farmers was Jason H. Manchester, who came with his parents from Vermont to central Ohio in 1865. They bought 200 acres of swampland in the northern tip of Auglaize County and began farming. Their Italianate farmhouse, in reality a mansion in 1877, showed that they were prosperous. By 1900, Jason had acquired 2,800 acres of farmland and decided to build this barn eight years later.

Tim Manchester, the fifth generation of this farming family, graduated from Ohio State University, as did his wife, Martha, but decided that any business job he might land, thanks to his college degree, was not strong enough to lure him from his inherited roots of farming. Carrying on the tradition of his family, Tim has expanded the farm to 4,500 acres and has maintained the barn immaculately. With a diameter of 102 feet, it's the largest round barn east of the Mississippi. Today, besides being an Ohio treasure, it serves as storage for equipment. It earned a listing in the National Register of Historic Places in 1980.

White lettering above the entrance continues to preserve the legacy: "J.H. Manchester, 1908, Maple Avenue Farm, Horace Duncan Builder." Yes, it's rare that the builders of such impressive barns are ever remembered, which makes this sign all the more special. Mr. Duncan, a native of Knightstown, Indiana, was born in 1877, and as a young carpenter, he was influenced by experienced round barn builders Isaac McNamee and Benton Steele, known today as the "Father of Indiana's Round Barns." Duncan's first known exposure to round barns came in 1901, and by 1902, at the age of twenty-five, he had become skilled enough to supervise construction of one of Steele's designs: the Boettcher round barn in Artis, South Dakota. He quickly developed a reputation for building round barns.

At this young age and armed with confidence, Duncan began getting jobs. In fact, in 1911 his business letterhead carried an image of Steele's Boettcher barn and warned farmers to be wary of amateur barn builders:

> *Some unscrupulous, would-be architects, in order to obtain a few dollars for worthless plans, gotten up with no knowledge of circular construction, thus causing many disappointments and much extra and unexpected expense during construction, are endeavoring to make prospective builders believe that my barn is not patented....I will promptly prosecute each and every infringer.*

Horace Duncan, 1910. *Courtesy of Mrs. Clifford Shively.*

This legalese lingo might have stemmed from Duncan's involvement with four other round barn builders—including Steele—who built the largest barn (102 feet in diameter, the same dimension as Manchester's barn) in Indiana for a wealthy Indianapolis lawyer, Frank Littleton. This attorney made a patent on the design of the "self-supporting conical roof" for Duncan and McNamee, which was approved in 1905. Over the years, Duncan used this patent to collect fees from builders of round barns and to promote his own business. Ironically, only a few years after construction of the Littleton barn, the windmill on top of the "patented" roof caved in.

However, his reputation spread to other states, and in 1908, Duncan designed and erected the Manchester barn, which he was so proud of that in 1911 he put a photo of it on his business envelope, which also carried the inscription, "Infringers promptly prosecuted. Beware of unscrupulous architects." Above the address side and under his name, Duncan included, "Designer and Builder of the Original Circular Barn with Latest Improvements." At thirty-three, this carpenter turned round barn architect was in his prime. However, the round barn craze had fizzled by 1918. He died ten years later but is remembered as the "Round Barn Man."

Although many of the barns that I paint and write about are now gone, this one, thanks to the expert construction by Horace Duncan and careful maintenance by the current generation, may last for centuries. Long live the mighty Manchester.

HANCOCK COUNTY

Dreams Come True

Judy Garland sang it in 1939, winning the Academy Award for best song. The classic "Over the Rainbow," written by Yip Harburg and composed

by Harold Arlen, was featured in the movie *The Wizard of Oz* and helped launch the career of Miss Garland. Two years later, America entered World War II. But for old folks like me, the lyrics still hold sentimental value, bringing back the image of Dorothy and Toto:

> *Somewhere over the rainbow way up high*
> *There's a land that I heard of once in a lullaby*
> *Somewhere over the rainbow skies are blue*
> *And the dreams that you dare to dream really do come true.*

In the case of this old barn, the rainbow stretched from this farm to where Lauren Etler grew up, in a house just around the corner. Lauren's great-great-great-grandfather Anthony Glick settled this farm and built the barn in the mid-1800s. She had always hoped that someday she could live in the farmhouse, which remained in family hands for more than one hundred years. After the Glicks sold the farm, it changed ownership often, was not maintained and, after a bankruptcy, went into a sheriff's sale in 2013, giving Lauren and her husband, Nathan, the chance to buy it.

After their purchase, the Etlers began a labor of love, restoring the farmhouse into a stunning beauty. They worked on the barn as well and

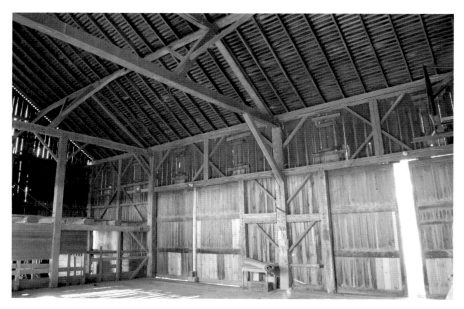

Rare eighty-foot hand-hewn beam.

wisely covered it with metal, getting rid of the leaky roof—which spells death for a barn—painted it and restored the decorated louvers. Boards of the original louvers frame this painting.

Inside, it's a marvel. An eighty-foot hand-hewn beam spans the length of the barn, and the truss system eliminates the need for supporting posts, keeping the main floor open, a unique look in such an old barn. I've seen a fair number of sixty-foot hand-hewn beams but never an eighty-footer. It would have been fun to watch the pioneers fell the tree and carve it up, squaring its shape almost as if they had used a machine.

Because the Etlers took this property from shambles to superb, I painted it in three different compositions and chose the snow scene to be the representative from Hancock County, thanks to a winter photo that Lauren supplied. After all, even though the most recent seller must have had hard times, returning this farm and its old barn to a direct descendant was indeed a dream come true.

HARDIN COUNTY

Kenton's Country

This large dairy barn sits next to the fairgrounds of Hardin County and serves as both an agricultural museum and an event center. Driving through Kenton, the county seat and only minutes from this barn, I began thinking about one of my favorite early Ohioans, Simon Kenton, the swashbuckling frontier fighter. *Why does the county seat bear his name?*, I wondered.

Soon after I arrived, I met Sheena Striker, the director of the Hardin County Historical Museums, and her father, Tim Striker, a county commissioner. They took me through this venerable barn, built in 1914 after a fire destroyed the original, and they pointed out that even though it no longer houses dairy cows, it continues to serve a purpose. Filled with nineteenth-century farm memorabilia—a red antique sled, a rustic wagon, a four-wheeled horse drawn carriage and vintage advertising signs—the barn has new life, displaying these relics of the past. It's also available for weddings and other events. During the Hardin County Fair, visitors can reminisce about the glory days of farming. At other times, reenactments such as Civil War Days take place here.

The farm traces back to R. Means, who bought one thousand acres of this Virginia Military Tract in 1820. Over the decades, the farm changed ownership several times until James Burnison took control in 1901. After the fire, Burnison built the present barn and used it for dairy farming; he also kept racehorses in it during the county fair. In 1984, the Yost family, then the owners, transferred it to the county, which now leases the farm to the Hardin County Museum. Sheena's family took care of the property for twenty years, although the museum now operates it.

After our tour, I couldn't repress my thoughts any longer and asked why the county seat was named Kenton, expressing my admiration for the great Simon Kenton, whose life story is told in the *Frontiersman*. Kenton, born in 1755 in Virginia, fought in the American Revolution, the Northwest Indian War and the War of 1812. He and his friend Daniel Boone were legendary for their ability to fire, reload and fire a flintlock rifle—without stopping—while on a full run. He died in nearby Logan County and is buried in Urbana. In 1845, Kenton was incorporated as a village and became a city in 1886.

However, Sheena said the reason why the city took his name is still a mystery, although the man did travel through here and may have done something to impress the locals. She told me that she also read the *Frontiersman*, a requirement in the local high school, which shows how much the town regards this mostly forgotten Ohioan, who will be long remembered, if not in this barn painting, then at least in its title.

3

MIDDLE WEST

This western section of Ohio, like its northern neighbors, sits on mostly flat ground ideal for farming, and with the exception of Dayton, its only industrial city, it is principally rural. In Darke County, for example, it's hard to drive for more than five hundred yards without seeing an old barn. Also, three incredible gems await: Champaign County's round brick barn at Nutwood Place, the octagonal stone barn of Clark County and Miami County's historic Johnston Farm and Indian Agency, which features a two-hundred-year-old log barn made from logs reclaimed from one of General Anthony Wayne's frontier forts of the 1790s.

DARKE COUNTY

Snow-Bound

According to Gretchen Snyder, who owns this farm with her husband, Chris, this barn is one of seven on the property, which they purchased in 2007. Seven barns meant that the original farm must have been large, proving that the farmer was prosperous. This barn, with its massive hand-hewn beams, built in 1872 by Joseph Glunt, could have been the first barn on the farm. Later, in 1884, S.C. and Mary Glunt Mote built the farmhouse, which the Snyders are currently rehabbing.

Although I visited this barn in April, when the scene was snow-less but not yet spring-like, I felt compelled to paint the barn in winter, thanks to a photo from the owners, reminding me of "Snow-Bound: A Winter Idyl," a poem by John Greenleaf Whittier that he published in 1866. In that era, Ohio was emerging from the Civil War, was mostly a state of farms with hand-hewn timber-framed barns and was full of hardy souls with large families. I'm sure that many of those pioneers could identify with this poem. Six years, later the Glunts built this barn.

The sun that brief December day
Rose cheerless over hills of gray,
And, darkly circled, gave at noon
A sadder light than waning moon…

And, when the second morning shone,
We looked upon a world unknown,
On nothing we could call our own.
Around the glistening wonder bent
The blue walls of the firmament,
No cloud above, no earth below,—
A universe of sky and snow!

The owners use the barn not only for storage but also to house goats and chickens; sometimes uninvited wildlife sneak in as well. Once they finish working on the farmhouse, they plan to restore the barn, whose foundation and roof need repair. However, as Gretchen wrote about the old barn, "It's a beautiful and mysterious place—dim, smelly, and damp…but in a good way." I would add that in winter, when it's draped in snow, it rewards the visitor with a priceless Christmas card scene, one that begs to be painted. I'm sure Currier & Ives would agree.

PREBLE COUNTY

Rinehart Homestead

Situated directly west of Dayton, this county borders Indiana and takes its name from Edward Preble, a naval officer in the Revolutionary War. Many

of its forty-two thousand residents are involved in some aspect of farming since there are close to 1,100 farms in the county. And there are plenty of barns too. Someday I'd like to have a look at Big Ole Fat Creek, a county stream named, presumably, for its girth. But who named it and why? So many Ohio counties, so many barns, so little time.

One of my neighbors, Rich Dineen, commissioned a painting of his grandparents' barn in Preble County that has since been dismantled, as have many Ohio treasures. Fortunately, Rich had old photos, which I used. I caught the essence of the barn, although fine details—like the 1897 date above the barn door—are hard to see in a small painting. Underneath the date, there was some more writing: "Rinehart Homestead." Home on the range!

David Rinehart, the great-grandfather of Rich, was born on April 3, 1852, shortly before the start of the Civil War. He married and had a son, George Grover Rinehart, born on November 14, 1892. Five years later, David bought 350 acres of prime farmland nine miles west of Eaton and established the family farm. The date of 1897 on the barn probably indicates it was built in that year.

George farmed the land for hay and corn, the main Ohio crops at the turn of the century, and also raised dairy cows—twelve to fifteen in the early days—as well as hogs and beef cattle in the later years. They used the barn to store hay and shelter the livestock in winter.

When Rich was a boy growing up in the suburbs of nearby Dayton, he spent a few weeks each summer on this farm with his grandfather and grandmother. His five years of memories between the ages of nine and fourteen are still vivid. He remembers sows giving birth to litters of pigs, as well as a very large John Deere tractor—an early model that ran on propane. He also recalls when he and a cousin had the job of stacking bales of hay in the barn's loft, a hot job in the summertime, though not as dangerous as when his eighty-year-old grandfather George, high on a ladder, painted "Rinehart Homestead" above the doors. As Rich said, "On the farm, life goes on and someone had to get that job done."

Few lads from the city or suburbs ever experienced life on the farm, and even fewer ever tasted the cool water coming from a barnyard windmill-driven well, as Rich did. Hopefully this painting will rekindle memories of the old barn for Rich and for others who were fortunate enough to have them. As my classmate from the rural Ohio county of Scioto told me many decades ago, "Bob, why am I going back home to practice? It's simple. You can take the boy out of the country, but you can't take the country out of the boy."

SHELBY COUNTY

Botkins

Years ago, whenever I drove south on I-75 and passed through Shelby County, I saw a quaint old barn not far off the highway. Somewhat deteriorated, its cupola tilted and boards missing, its rustic character called out to me. So, on my return trip from northern Indiana on Veterans Day weekend in 2018, I decided that I'd stop to find it. I exited the highway at the village of Botkins, just across the county line, south of Auglaize County. After getting gas and a coffee at the Gulf Station—they still exist—I went down a few roads, looking for the barn. But no luck. Perhaps it was dismantled. Yes, it probably was. Another loss.

But the stop wasn't wasted: I found a barn, a pretty big one, although I didn't venture too close since the wind chill wasn't much above fifteen degrees. I did a quick value sketch, took some photos and got a barn in Shelby County, although it wasn't my first choice. The composition needed a little color, which explains the harvested corn field in the dead of winter.

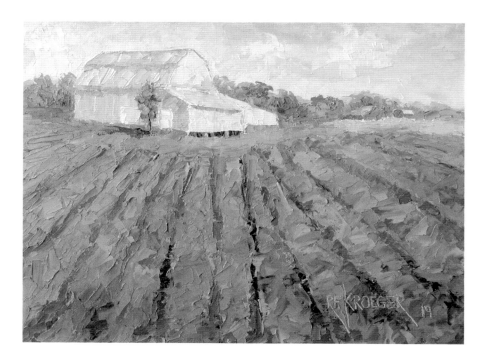

What also attracted me was the name of the town: Botkins. It sounded Halloween-like, foreboding, like a witch's kettle brewing. The population of this Shelby County village was 1,155 in 2010. And one of the first things I discovered was that the Shelby House, a historic building that local businessman Philip Sheets built in 1864, served as a hotel for railroad passengers. When the rail service declined, the building found other uses, but it was finally donated to the Botkins Historical Society. It converted it to a museum and got it placed in the National Register of Historic Places.

But what about the name? Unlike early nineteenth-century villages and towns in rural eastern Ohio, Botkins was platted later, in 1858, and named for Russell Botkin, the original owner of the townsite. But as I suspected, the name itself comes from the Middle English *bodkin* or *bodekin*, meaning dagger or a short pointed weapon. It seems to have originated in England; the name Botkins has been recorded in British history since the time when the Anglo-Saxons ruled over the region. It evolved into an occupational name for a maker or seller of such weapons, although most of the folks named Botkins were farmers in the 1800s.

Alas, even though I didn't find that magical old barn, I did find one in Shelby County, and whenever I drive by the exit now, I'll think of daggers, one of which pierced my heart when I didn't find that mysterious barn. Next time I see one like that, I'll stop first and ask questions later.

MIAMI COUNTY

Colonel Johnston's

There's a lot to see at the Johnston Farm and Indian Agency, located in Piqua right off I-75, north of Dayton. One of Ohio's historical gems and part of the Ohio History Connection, the farm features a spring house, a cider house, an 1815 Federal brick farmhouse, an Adena Indian earthwork and mound, a canalboat (and the chance to ride on it) and, of course, the barn, a rare double-pen log barn, one of few left in Ohio and one of the earliest ones, built in 1808. Throughout the year, the farm plans activities for the entire family, ranging from reenactors portraying early Ohioans to a relaxing ride on the *General Harrison* on the Miami and Erie Canal.

With the exception of the Indian mound, the other structures trace back to John Johnston, born in Ballyshannon in the north of Ireland in 1775,

one year before America's declaration of independence. In 1786, three years after the Treaty of Paris, John, only eleven, left his family in Ireland and immigrated to the new country, accompanied by a priest and a trusted family friend, also his tutor. He settled in Pennsylvania. Five years later, his family joined him.

This was 1791, a time when Ohio and Indiana were considered part of the Northwest Territory, filled with many tribes of Native Americans, some friendly and some hostile. During Johnston's travels, he found his dream land in Upper Piqua, near the Great Miami River, and promised himself that someday he'd own a farm there.

But this was untamed land of the new country and full of danger. To provide safety for the influx of white settlers, many of them veterans of the Revolutionary War who were awarded land grants in Ohio and Indiana, President Washington sent General Josiah Harmar with 1,500 troops, many untrained militia, to build forts and seek peace with the tribes in western Ohio and eastern Indiana in 1790. However, Chief Little Turtle and his Miamis soundly defeated Harmar and his army. The next year, Washington sent General Arthur St. Clair, the governor of the Northwest Territory, to solve the problem. But again the Indians prevailed. Of the 1,400 troops, mostly untrained militia, fewer than 800 survived. Frustrated but still hopeful, the president appointed General Anthony Wayne as commander of the U.S. Army of the Northwest.

This was 1792, when the Northwest Territory became the real-life education of John Johnston. Now seventeen and working as a wagoner, he brought supplies to General Wayne's forward supply post, Fort Piqua, located on the present-day Johnston Farm site. Determined both to win and have peace with the Indians, General Wayne seemed to have more foresight than his two predecessors and ordered forts to be constructed along the western Ohio border—Fort Recovery, Fort Greenville and Fort Defiance. Large hand-hewn logs were used to construct these forts, making the walls impenetrable to hostile fire.

President Washington and the young Congress also realized that an army of militiamen was not sufficient, and they authorized the creation of a regular army, the foundation of our armed forces, and put General Wayne in charge of training. This army, assembled and trained in Fort Pitt, numbered more than five thousand. Together, General Wayne and his men marched north, along his line of forts, and defeated the Indians at the Battle of Fallen Timbers in 1794. Johnston kept them supplied. One year later, General Wayne signed the Treaty of Greenville with Indian leaders,

who relinquished the majority of Ohio land to the United States. The great Tecumseh refused to attend. He still planned to unite the many diverse tribes into one central force to stop the tide of the pioneers.

By now, Johnston had returned to Philadelphia and took a clerkship in the War Department. He rented a room at that time with a family by the name of Robinson. In 1802, romance struck when, at twenty-seven, he fell in love with sixteen-year-old Rachel Robinson, eloped with her and traveled west, where he ran the trading post at Fort Wayne, Indiana. She bore four of their fifteen children in their time at the fort. Later, Johnston became both the factor and Indian agent at Fort Wayne, although his heart still yearned for the land near Piqua. He bought the property in 1804, the same year that President Jefferson commissioned the expedition of Lewis and Clark to explore the new land that the United States had purchased from France in 1803.

In 1808, Johnston, still working in Fort Wayne, began to construct buildings on his farm, including the barn. Cleverly, rather than cutting down huge trees and hewing them for beams in the double-pen barn, Johnston used timbers from one of General Wayne's forts. To look at these massive beams and realize where they came from is inspiring.

In 1811, the same year as the Battle of Tippecanoe, won by William Henry Harrison, governor of the Indiana Territory, Johnston left Fort Wayne to become a farmer on his property in Piqua. Ohio, now having been a state of the Union for eight years, was still full of American Indians, but it's where Johnston decided to drop his anchor.

When the War of 1812 broke out, the government appointed Johnston as the Indian agent in Piqua. His work with the Shawnee, Delaware, Seneca and Wyandot tribes helped to ease tensions during this war and earned him respect and recognition as an early Ohio leader. He continued his work at the agency until 1829, when he was removed by President Andrew Jackson for political reasons. By that time, many of the tribes had relocated to western states.

Colonel Johnston also helped found Kenyon College in 1825, became one of Ohio's canal commissioners and played a role in the creation of a major road from Fort Meigs to Wapakoneta. He continued to farm and raise his large family. One month before the Civil War began, Johnston died in February 1861. Although he was gone, one of his sons served for the Union. Two older sons served in the military during the Mexican-American War and died as a result of their service. I'm sure he would have been proud of them. We're likewise proud of this early Ohio pioneer, and we're grateful that the Johnston farm preserves not only the magnificent log barn but the other old buildings as well.

MONTGOMERY COUNTY

The Medic

I didn't see the small Christmas tree sign on Route 35, west of Dayton. I sped by it, turned around and finally arrived. As I entered, the farm looked like a scene from the *Barn Builders*, a popular series on the DIY network. A tall red crane was lifting a long hand-hewn timber beam and positioning it, while several workers were drilling, cutting and shaping other lumber. The Renches, Laura and David, had hired a framer to restore their 1816 barn from across the street. Noble souls. Historical preservationists.

They also own another early nineteenth-century barn, which they used as an office for the Christmas tree farm they've operated for many years. A third "newer" one, built in 1903, serves as storage, a good place for old barn wood, allowing me to choose and pick for framing this painting.

Christian Shively settled this farm in 1806. Later, the Heeter family took over, as an 1898 photo attests, showing a proud family of four in front of two horse-drawn buggies. Eventually, Laura's dad, Dr. Mason Jones, bought the farm in 1950. He married in 1939, graduated from Ohio State University's medical school and served in World War II. He became one of the first pediatricians at Barney Children's Medical Center, which later was named Dayton Children's Hospital.

When I asked Laura why a pediatrician would want to own a farm, she explained his Christmas tree project, which was tied to his desire for land conservation. It also served as a valuable lesson for his children—hard work and entrepreneurship. The family began selling Christmas trees in 1960, using an old barn to display cut trees and keeping donkeys in stalls to entertain the visiting children. Her dad made an office out of the granary and kept his winemaking equipment and his World War II army chest in the hay loft. For many Christmas seasons, the family hustled, working together in selling trees, and gathered in the barn next to the stone fireplace, sharing camaraderie and bringing cheer to visitors. Those memories were so special that Laura and David have decided to keep these old barns instead of dismantling them, as a neighbor recently did. Such barns are hard to part with. The Christmas tree business ended in 2016 but reemerged in December 2019 to help pay for the reconstruction of the old barn.

Another memory was her dad's collection of photographs he took while in Europe during the final days of World War II, when he served as a medic-physician with the soldiers who marched through Germany. When

Laura mentioned that he was with troops who liberated the concentration camps, I asked if I could see his photos. I was intrigued that her dad would have had enough foresight to preserve such history. So I began leafing through the huge volume and came to a section with a warning about graphic images. Sure enough, there they were—photos of corpses in striped uniforms, lying next to one another, arranged like fence posts—a tragic sight, but one that probably left an imprint on this young medic, shaping his life into one of helping others. Another story that Laura remembered was when her father protected two nurses, a man and woman who were German Jews in a camp, making sure that they had safe passage to Canada. They became lifelong friends.

Although the early pioneers of this farm left a legacy behind in the form of two sturdy timber-framed barns and one "newer" one, the title of this painting—its composition taken from a photograph of the original 1816 barn—must go to the medic of World War II, a member of the Greatest Generation. May we never forget Dr. Jones and the other men and women of his era.

Logan County

Last Days

This venerable old barn traces back to pre–Civil War times, and since it's large, it may not have been the first barn on this farm, which is in its sixth generation of Hudson family ownership.

Jacob V. Hudson, patriarch and pioneer, settled this land in 1827 and began farming, hoping to take advantage of the Land Act of 1820, which reduced the number of acres that Ohioans had to purchase from 160 to 80 and lowered the cost from $2.00 per acre to $1.25—an attempt to encourage additional land sales. He might also have used the Relief Act of 1821, which allowed Ohio farmers to return unused land back to the government, earning credit toward their debt. President Andrew Jackson signed the Hudson deed in April 1829, which recorded the sale of 78 acres.

It's likely that Jacob first built a log cabin for his family and then a small barn. As the farmer prospered and needed more room for livestock and crops, he eventually built this larger barn, perhaps in the 1840s. The family passed down the farm to sons Andrew J., James L., Emery C. and finally

to Gerald L. Hudson, who currently resides on the farm. His son Bob, the sixth generation, manages the farm, which was well thought of in the 1920s, according to a passage in the third volume of *Memoirs of the Miami Valley*: "The pretty estate of the Hudson's, known as the Hudson Homestead, is the abode of affection and hospitality, where the many friends of this worthy couple and their children always find a sincere and hearty welcome."

I met JoAnne Hudson and her husband, Bob, on a warm July morning. At first, I drove by the barn, hidden by a stand of trees. Eventually, after seeing only a vast acreage of corn and soybean fields, I turned around, stopped at a solitary mailbox, drove down a long gravel path and parked in the shade of the trees. JoAnne and Bob told me that I passed the navigation test and gave me a tour of their magnificent barn, warning me to be careful since Bob recently fell through the top floor. He was lucky to escape with only a dislocated shoulder.

Formerly used for livestock—including horses and cattle—the barn has outlived its usefulness and has become a virtual money pit, a fate shared by many old Ohio barns. As I looked, first at the massive hand-hewn beams, still supporting the roof, and then at the sadness in the eyes of the owners,

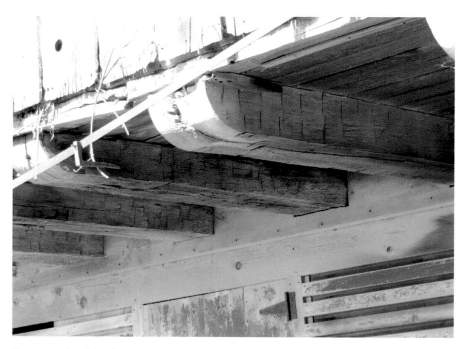

Rare chamfered forebay struts.

I could sense that this old boy will be missed. With its broken boards and weathered exterior, it looks quite different than it did in an old hand-colored photo, showing four prominent cupolas, eleven smartly white-trimmed windows and an owl hole under the eave.

The Hudsons must have been prosperous farmers to have been able to build such a large barn, one that has lasted now for more than 150 years. Pink granite boulders still fortify the earthen bank—evidence of expert stonemasons, who may have quarried the rocks nearby. What really caught my attention was the forebay side of the barn. Hand-hewn beams, joists from the upper floor, strut out from the barn, supporting the cantilevered forebay, and have been rounded up to the edge.

Experts from the Friends of Ohio Barns advised that the purpose of this tapering was to reduce the amount of splitting and avoid rotting, as well as adding an esthetic finish to the timber. Another expert explained that these edges could be the rounded shape of the log, stripped of the bark. They've stood the test of time.

But the years have caught up, and the barn doesn't have much time left before it's either dismantled or repurposed. Perhaps its hand-hewn beams will grace the ceilings of a mountain retreat in Montana or Wyoming. Perhaps not. Regardless, its memory will always be fresh in the minds of JoAnne, Bob and the rest of the Hudson family. As it should be.

CHAMPAIGN COUNTY

Nutwood

The dictionary defines nutwood as any nutbearing tree or its wood. In 1815, when this farm's history began, plenty of nutbearing trees dotted the Ohio landscape: chestnut, walnut and hickory and more. Perhaps William Ward, the farm's founder, named his farm Nutwood Place after such trees.

Ward, a native of Virginia, served as an officer in the Revolutionary War. Both educated and business-savvy, he made the most of his and his father's war service land grants. Moving to Maysville, Kentucky, he claimed land that had been axe-marked by Simon Kenton, the legendary frontiersman who, unfortunately, was illiterate and never bothered to register in the land office. However, Ward decided to become business partners with Kenton.

As early as 1788, they began exploring the frontier, still hostile territory, and making claims in the Mad River Valley. In 1799, they moved their families to this area, and by 1810, the partnership had amassed more than twenty-five thousand acres of land. Five years earlier, Ward convinced Ohio's legislature to create a new county, Champaign, taking land from Greene and Franklin Counties. After purchasing land, he again convinced officials to establish the county seat, Urbana, on this property, where he began farming.

He lived in the farmhouse until his death in 1822. Thirty years later, another Ohioan purchased it. Absalom Jennings, born in 1815 on a pioneer farm in Clark County, Ohio, began work in the harness trade when he turned fifteen, after moving to Urbana. He eventually started his own harness and saddle company, selling goods in Marysville for four years before moving to New York in 1844. Not content to be an employee again, Ward joined forces with a partner to launch a company that made hats, caps, straw goods and fancy millinery. It must have been successful—in those days everyone wore a hat—since Jennings began owning and racing trotters.

Despite his apparent financial prosperity on the East Coast, Jennings yearned to return to his native Ohio, and in 1856, he purchased the Nutwood farm. Three years later, at the age of forty-one, he "retired" from his New York City business and, according to his obituary, "brought with him a number of fine horses to put on the farm." Although retired from his hat company, he expanded his horse business and built a barn to house and raise them.

And what a barn it was. Brimming with money—presumably from the sale of his business and perhaps from the horse trade—he commissioned this brick barn to be built in 1858. Finished in the 1861–62 period and designed by Massachusetts architect Charles Theodore Rathbun, the barn cost $23,000, which equates to well over $1 million today. To put that into perspective, some of Jennings's horses were valued in the thousands and their stud fees in the hundreds. And what a barn it still is.

Nearly 100 feet in diameter and approximately 286 feet in circumference, the barn, fortified with 180,000 colorful orange bricks, rises to a peak of 51 feet. At the top of this peak—in a large observatory, reached by a circular winding stairway—Mr. Jennings was able to watch his horses running on the one-mile track he built. Another rarity was the roof—6,700 square feet of tin, which was not only expensive but also unusual in the 1860s, a time when most barn roofs were covered with wooden shakes. Slate came later. The 30,000 feet of oak timbers, 11,800 feet of ash flooring and a cistern that had

a capacity for three hundred barrels of water ensured that the racehorses were well cared for.

Besides training and breeding racehorses and Jersey cattle, Jennings had other business interests, eventually testing new varieties of crops. In the late 1800s, Nutwood was recognized by Ohio's state agricultural college for its "adaptability for every kind of agriculture."

The historical legacy, left behind by William Ward in founding this county and its seat and by Absalom Jennings in this barn, is being continued by current owners Ellen and Fred Krift, who plan to restore this national gem. They've also kept up the 1815 farmhouse, preserving yet another page in Ohio history.

CLARK COUNTY

Rarest of the Rare

Most round or polygonal old barns were built with wood, making this stone octagonal barn and its solid limestone block construction almost one of a kind. In fact, I had to search far and wide before I found another—the Gilmore barn in Missouri, a three-story limestone octagonal bank barn built in 1899. Restored smartly, it serves as an event center for the community. In 1994, it made the National Register of Historic Places.

I couldn't find any other ones in Ohio. Yes, Ohio has round and polygonal barns, but they're wooden or brick, as in the case of Champaign County's Nutwood. So I was excited to find this one and to meet Bob McClure, son of the owner, Marjorie McClure. Fortunately for me, Bob took some time out of his farming schedule to show me not only his barn but also several others close by, including a wooden octagonal. Ohio's wet spring had delayed planting.

Mrs. McClure bought the barn in 2010 in a farm auction from Glenn Murphy, not because of the unique barn but because of the sixty-four tillable acres that came with it, ideal farmland. The stone barn was a bonus, but it was a mess. Bob told me that they filled fourteen large dumpsters with trash from the barn and disposed of three hundred old tires in the cleanup. He also installed new shutters and a front door.

Bob didn't know much about the history of the barn, although a local farmer, Walter Shank, owned it at one time, along with the wooden octagonal

barn a few miles away. McClure's barn was probably built between 1880 and 1910 in a time when many polygonal barns were built, though much later than another Ohio icon, the octagonal brick one-room schoolhouse in Sinking Spring, Highland County, built in 1831.

Although most of the timber in the top level is saw-cut, hand-hewn beams, possibly reclaimed from an earlier barn, frame the front door. On the lower level, the major beams are hand-hewn, and stalls for sheep remain intact. The octagonal cupola was in good shape, and the stonework reminded me of the craftsmanship of the Kindelberger stone barn in Monroe County. Stonemasons can leave a mark that withstands all kinds of weather.

Overall, this barn, maintained well by the McClures, is not only an Ohio gem but also a national treasure, and it deserves a listing in the National Register of Historic Places. After all, it's the rarest of the rare.

GREENE COUNTY

Caesar's Freedom

One must wonder why, in 1749, Hans Ulrich Spahr left Basil, Switzerland, with his wife, Margaret Seyler Spahr, and twelve children to immigrate to America, then mostly a British colony, although the French and Spanish both had their hooks in the new land. But like so many Europeans, they might have felt they'd have a better life here.

They settled in Virginia and raised their children, one of whom, Philip Spahr, got married in 1803 and, after his father died in 1814, moved with his entire family to Greene County, Ohio. Again, why? Perhaps, like many of the early Ohio pioneers, they became disillusioned with slavery, freed their enslaved and moved north. Like most Ohio pioneers, they farmed. Philip Spahr and Mary Shook were the parents of eleven children, one of whom was William Spahr. He was born in 1805 in Hampshire County, Virginia (now West Virginia), married Sarah Smith in 1828 in Greene County and died in 1891. William and Sarah are the ones who built this barn—probably in the early 1800s, judging from the barn's eight-inch hand-hewn beams and the adjacent old brick farmhouse. Tax records show that the farmhouse was built in 1850.

Over the years, the farm passed through several families, ending with Jean Stuck-Monger, who purchased the farm in 1981 and still owns it. Her

daughter Karen married Walter Borda, an attorney, and together they converted part of what had become a grain and cattle farm into a vineyard, first planting vines on the farm's two hundred acres in 2005. In 2011, the winery operation began, and in 2013, Caesar Creek Vineyards had its first public tasting. Unfortunately, Mrs. Borda, Dr. Karen Stuck, could not attend—she had passed away in 2008. Walter runs the vineyard and winery now, although corn and soybeans grow on most of the acreage. Their winemakers have already won awards for this new vineyard and winery.

As stewards of history, Karen and Walter named their enterprise Caesar Creek Vineyards, after an African slave named Caesar who had escaped from his masters in Kentucky. Legend has it that the Shawnees adopted him into their tribe in the late 1700s and that he remained with them the rest of his life, fighting with them in many battles against encroaching white settlers. I can imagine the joy that this man had when, freed from the bondage of slavery, he lived with people who respected him.

The creek that runs to the south of the vineyard bears Caesar's name and has long been a dwelling area of Native American tribes. Walter told me that evidence of the "mound builder" cultures exists on the property and along the creek, and an actual axe-head, found on the property while Walter and Karen were digging a retention pond for vine irrigation, has been estimated by anthropologists at Ohio State University to date to circa 5000 BC. Numerous pre-Columbian relics have been found up and down the Caesar Creek watershed over the years. So it's fitting that Caesar Creek Vineyards still keeps the memory alive of that African slave who became a Shawnee warrior, reminding all that people can get along regardless of race.

4

SOUTHWEST

The southwestern section of Ohio begins with the metropolis of Cincinnati, whose borders with Kentucky and Indiana give the tri-state region a population of more than 2 million. Its suburbs continue to march north and east, gobbling up farmland, although the neighboring counties of Butler, Warren and Clermont still have a fair supply of agricultural land and old barns. Nineteenth-century Quakers settled in Clinton, Highland, Brown and Adams Counties, providing a network for enslaved people crossing the river, through this free state and northward to Canada. Adams and Brown Counties, the top tobacco growers in Ohio, also border the Ohio River and see the beginning of the Appalachian hills, both scenic and sometimes challenging to visit. Plenty of old historic barns are waiting to be discovered in these parts.

BUTLER COUNTY

The Beer Baron's Barn

It's old—as the 1881 date on the roof testifies—and it was built by Gottlieb Muhlhauser, whose name also graces the slate roof. This barn, rescued by West Chester Township, introduces a colorful page of Ohio history: the breweries of Cincinnati's Over-the-Rhine and their farms in Butler County.

The story begins with Conrad Windisch, born in Bavaria in 1825, who learned the trade in his father's brewery in Germany before he immigrated to America in 1849. After arriving, he worked in breweries in Pittsburgh and St. Louis. When he moved to Cincinnati, he became partners with Christian Moerlein, who had established a brewery in 1853. Windisch sold his interest to Moerlein thirteen years later in 1866.

The other half of the story, and its main character, is Gottleib Muhlhauser, also born in Bavaria, who came to America with his family when he was four in 1840. They moved to Cincinnati in 1845. However, he had to leave school when he was thirteen, the oldest in the family, and assumed the lead role, due to the death of his father. He began working in a pottery and later entered the mineral water business, becoming the plant's foreman in 1852. Two years later, armed with knowledge of the business as well as an entrepreneurial spirit, Gottleib started a company in the water business. Apparently, he prospered and was confident enough in 1857 to marry Christina Windisch, the sister of Conrad. One year later, at the ripe old age of twenty-two, he built a mill for crushing malt and another for steam flouring with the help of his brother Henry. He continued in this business, supplying flour to the Union army during the Civil War, and after Windisch sold his interest in his first brewery, Muhlhauser became partners with him, establishing the Windish-Muhlhauser Brewing Company in 1867. Gottleib became president and general manager.

According to a report in the 1890s, the company was incorporated in 1881 with capital stock of $100,000. Henry Muhlhauser, Gottleib's brother, was vice-president, and other relatives held positions as well. Edward Muhlhauser was brewmaster. Near the Miami-Erie Canal, they built an incredible brewery in Over-the-Rhine, a building that occupied several blocks and was topped by two gigantic lion statues, estimated to weigh ten tons each. By the 1870s, the brewery was the third busiest in Cincinnati and twentieth largest in the country.

Beer brewing in Cincinnati began on its riverfront in 1812, when Davis Embree, an Englishman, opened the first one. Historians claim that 250 have opened and closed since then, but the Germans led the way. In 1829, Robert Wimberg became the first German to open a brewery, and many more followed as Germans began migrating here in the 1830s. By 1856, Cincinnati had about three dozen breweries, thanks to the beer-loving Germans.

By 1890, Christian Moerlein and the Windish-Muhlhauser breweries had become giants in the industry, and at least twenty local breweries were producing more than 1 million barrels per year. Cincinnatians drank a

lot of it. Can't blame them—there were 1,841 saloons in town. In 1893, the average annual consumption of beer was forty gallons for every man, woman and child—men presumably drank most of it and children the least of it. Regardless, it was two and a half times the national average.

Years later, Carrie Nation began her anti-drinking campaign and went from town to town, busting up saloons with her axe, intimidating drinkers wherever she traveled. In 1902, she came to Cincinnati, determined to continue her temperance crusade, but when she looked up and down Vine Street and counted 136 saloons, she left town without delivering a single blow from her axe. Later, she admitted that she "would have dropped from exhaustion" in that first block.

The breweries thrived, even though some succumbed during Prohibition, until the 1960s and 1970s, when Anheuser-Busch of St. Louis and the Miller Company of Milwaukee launched massive national promotions and grew to become the two major players, forcing the little guys out. However, nowadays, craft breweries, along with wineries, are springing up nearly in every city. And though on a limited stage, Cincinnati's breweries are being reborn.

So, where does the barn fit into this? Although the beer barons of the 1800s located their breweries in Over-the-Rhine, they grew their barley and hops on their farms in Butler County, which offered good land for crops. Before railroads, the farmers transported their yields in horse-drawn wagons, a journey of about thirty miles. But when the rails arrived, transporting grain became much easier.

Accordingly, Gottleib built this barn on Seward Road in 1881, next to where the train stopped—at the intersection of Seward and Muhlhauser Roads—enabling him to load the rail cars directly. The barn housed the crops and livestock and was built well enough to survive nearly 150 years. In 1998, the Ohio Casualty company purchased the land where the barn was located and offered to donate the barn, an offer that West Chester accepted around 2002. But moving and restoring an old barn, as well as giving it a new purpose, was not an easy task.

West Chester Township responded to the challenge. Through the generosity of the Muhlhauser family and others, the township hired David Gaker, an expert at barn renewal, who dismantled the barn. Unfortunately, he became ill soon after this and was not able to reconstruct it at a new site, Beckett Park. Instead, Gaker's son took over, using nearly all of the original hand-hewn beams. He reestablished the slate roof, keeping both the Muhlhauser name and the date of 1881. Today, West Chester rents out the barn, as well as a copper-roofed gazebo from the original Moerlein

homestead, for weddings, reunions and parties. In the ten-year span from its opening in 2008, it has hosted more than one thousand events. The barn has space for up to 220 people and has a kitchen area and restrooms. The old boy has new life, and I'm sure it's looking forward to hosting the all-Ohio exhibit—essays and paintings of barns in each of Ohio's eighty-eight counties—in May 2021.

The crew of the television series *Barn Builders*—who lovingly take down and repurpose old log barns and log homes—would be proud of the Gakers, the Muhlhauser family and West Chester for their efforts in preserving early Americana. So would Gottleib.

HAMILTON COUNTY

The Preacher's Barn

One morning in the summer of 2015, while running in Sharon Woods Park, I noticed this old barn as the sun shone on it, lighting up its honey-brown siding. I contacted William Dichtl, the director of this Williamsburg-like village, a collection of about a dozen vintage buildings from southwestern Ohio, to see if I could paint the barn. He agreed and provided articles on how the Heritage Village Museum acquired it.

Philip Gatch was born in Baltimore County, Maryland, in 1751, a few years before the beginning of the French and Indian War, which lasted until 1763. The strain of England's worldwide empire was draining its pocketbook, leading to more taxation on its colonists, including those in America; this taxation without representation helped fuel the revolution, which began in April 1775. Philip was twenty-four then, a convert to Methodism, and had become one of the first American-born Methodist circuit riders, itinerant preachers. Colonists, tiring of England's taxation and its cherished concept of nobility, wanted a religion that was down to earth. And so Philip rode from town to town, preaching his Methodist faith, first in New Jersey and then in Maryland and, during the war, in Virginia.

Once, while preaching in a town, another Methodist minister converted a woman but did not get her husband's consent. Men ruled in those days. Outraged, the husband told his cronies that he would retaliate against the next Methodist preacher he saw. And guess who came to town next? Philip Gatch was in the wrong place at the wrong time: he was tarred and feathered

for something he didn't do. Despite the damage to an eye from the tarring, he recovered, married and settled in Virginia, adding farming to his preaching. It was hard to raise a family on a preacher's income in those days.

As did many Virginians, Gatch used enslaved people to help farm his land. But he grew tired of and perhaps felt guilty about using slave labor. He freed his eight slaves in 1780, three years before the war ended. Growing even wearier of slavery and not wanting to raise his family in such an environment, Gatch, with three other families, moved to Ohio in 1798 and settled on farmland on the banks of the Little Miami River in Clermont County. After purchasing land from Jon Nancarrow, who earned the land through a Revolutionary War grant, Gatch built a log cabin in January 1799, showing that his family could handle Ohio's harsh winters—they were hardy pioneers. Shortly before this, in 1794 up in northern Ohio, General "Mad" Anthony Wayne defeated a coalition of Ohio Indian tribes in the Battle of Fallen Timbers, marking the end to Indian wars in Ohio. This was raw territory.

Reverend Gatch, probably together with his sons, built this barn in the early 1800s and lived here until he died in 1834. In 1800, the territorial

Swing beam, circa 1800.

legislature appointed him as a justice of the peace. But running the farm was his livelihood. It meant survival. In addition to farming, he spent twenty years as an associate judge in common pleas court, became a delegate from Clermont County to the new state's legislature and helped write Ohio's first constitution. He probably voiced his opinion on slavery too, which may have led to Ohio's becoming a free state. His youngest son, George, followed in his father's footsteps, becoming a "circuit rider" preacher.

In 1972, the Miami Purchase Association, a nonprofit formed in 1964, bought the first building in Heritage Village. The group acquired this barn in 1974, moving it from its home in Clermont County to Sharon Woods Park. Eleven other buildings followed, providing a glimpse into Ohioans' life in the 1800s. Historic Southwest Ohio, another nonprofit, runs the museum, giving tours and holding events here throughout the year.

The barn has been maintained exceptionally well; its original wood siding and stone foundation work are still intact, although new wood shingles were replaced on the roof in 2004. Inside, there's a massive hand-hewn wooden swing beam stretching across the interior, mortise and tenon joints, tobacco hanging from the rafters, an old wooden wagon and many pieces of antique farm equipment. Standing inside the barn, I tried to imagine Philip Gatch and his sons working in here. They're gone now, but their memories are preserved in this barn, in this essay and in this painting, for future generations to enjoy.

CLERMONT COUNTY

Billy's Barn

In the early stages of my Ohio Barn Project, a friend of mine told me about this barn and introduced me to its owners, Billy and Nancy Kahn, who graciously supplied original barn wood for the painting's frame. They told me that the farmhouse was built in 1814 and that it still retains its original wood shingles. The barn probably came soon after that—or even before it, since often in early pioneer days the barn was built before the farmhouse. Its large oak hand-hewn beams, connected with mortise and tenon joints, and the original floor planking suggest that it was built well before the Civil War.

The early settlers, who built this house and barn, chose the site based on water. A creek flows at the base of the hill where the barn sits, and two old wells, capped with identical gray rectangular metal boxes, are still

present—one near the barn and one near the house. These were hand-operated pumps, which worked through a cranked sprocket that pulled a loop chain up with cups of water that would fall into the spout. Some were made by a company in Blue Ash, Ohio, which labeled its pumps "G.E.M.," although these don't bear such stamping. The hand crank is visible on the right side of the pump. Water supply was vital to the early farmers, and it had to be close to where they settled. The wells were functional until 1981, when city water was piped to the house.

Only four families have lived here in more than two hundred years, testifying to its bucolic setting, heavily wooded and peacefully removed from the buzz of city and suburban life. "Walking on these floors makes me think of the early farmers who walked on these same floors two hundred years ago," Nancy told me. Yes, the home and barn, its striking green metal roof and crisscrossed doors, reflect Ohio history, which will continue to survive since the Jewish Cemeteries of Greater Cincinnati has purchased the property, converting it for future cemetery use. Billy, the director of Weil funeral home, has rights to live here and oversee the cemetery development. It's yet another way to preserve a piece of early Ohio and pay tribute to an old barn, the "money maker" of this nineteenth-century farm.

Warren County

Barn at Crossed Keys Tavern

This old barn, its siding colored with splashes of honey-brown against dark-gray charcoal, sits close to State Route 350. Next to the barn is an old tavern where a guide was about to take a group of people on a tour on the day I visited. When asked about the barn, all he knew was that the YMCA at nearby Camp Kern owned it. So I drove down a winding road, curious since I had never visited this camp where my children had spent time many summers ago. I met the director, who gave me permission to paint it and to take whatever scraps of wood for the frame, which I did. But no one knew much about it. The nearby tavern was a different story.

The tiny stone house, added to the National Register of Historic Places in 1976, traces back two centuries to Captain Benjamin Rue, who served in the Continental army and who later operated the tavern. Rue and another officer raised a company of artillery in January 1777 and fought in the

Battles of Trenton and Princeton. Things moved rapidly in those days, with greenhorn farmers against experienced British troops.

Rue was given the rank of captain in 1775, according to his obituary, published in 1823 in the *Western Star & Lebanon Gazette*, and commanded a gunboat on the Delaware River. He also served under General Benedict Arnold when he was placed in command of a "gondola" in the Battle of Lake Champlain. This ship was, in effect, a boat that the Americans could build quickly and cheaply, as described in *The Gondola Philadelphia and the Battle of Lake Champlain*, a book by John R. Bratten. These flat-bottom boats could carry lots of soldiers and cannons, and they could land easily, without damage, on the shallow shores of Lake Champlain. Captain Rue controlled one of these, which now is displayed in the Smithsonian.

After he finished military service, he moved to Oregonia in Warren County, Ohio, where he may have lived in this house, built in 1802, which became a tavern in 1809. However, he fell on hard times, and at the age of sixty-seven in 1818, he appeared in common pleas court in Warren County to claim or clarify misunderstandings about his government pension. According to the old court document, "[H]e also states that he is now in reduced circumstances and stands in need of the assistance of his country for support."

After the Crossed Keys Tavern closed in 1820, Captain Rue had to seek work elsewhere, which he found at the Golden Lamb, a Lebanon hotel and restaurant dating to 1803. Captain Rue also worked at and possibly ran the Indian Chief Tavern in Lebanon, founded in 1805, but apparently he was not financially successful. He may have been a good soldier, but he likely wasn't a savvy businessman nor a good farmer, which was how most survived in those days. He died in 1823.

So, now for the barn, whose history is sketchy. Judging from its weathered wood and construction, it was probably built in the early 1800s. Did Captain Rue build it? Maybe he or one of his relatives did. According to a legend related by a longtime local historian, Captain Rue's brother or brother-in-law, a certain Norman, had a reputation for being lazy. When told to paint the barn, Norman instead wrote his name on the wall. An old picture from the late 1800s, faded and grainy, shows the barn and its foundation stones, next to an old carriage road, as well as a gravel road where Route 350 is now.

In 1917, the Dayton YMCA purchased the tavern, the barn and 468 wooded acres. It restored the tavern, maintained the barn and turned the land into a camp for young summer visitors. The Warren County DAR got the tavern into the National Register. And who knows, maybe that group will someday unearth more information about this beautiful barn.

CLINTON COUNTY

The Museum

It's not often I visit a barn and a farmhouse that are both in the National Register of Historic Places. These two old buildings are, and rightfully so, since the history of the farm, the families and the house could easily fill a book.

I met Christine Hadley Snyder and her husband, Gene, a retired veterinarian, in March 2019. Christine told me that she and her three sisters were born in this reddish-orange brick Federal-style farmhouse, built circa 1830 by her great-great-great-grandfather Eli Harvey. I'm sure it's witnessed other births over its lifetime.

The story begins much earlier and far away in England when King Charles II owed William Penn, who had become a Quaker, a debt of about $80,000, a huge amount in 1681. Penn, a savvy and wealthy man and also a politician, asked for wilderness in America in exchange for the debt. The king granted him a tract of land stretching from the Delaware River between New York and Maryland. It became known as Pennsylvania, a word meaning "Penn's Woods." In 1682, Penn organized this new colony in America as a "holy experiment" where there would be religious freedom for all, trial by jury and many of the rights later incorporated into the U.S. Constitution. Quakers by the thousands plus many others seeking religious freedom moved from England to the Pennsylvania colony in the late 1600s and early 1700s, including the Harveys and the Hadleys.

In 1787, when the Northwest Territory—the land of present-day Ohio through Wisconsin—became safer and slave-free, many Quakers moved here from southern states, hoping for a new start—one without slavery. In 1806, the Quaker families of Harvey, Hadley and Hale bought land in Clinton County and began farming. Christine's great-great-great-grandfather Eli Harvey, the patriarch of this pioneer family, had a son, also named Eli, who continued to work the family farm. One of his daughters married a Hadley.

With the exception of a few decades, the land remained in the Hadley and Harvey families. Finally, in 1946, Herbert Hadley purchased the farm outright, which eventually passed down to Christine and her three sisters in 1997. In 2010, Christine and her husband became the sole owners of this property, which entered the National Register in 1978.

Christine and Gene allowed me to tour the barn and select barn siding for the picture frame. The hand-hewn timbers and wooden nails suggest that it

was built around the same time as the farmhouse nearly two hundred years ago, both remarkably well constructed.

Today, they lease seventy-eight acres to a soybean farmer, although over the centuries, the families raised many crops and livestock. Unfortunately, old barns can't compete with modern ones for housing massive machinery used in today's farming, which is why this one stands as a memory of times past. As does the farmhouse, also in the National Register, which was next on my tour.

Christine took me through it, room by room, and showed me their Quaker traditions—family portraits and photos dating to the early 1800s, Quaker silk dresses and bonnets, a spinning wheel and reel, women's hats and dresses of those days, the original 1811 property deed, meticulous store ledgers, school books from the nearby one-room schoolhouse and Indian artifacts found on the farm.

From an artistic view, one of the Harveys, another Eli, born in 1860, had a natural talent for drawing, and even though some Quakers viewed this as frivolous, he studied in New York and Paris and became a well-known sculptor. Today, his bronzes stand at Brown University and in many museums and private collections. Interestingly, after Eli Harvey and his wife moved to Alhambra, California, in 1929, they became acquainted with the celebrated illustrator Norman Rockwell, who asked Eli to pose for two of his paintings.

At the end of my visit, realizing that preserving the farm with these two historic buildings filled with family artifacts was a supreme labor of love, I wondered about the next generation. Christine told me that they had three sons: one a history professor at Yale University, another a physicist in San Diego and a third a professor of English at the University of Oklahoma. "And none of them plan to come back to Ohio," Christine said wistfully. I could feel her discomfort, and I wondered what would happen. Such a legacy deserves to be remembered, even if there are no direct heirs. After all, it tells the story of Quakers in Ohio. And that merits the title of "The Museum," if only in this painting and essay.

HIGHLAND COUNTY

Hunting Mushrooms

On Mother's Day 2015, I met my first barn scout, Sandy Shoemaker, thanks to the Highland County Historical Society. One month earlier,

when I was scouting barns on my own and faced a rifle up close and personal, I decided to contact this historical group, hoping for a local tour guide. It seemed a lot safer.

A former USDA employee, Sandy issued permits for waterway construction on farmland. So, after three decades of this, she came to know most of the farms, farmers and barns in this rural county, about an hour east of Cincinnati. Were it not for the support of Sandy and her husband, Tim, I might not have kept going with this barn project.

My wife, Laura, and I arrived early in the morning and spent most of the day touring the northern half of the county, talking with barn owners. I took photos and made sketches. Sandy gave us the history and told me she could show me many more. But as it was Mother's Day, Sandy and my wife deserved some personal time.

Their barn was a beauty, a formidable gray structure framed by huge spreading trees in front of a built-up bank leading over a wooden ramp to the cantilevered entrance, a rarity in bank barns. Sandy and Tim co-own it with Howard Grabill, whose family name graces the road alongside it. Originally unnamed and called "West Road" by locals, it officially became Grabill Road in the 1970s when the state introduced 911 and mandated names for all public roads.

As we sat on the porch of the 1912 farmhouse, Sandy told me that Howard Grabill was born here. She was right…sort of. In 1945, when Howard's mom felt strong labor pains, Howard's dad was nowhere to be found since he was hunting mushrooms deep in the woods. In those years, there were no cellphones. Horrors! So, grandpa took Howard's mom in his truck and sped to the hospital, but they never made it. Howard was born in the truck. In farm life, everyone pitches in.

The farm is named Millstone Creek Farm, in reference to the many mills that lined nearby Clear Creek. Several large millstones greet visitors on the driveway, as does a big brass bell that Howard got from a West Virginia steam engine. If you ring it, Howard, a railroad aficionado, will answer with a *toot-toot-toot* from his horn.

A farmer built the barn in the 1880s, a time when Ohio pioneers knew the properties of wood and how to make a barn last, and this one has. In those days, Ohio was primarily a farming state. But farther west, Indians still roamed the plains. And one of the Grabill family was there to document those days. John C.H. Grabill was a photographer of the Great Plains, and in 1886, he opened a studio in Sturgis, Dakota Territory. He took photos of the Wild West: mining, stagecoaches, the Devil's Tower (now a

national monument) and cowboys, including the famous Buffalo Bill. But his most memorable work, now in the Library of Congress, showed the aftermath of the massacre at Wounded Knee in January 1891, a tragedy that happened in the unforgiving Dakota winter. All this while his Ohio relatives were building barns and farming.

Howard's grandfather, the one who provided his truck for Howard's delivery, had farmed for decades in Highland County before he purchased this farm in 1944. Much earlier, when Howard's grandmother was a child, an old freed slave named Manny took care of her. They called her husband, also a freed slave, "Uncle" Oliver. In return, the Grabills took care of them when they grew old. Highland County was one of numerous Ohio counties where assistance was provided to enslaved people as they escaped via the Underground Railroad.

Barns have to be resilient to survive. In 1960, a tractor loaded with hay fell through the floor, but it was repaired. A few years later, Howard explained, his parents spent $5,000, a considerable sum then, to level the barn with railroad ties and steel beams since it was seventeen inches "out of plumb," as Howard put it. "Many barns fail because of lack of support," he added. During his later years, Howard's grandpa still owned the farm but allowed Howard's family to live upstairs in the farmhouse. That changed when little Howard began making too much noise. So grandpa, tired of Howard's bouncing on the ceiling, moved upstairs. Howard's grandfather died in 1953.

Co-owners Sandy and Tim grew up on Highland County farms as well. Sandy's parents raised dairy cows, so Sandy spent a lot of time milking. "We had one hundred cows, and I had to milk them. But my dad sold them the year I left for college. He could have done that a lot sooner," Sandy told me. Tim also grew up on a farm, one in the southern part of the county where his parents and grandparents had been farmers. But Tim decided to spend his career working in a hospital—until 1995, when they bought into this farm. Even though they are retired from their jobs, they work the farm, raising cattle and crops.

Who knows what the future holds for this Highland County barn? Maybe another father will be out hunting mushrooms at delivery time. Maybe.

BROWN COUNTY

Dr. Tyler's Horses

I met Brian Kelley quite accidentally in September 2015 when I was touring Brown County with barn scout Kristel. While driving down a country road, I noticed a fellow using a flame thrower on the edge of the pavement. "Stop here, Kristel," I said. "I'll bet this guy knows where some old barns are." Brian was clearing weeds on the side of a road and was nice enough to chat with us. After he learned about my project, Brian smiled: "I own a lot of barns and I know their stories." He wasn't kidding.

The following spring, I visited Brian and his barns and was intrigued not only by the barns but also by how he acquired them, which is one of Ohio's greatest barn stories. There are lots of old barns here, including one dating before the Civil War and others that were built from 1880 to 1930. Although Brian didn't have information on the early pioneers who started farming here, he did know about the previous owners: Dr. Tyler and his father, both country physicians, who made house calls. The elder Tyler made them in the 1920s in a horse-drawn buggy. In the 1940s, the farm passed to his son, also Dr. Tyler, who not only continued his dad's tradition of house calls but also got into banking. He eventually owned Ripley Savings and Loan, which probably helped him acquire nine other farms, which he amalgamated into one large one, stretching to nearly one thousand acres and full of old barns.

Dr. Tyler died in 1962, but his widow, June Tyler, ran the farm until, at ninety-six, she sold it to the three Kelley brothers in 1967, Kevin, Jack and Rohan Kelley—all bachelors. There were eighteen barns on the farm in 2009. Today, nine remain.

The family history traces back to Brian's great-grandfather, who emigrated from Ireland. He settled in New York State and founded the Churngold Butter Factory, eventually getting a patent for margarine, which the Fleischmans bought for a considerable sum. With that sale, the Kelleys became wealthy and eventually moved to Ohio.

In 1967, when the brothers purchased this farm, Brian, who grew up in an eastern suburb of Cincinnati, was four. "As a kid," Brian explained, "I loved to come to the farm whenever I could, spending time with my uncles." This must have impressed his uncles, who continued to run the farm, raising animals and crops, including tobacco.

But age caught up to them—Rohan died in 1987, Kevin in 2001 and Jack, the oldest, in 2009. They never married and had no children. When

Entrance, Kelley Brothers Farm, circa 1850.

Brian got a phone call from a Brown County attorney, he drove to his office for the reading of his uncle's will. To his shock, Brian inherited the farm. Happy days.

The uncles must have known that their nephew's love for farming would keep their legacy in the family. Brian's young son Rohan, named after an uncle, seems to have his dad's passion for the farm as he rides around the fields in his mini-ATV. Maybe he'll be the next generation of Kelleys to own it.

The farm, where I painted five of the barns, sits relatively close to where Fox Hollow Run empties into Eagle Creek, the site of a Shawnee camp hundreds of years ago. Over the years, Brian said, stone tools, axes and arrowheads would surface in this area, attracting collectors, who would trespass to look for artifacts. Signs clearly labeling this property private don't seem to work—the collectors often feign ignorance when Brian approaches them. They keep returning to rummage through the creek and sometimes over freshly plowed fields. You see, there's a lot to this Eagle Creek—not only littered with stone tools and weapons of the Shawnees and other tribes but also rife with fury and power.

The creeks (Eagle Creek, Straight Creek, Red Oak and White Oak Creek) and the roads (Fox Hollow, Chicken Hollow, Indian Lick, Ebenezer, Stony Lonesome and Myers Hollow) of Brown County paint a colorful picture of rural Americana. To drive along these roads is like driving through a national park: a delightful ramble along creek beds lined with old layered stone walls, forests framed in tall hardwoods and evergreens—a photographer's heaven. For those painters who like to paint plein air, the area is a never-ending array of inspiring scenes.

But there's another side to these creeks, especially during heavy rains, when water cascades southward from points north, stretching into Highland County. In March 1997, swollen creeks in this part of Ohio and neighboring Kentucky overflowed their banks, wreaking havoc and taking twelve lives. Creek flooding made the Ohio rise to more than sixty feet, the first time since 1967.

In the spring of 2017, Brian showed me the doctors' horse barn, a rectangular structure with twenty-five stalls for the many horses they collected. That day, several large cows owned the turf, but no horses showed up—the stalls were empty. Next to the barn sits the foundation of a blacksmith's shop and forge, sheds with fireplaces, a spring house and a ring for training the horses. Dr. Tyler spared no expense in building this complex, which must have given him much enjoyment and, with horse sales, perhaps more income as well. I liked the wavy roof, with its violet-pinkish color, so much that I chose this composition to represent Brown County.

When I look at the painting, I try to imagine these country doctors, traveling in all kinds of weather in horse-drawn buggies, making house calls, delivering babies in farmhouses and tending to the sick. Even though the barn's days are numbered, the memories of Dr. Tyler and his son, as well as the three Kelley brothers and their nephew Brian, will live on, recalling early Ohio days in Brown County.

ADAMS COUNTY

Eight Generations

Ironically, the oldest farm in Ohio is one of the most difficult to find. I followed my car's GPS, which led me down rural Adams County roads, past a drive signposted to an old farm open to the public for "Pioneer Days."

But that wasn't the one I wanted. So I kept going until I heard the message from my GPS lady that I had arrived at my destination. An unmarked road, leading up a steep hill, was my only option, so I turned up the hill and parked in front of a farmhouse, where I met John Smiley and his son James, the eighth generation of Smileys. One of James's two sons, who represents generation number nine, tagged along. The map shows "Smiley Road," but in reality, it is unmarked.

John, the seventh Smiley generation, had just returned from a tractor pull, a competition to see who has the strongest of these workhorse farm machines, where he won third place, good for ninety bucks, more than covering his twenty-dollar entry. "It beats farming," he joked. John and his son James continue the Smiley tradition of farming on six hundred acres, raising Charolais cattle as well as corn, soybeans, wheat and hay.

John explained that his ancestor Alexander Smiley, an Englishman who worked in the court of the king, was granted five hundred acres of this land by King George III in 1772, four years before the Declaration of Independence. Why here? Why then? This was forested, wild, uncharted land, the foreboding Northwest Territory, most definitely Indian country—land of the Shawnees, Miamis, Mingos and Delawares. It was a time of frontiersmen.

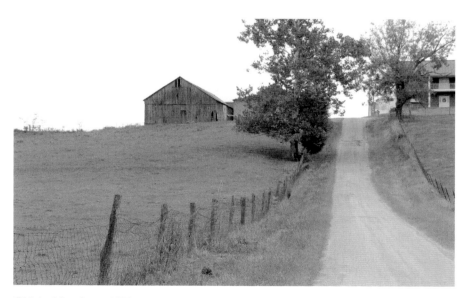

Ohio's oldest farm, 1772.

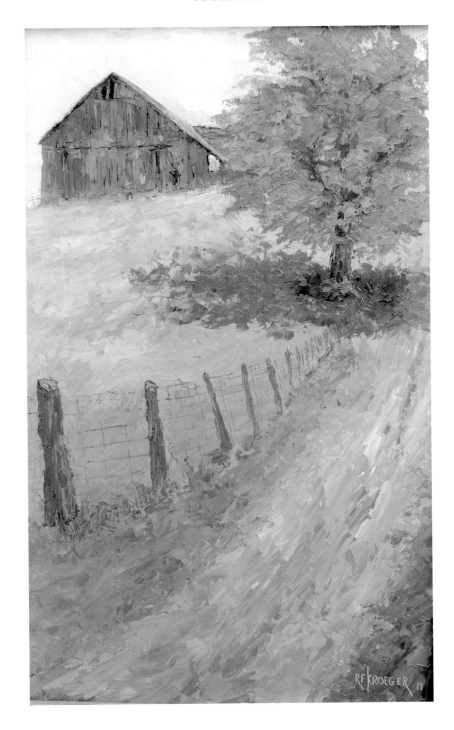

One of them, Simon Kenton, a peer of Daniel Boone's, who turned seventeen in 1772, had fled his Virginia home one year earlier after he thought he had killed a boy flirting with his girlfriend. Kenton, unaware that the lad survived and fearing reprisal, didn't return home, instead choosing the life of a scout and Indian fighter in what is now Ohio, Kentucky and West Virginia. He was a natural in the woods, and in 1774, two years after Smiley established his farm, Kenton served as a scout for settlers—British colonists—in Lord Dunsmore's War as they battled the Shawnee and Mingo tribes. Even though the war ended in 1774, fighting between the settlers and Indians continued for more than twenty years in Ohio. Kenton was captured twice by the Shawnees, who respected him as a great warrior but forced him to run the gauntlet. He survived—twice. All this while Alexander Smiley was farming in the hills of Adams County. It was a time of great adventures.

The original farmhouse Alexander Smiley built burned down. Another was built in 1813 and lasted almost two hundred years before it, too, burned. John was born in this house in 1952, as was his father in 1915.

When I visited in 2016, John and his son James were still using this old barn, although one of their relatives, Gloria Smiley, contacted me in 2019, explaining that the barn had been dismantled. I'm glad I could capture it and help preserve the Smiley heritage and Ohio's first farmstead.

5

NORTH CENTRAL

Four of these counties bear names of the Native American tribes who lived here in the 1700s and left for reservations in western states in the early 1800s. Bellevue, a town whose city limits touch four counties, including three in this section—Erie, Seneca and Huron—is a rail hub of the Norfolk Southern company, which handles eighty trains and two thousand rail cars daily. Railroad aficionados from all over the country flock here, drawn in part by the busy train schedule and by the spacious railroad museum, one of the best in its niche, displaying dozens of engines, cars and pieces of memorabilia of nineteenth-century trains. The other counties are predominately agricultural, with plenty of old barns just waiting to be captured on canvas.

SENECA COUNTY

The Underground

Barn scouts Judy and Mel introduced me to Roger Kinney, the owner of this old barn, which, judging from its construction, was built in the early 1900s. Eighty-eight-year-old Roger, engaging and lively, told us that his parents bought the farm around 1910, probably from his grandparents. Originally, the settlers lived in a log cabin close to the barn, and they stored food in a cave underground, which served as a refrigerator, au naturel.

Roger told us that the barn was originally built near Fremont to store wood for the steam locomotives that passed by on tracks that ran by the barn and connected Lodi, Tiffin and Fostoria. When coal replaced wood to fuel the engines, the railroad barn was sold to Roger's father, who moved it to its present site on the family farm. Today, the railroad tracks are gone, but the barn still contributes historically by storing antiques for nearby Lyme Village, which has preserved several old buildings, giving a glimpse into life in the 1800s.

What is more interesting is not what's on top but rather what's underneath the barn, as well as beneath most of the land around Bellevue. In June 1872, two boys, Peter Rutan and Henry Komer of Flat Rock, an area just south of Bellevue, were hunting rabbits with their dog, which chased a rabbit into a brush pile. Both the dog and rabbit disappeared. When the boys dug around the brush, they discovered an opening, a natural sinkhole, which they promptly fell through, landing in the first level of a large cavern. They found their dog, crawled back up through the opening, returned home and told everyone about their experience.

Through this discovery, the farm owner Emmanuel Good later found an underground stream that he named "Ole' Mist'ry River," one that would rise and fall, depending on the amount of rain. Later, in 1888, a gentleman described Bellevue's underground river and posed the question about what would happen if the river should be dammed up: "[S]hould the subterranean stream become dammed, and then the people of that part of Ohio may wake up some morning to find their farms afloat." In fact, when I toured the farms of these northern Ohio counties, the flat ground was so wet in April that crop planting was delayed for a month, especially in Putnam County.

One of the more interesting reports about these underground streams was published in the November 1934 issue of *Popular Science*. The article examined the presence of underground rivers, such as the complex underneath the Bellevue region, and was titled "Mysterious Lost Rivers Run Mills and Power Plants." It described the work of George Adkins of Bellevue, whose job was to drill "garbage wells," a task he had been doing for twenty years.

You see, in the early 1900s, Bellevue's rainwater and sewage drained into the mysterious rivers below it. To establish a well on a residence or a business, Mr. Adkins would first dig a reservoir several feet deep and three feet wide. Next he would sink an eight-inch pipe until it penetrated the underground cavern, which might require only fifteen feet of drilling…or up to three hundred feet. Usually a single well would service two homes. But where would the water go? Investigators tried to find the answer by

pouring liquid with a special dye and watching outlets for days. But no dye was found. Floating corks didn't work either. Scientists are still puzzled by this question. Does the underground river flow into Lake Erie, as do many of the nearby rivers? Does it go farther toward the earth's core? Does the water flow east or west or south? Today, Bellevue has a separate sewage system, but rainwater from the streets flows into culverts, which still empty into the underground rivers.

Regardless, I'm sure the early settlers on these farms didn't lose any sleep, wondering about the underground caverns. The caves kept their food cold, and that was the only answer they needed. Life was simpler in those days—both on top of and under the ground.

HURON COUNTY

Kinda Homely

On our tour of Huron County, barn scouts Mel and Judy introduced me to Debbie Schwiefert, whose brother Craig owns this old barn. The slate roof, though more expensive than traditional wooden shakes, has proven a good investment, having protected the barn for more than a century.

According to Debbie, who was interviewed by barn scout Judy Miller, the Seibel family built it in 1912 using lumber from the adjacent woods and moving dirt to form a bank to the upper level. At the time, it was the largest barn in Huron County, and even today, it commands attention with its dimensions of eighty by one hundred feet.

Craig's grandparents Fred and Marie Koch purchased the farm in 1941, but this story begins before that. Marie, also known as "Granny" Koch, liked to dance and would jump at the chance to go to one, especially when the dance was in a barn. In fact, this one held square dances from the 1920s well into the 1940s. And even though Marie dated Fred's brother initially, she couldn't resist Fred's invitation to barn dances and often would say that "Fred was kinda homely but he took me to all the barn dances, and I loved to dance." See, there's more than one way to win a girl's heart.

After they married, Fred and Marie owned the Red and White, a grocery store in Sandusky, for several years, but they didn't like being in that business and began saving their money to buy a farm. One day, by chance, Marie visited the Seibel family and learned that they were about to lose their farm

to the auction block for failing to pay taxes, which sadly was not unusual coming out of the 1930s and the Great Depression. So, without consulting Fred and recognizing a good deal, Marie wrote a check and bought the farm. Fred found out later. As Debbie admitted, "Everyone knew who wore the pants in the family." And she wore those pants for a long time, passing away at age 106.

Whereas the Seibels used horses to plow the farm fields—the old-fashioned way of the 1800s—Fred used a tractor, which was much more efficient. His first one was a 1942 Allis Chalmers, and his next one, a 1948 model, is still in the barn. His farm prospered, although he stopped farming in the 1960s.

But times changed: the square dances in the barn gave way to Halloween parties that drew hundreds of visitors over the years. After all, haunted barns can be scary! And even though the barn stores only an old tractor these days, it remains important to the family, many of whom live close by. They hope that someone will dismantle it and rebuild it somewhere. That, of course, is a costly project, but if it should happen, I'm sure it would bring a smile to Granny Koch's lips, if she were still around.

ERIE COUNTY

Prisoners of War

In the spring of 2018—a year before my barn tour of Erie County—my barn scout Mel sent me a photo of this unusual barn and told me its story, which was the first time I'd learned that the United States took in POWs during World War II. But let's begin at the beginning.

The barn, now dismantled, had a slate roof with the date of 1901, probably signifying when the barn was built. The farm may have been started earlier than that, as many were in Ohio's northwest. And the original family may have been the Ohlemachers.

Eventually, the Picketts took over the farm and planted many orchards of cherry trees—all kinds of them, sour, sweet and in-between varieties. By the 1930s, the trees were ready for harvest, which began a family tradition and provided work for many, not just locals but also migrant workers. According to eighty-seven-year-old Bill Oddo, a local historian and founding member of the Bellevue Historical Society, each morning a

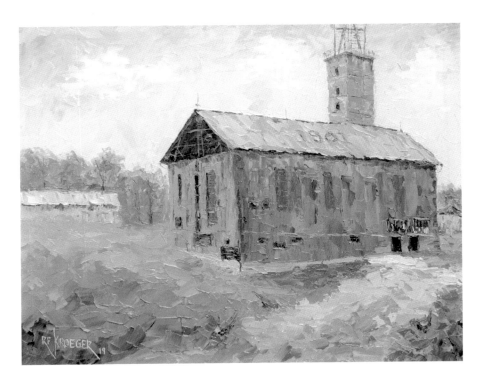

flatbed truck would pick up workers throughout the region and transport them to the orchards during picking season, which lasted five to six weeks each summer. The migrant workers from out of town would be allowed to live in grain bins inside the barn. Mrs. Pickett would cook for them with her daughter Eileen, and eventually her granddaughters, Jean and Sue, helped with cooking and serving.

Bill, a teenager then, worked summers on this farm from about 1943 to 1947, picking cherries with his five brothers, closely supervised by their mother, who told them that their father didn't make enough money in a factory job and that the extra cash would come in handy. Apparently, according to Bill, this amused his dad and may or may not have been true, but it taught the children the value of hard work. Each child was supposed to pick twenty buckets—with a team goal of one hundred buckets per day. One day, Bill said, they did out-earn dad's daily wages. But Bill, and many of the other teenage boys, preferred working inside the barn, where the cute girls worked—two or three dozen of them, preparing and pitting the cherries and then measuring them out into boxes.

The children also learned another valuable lesson. During the war years, American troops overseas simply could not handle the vast numbers of German and Italian POWs, so they transported them to our soil. According to some sources, more than 435,000 POWs—in forty-six states and Alaska— were held here during those years, an exodus that began in August 1942, when Britain could not handle its 273,000 prisoners. Churchill convinced our leaders to take 150,000 of them to start, and in the middle of 1943, when he visited Washington for a war conference, he shared the *Queen Mary* ocean liner with several thousand POWs.

During cherry harvest season, guards would load buses with prisoners from nearby Camp Perry in Port Clinton and bring them to the farm. Remember, in the early stages of the war the Germans, Italians and Japanese were winning. Our Pacific fleet was ravaged. The Japanese occupied two of our Aleutian Islands—where my own father had been stationed—and the Germans were turning Britain into a bombed-out graveyard. U-boats patrolled our eastern coast and torpedoed ships. So, many Americans weren't pleased to provide food and shelter for these troops, although they treated them according to the requirements of the Geneva Convention. Unfortunately, the Germans didn't treat our POWs equally well in their camps.

According to locals who interacted with these POWs, including Bill and his family, each POW had a daily quota of twenty buckets of cherries. When the stoical Germans reached their quota, they'd return to the bus and wait

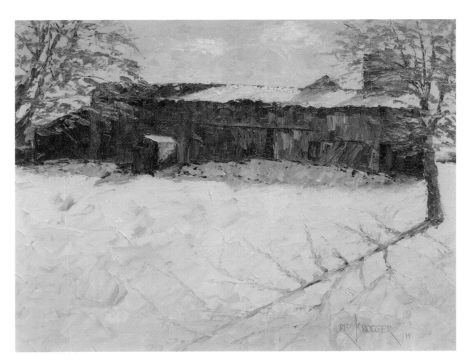

Williams County. *The Gunner's Pool*.

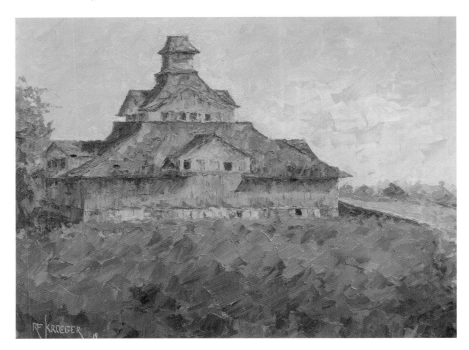

Henry County. *George's Giant*.

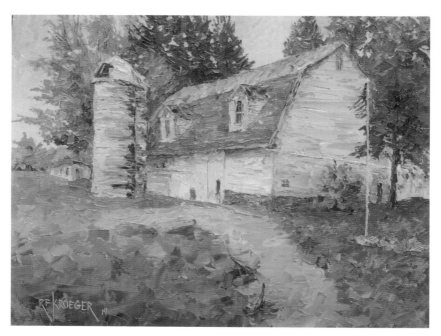

Lucas County. *All-American*.

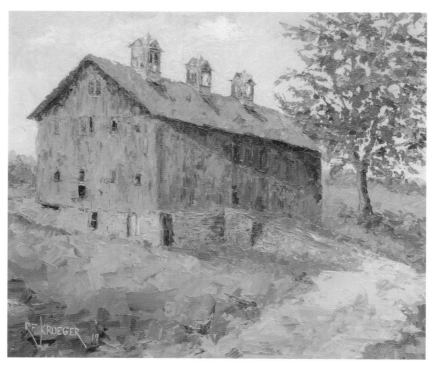

Wood County. *Spectacular*.

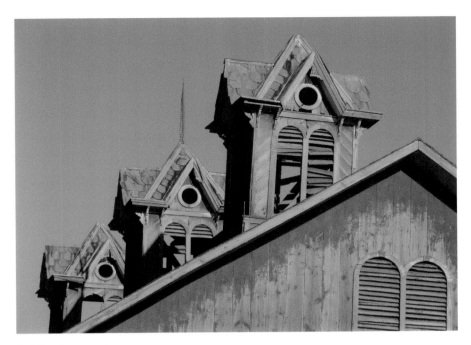

Striking slate cupolas.

Putnam County. *The Docent*.

Auglaize County. *Magnificent Manchester*.

Hancock County. *Dreams Come True*.

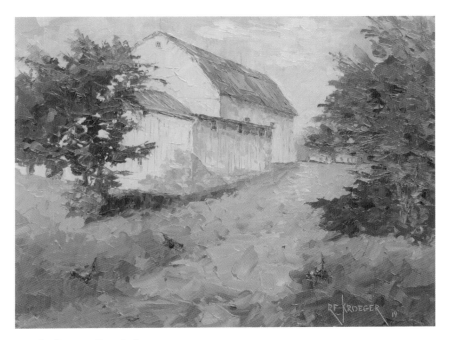

Hardin County. *Kenton's Country*.

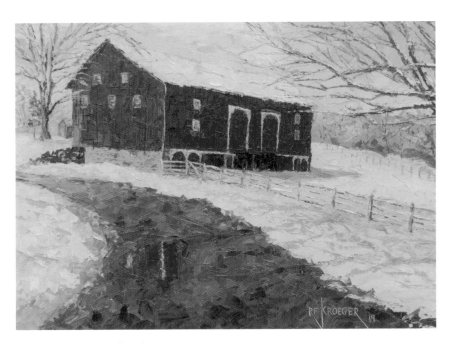

Darke County. *Snow-Bound*.

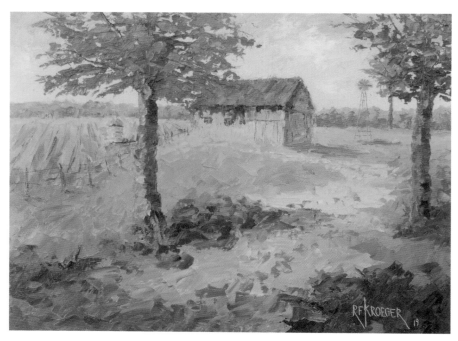

Preble County. *Rinehart Homestead*.

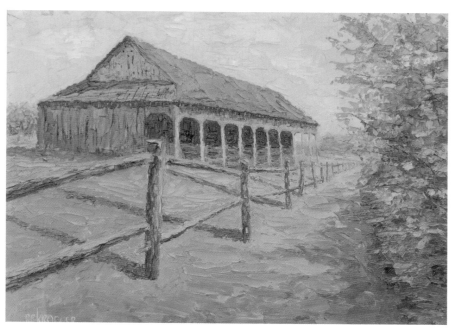

Miami County. *Colonel Johnston's*.

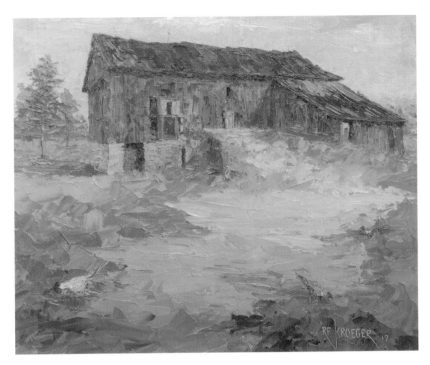

Montgomery County. *The Medic*.

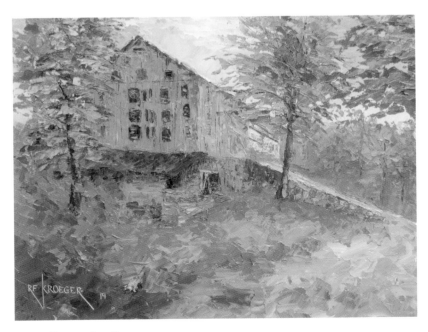

Logan County. *Last Days*.

Champaign County. *Nutwood.*

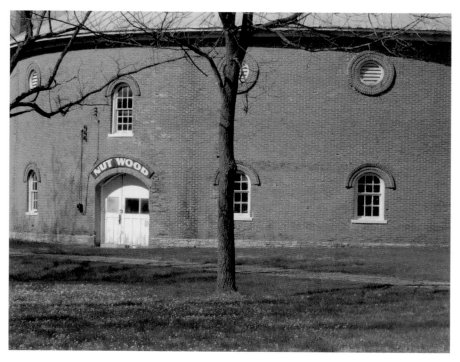

Nutwood, detail of this rare brick round barn.

Left: Clark County. *Rarest of the Rare.*

Below: Greene County. *Caesar's Freedom.*

Butler County. *The Beer Baron's Barn.*

Hamilton County. *The Preacher's Barn.*

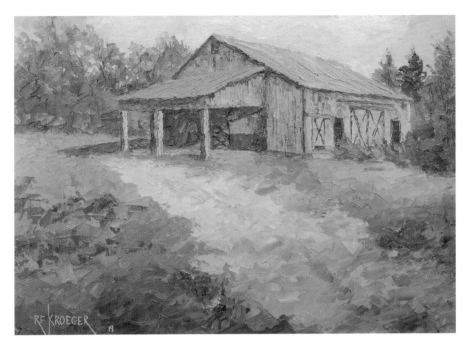

Clermont County. *Billy's Barn.*

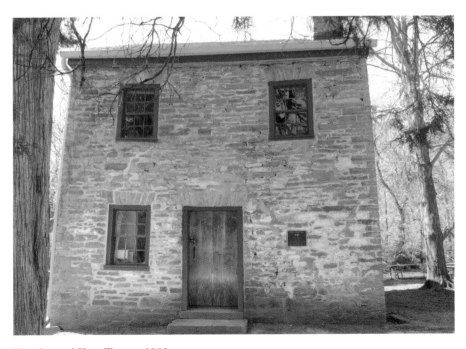

The Crossed Keys Tavern, 1802.

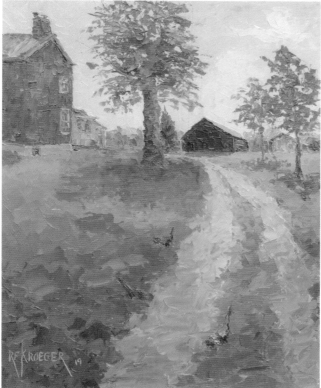

Above: Warren County.
*Barn at Crossed Keys
Tavern.*

Left: Clinton County.
The Museum.

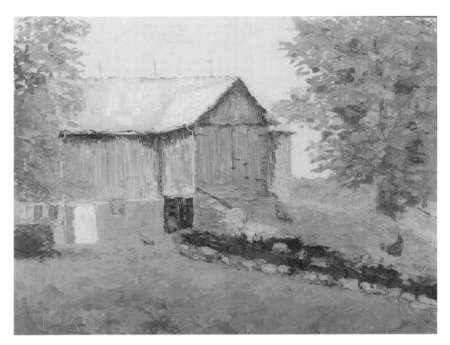

Highland County. *Hunting Mushrooms*.

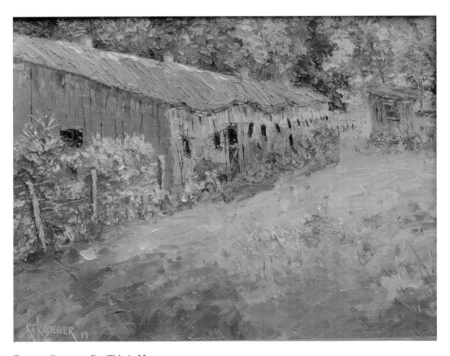

Brown County. *Dr. Tyler's Horses*.

Seneca County. *The Underground*.

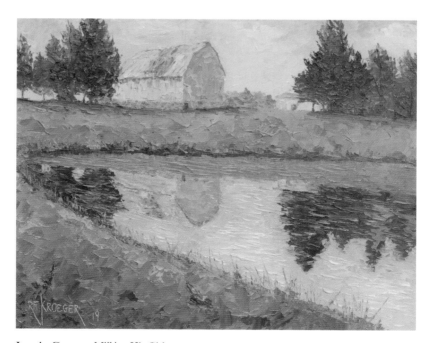

Lorain County. *Milking His Girls*.

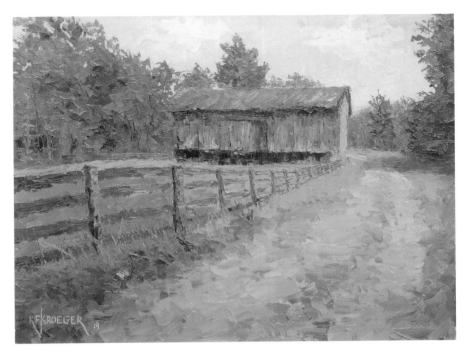

Ashland County. *Daniel's Dream*.

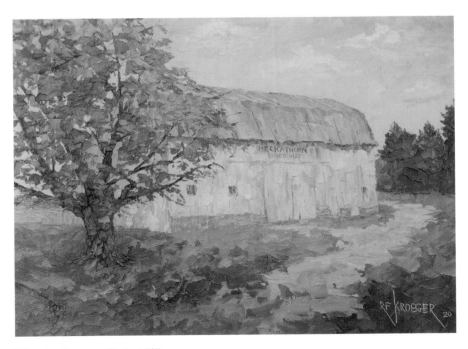

Wyandot County. *The Last Tribe*.

Left: Franklin County. *Rosedale*.

Below: Marion County. *Seven Sisters*.

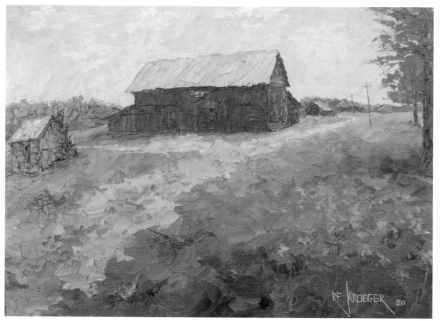

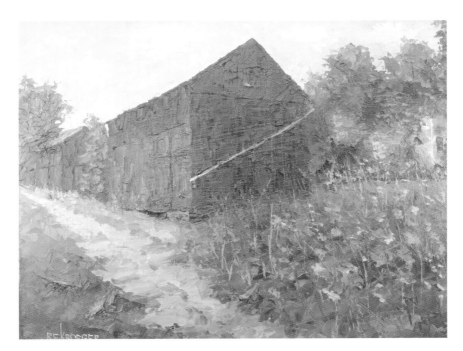

Union County. *Defiant*.

Knox County. *The Saltbox of Ohio*.

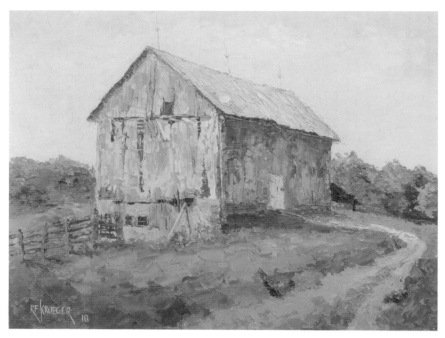

Licking County. *Granville Gray*.

Licking County. *Granville Gray*, a rare example of log-supported roof with original planks.

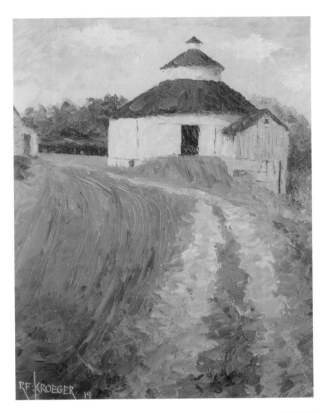

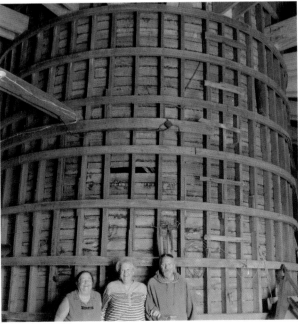

Top: Ross County.
Marvelous Maxwell.

Bottom: Rare circular
wooden silo. Owner
Chip Maxwell, along
with his sister, Peg, and
friend Nancy.

Fairfield County. *The Captain*.

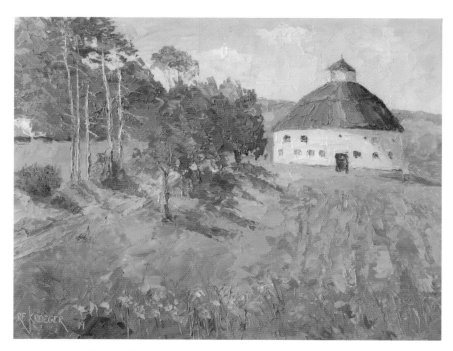

Perry County. *The Round Barns of Perry County*, McGaughey barn.

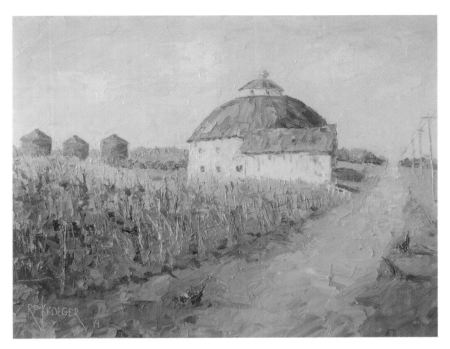

Perry County. *The Round Barns of Perry County*, Cooperider barn.

Morgan County. *The Snake Killer*.

Athens County. *Flight School*.

Hocking County. *White Chickens*.

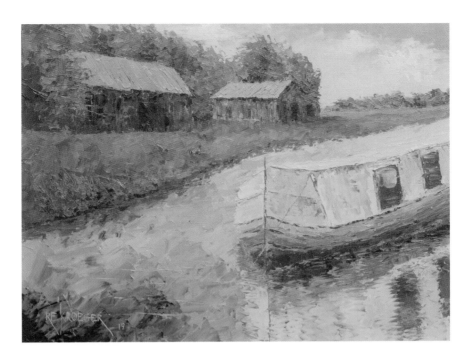

Above: Pike County. *The Bell*.

Right: Lawrence County. *Castle on the Hill*.

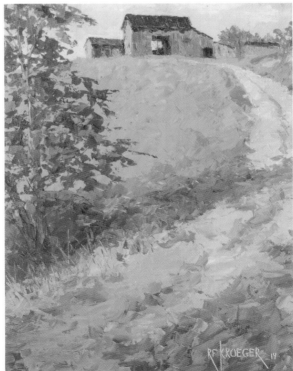

Left: Weathered siding and the haymow's barn door.

Below: Meigs County. *Presidential*.

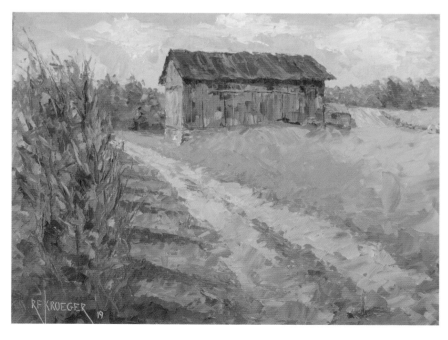

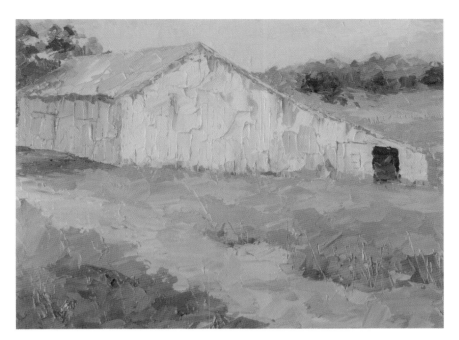

Gallia County. *Bob's Place*.

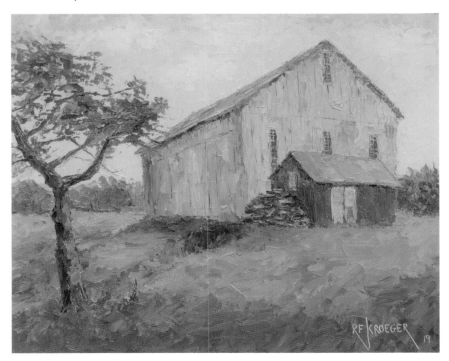

Medina County. *Longview Acres*.

Summit County. *Hartong's Heritage.*

Cuyahoga County. *Tinker's Creek.*

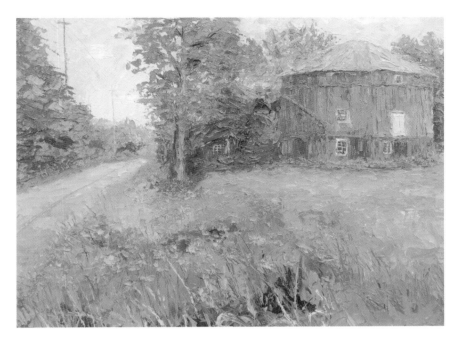

Ashtabula County. *The Octagonal.*

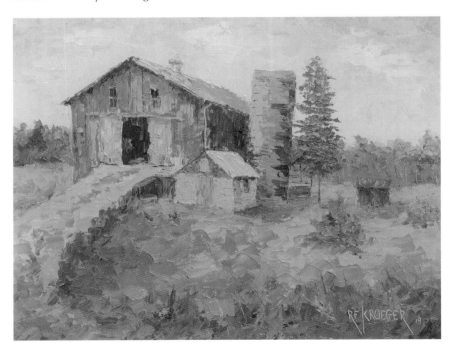

Geauga County. *Trophy Husband.*

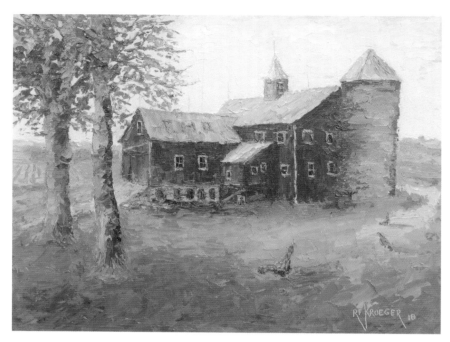

Trumbull County. *The Klondike.*

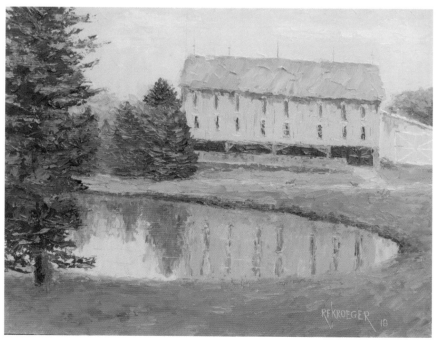

Wayne County. *Johnny's Legacy.*

Mahoning County. *Peter Pan, Wendy, and Tinkerbell.*

Columbiana County. *Harvey's Heritage.*

Carroll County. *Serendipity*.

Harrison County. *Workley's Wonder*.

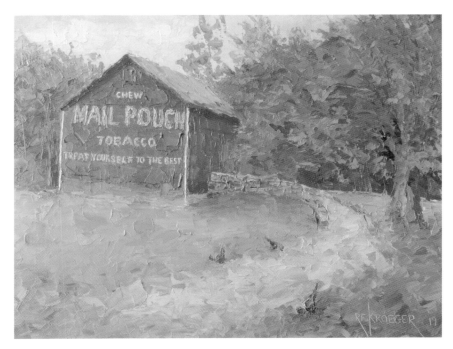

Belmont County. *Bentley Sweet.*

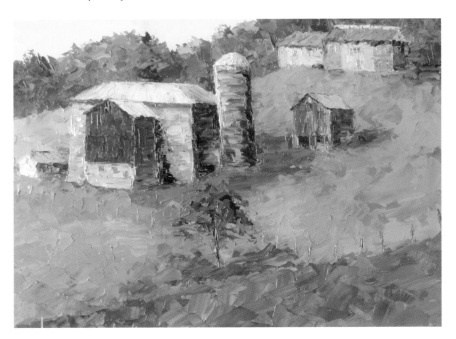

Monroe County. *Kindleberger New.*

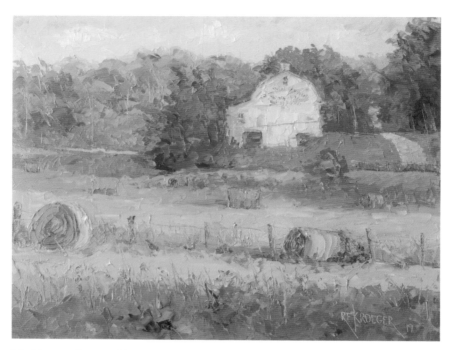

Muskingum County. *Pristine.*

Square-headed cut nails, circa 1830–1890s.

until it was time to return to Camp Perry. On the other hand, the gregarious Italian POWs, much more chummy than their German counterparts, would spend any extra time chatting. Sharing a common culture with local Italian immigrants, many returned to settle in these counties after the war.

Behind the barn site stood a large cement tower with metal rigging and antennas, a structure that, according to Bill, the government built in 1946. My barn scouts explained that it was a booster radio transmitter that was used to enhance signals between Cleveland, Toledo and Detroit.

But all good things come to an end, and eventually cherry trees stop bearing fruit—usually after fifteen to thirty years. Summer work shut down, and the trees became ornamental. Farm ownership passed from patriarch Harold Pickett to his son Charles. Around 2010, the land was bulldozed, removing the trees, and the farm was sold at auction in 2012, when present owner Kevin Schaeffer purchased it. A history buff himself, and mindful of the heritage of this farm, Kevin saved some barn siding after the barn was dismantled in 2018 for the framing of this painting, one that provides yet another story of our past—a memory of the POWs who once worked here and a reminder of the brave men and women who captured them during World War II.

Lorain County

Milking His Girls

Lorain County, just west of the Cleveland airport, is loaded with old barns, unlike its neighbors, Cuyahoga and Lake Counties. After the *Chronicle*, the county's biggest newspaper, ran an article about my barn project, many barn owners inquired. Sadly, I had to turn down all but two, both located in the southern part of the county, which was easier for me to reach on this extensive barn trip. I told the others that I'd return if a local nonprofit becomes interested in raising funds with my paintings.

I met the barn owner, Dan Clark, an effervescent, extroverted former National Guard helicopter mechanic turned IT expert. Although his job at Sherwin-Williams takes him on projects around the world, his busy schedule allowed him to show me around his barn. He also told me that his township of Pittsfield no longer has a post office and seems to be disappearing amid adjacent towns of Oberlin, Wellington and LaGrange. The latter, a French word for "the farm," symbolizes the heart of this area. As Dan said,

"Agriculture is in our blood and we are generational stewards of the land, ensuring there is a farm to call home to some future generation that wants to put a plow in it."

The barn's massive hand-hewn timbers, most likely cut from trees on the farm; the mortise and tenon joints; and the sandstone blocks, cut from a local quarry, testify to probable construction in the pre–Civil War era. Dan's family took over the farm in the 1920s, and Dan took the reins in 2006, an example of one of the younger generations interested both in history and preserving old barns. Refreshing.

For the painting, I selected a spot far below the barn and in front of a pond that mirrored its reflection like glass. Even though the grass was still winter brown, the composition was pleasing and one of the few that feature a barn's reflection. Perhaps Dan's grandfather liked the scene, too, since according to Dan, one of the reasons why he purchased the farm was this old barn, which he converted into a fairly sophisticated milking operation running from the 1930s and into the 1960s. Even though he worked outside the farm, he came back every night to do a job he loved: farming.

Milking his dairy cows—or "his girls," as he called them—was grandfather's favorite pastime. One day, when he was late for dinner, his wife went to look for him and found him dead of a heart attack in the barn, having worked on the cow that gave him the most trouble. He died "milking his girls." We all should be so lucky to die while doing something we love. Unfortunately, Dan never met his grandfather, although he treasures his memory. And the farming genes seemed to have been passed on, even though Dan rents most of his land to a tenant dairy farmer and raises hay on the remaining five acres.

Over the years, the barn has become less useful—it is too small to house large farm machines—but it does provide storage for lumber that an uncle uses in home building. And Dan, even though working in technology, has a passion for wood as well; he and a friend own a small woodworking business, which operates partly out of Dan's basement workshop. The artistry and engineering involved in making such fine furniture must give Dan a needed sense of fulfillment, even if he can't milk cows as his beloved grandfather did. A gift he surprised me with—a beautiful cutting board made of multilayered strips of wood—showed me that his business will thrive.

Yes, the barn needs help, and sooner or later, it will get it. Dan said, "Someday I hope to bring the barn back to its former glory and then bring all of the pieces of the farm back together to carry on my grandparents' name. Until then, I just keep watching it and hoping that it continues to stand the test of time."

ASHLAND COUNTY

Daniel's Dream

At the end of a long day of touring the barns of northeastern Ohio, including negotiating the highways of Greater Cleveland, I arrived at the Gilmore barn, my final stop. Despite my late arrival, George graciously answered my questions and showed me the barn, one his family has owned since 1964. George and his wife, Violet, purchased it in 1976. As with many other old Ohio barns, this one goes back much farther, as I learned from copious notes written by Sandy Stryker, who visited here with her cousin Roger in 2016 while retracing roots.

Daniel Way, born in 1816 in Pennsylvania, was the great-great-grandfather of Sandy and the great-great-great-grandfather of Roger Edgerly. Their visit to the barn was more than nostalgic, as Sandy wrote, "The hair on both Roger's and my arms just stood up." They knew the story and could feel their grandfather's presence.

Sandy believes that Daniel moved from Pennsylvania with his wife in 1848 to begin farming. After two years, presumably having saved money, he bought land and built this barn. By 1852, Daniel and Hannah had seven children—four boys and three girls, a large family, which was common in farm country—all potential workers for the farm. The oldest, Mary Ann, eleven, and her brother Samuel, nine, probably did their fair share of chores. The others, ranging in age from one to seven, contributed to a lesser degree. It's not hard to imagine that in the summer of 1852, the Way farm must have flourished with activity. Then tragedy struck.

In September, Daniel, only thirty-six, fell from the roof of the barn he had just built and died, leaving behind his dream of a working farm, a wife and seven children. Hannah, now a widow, was in charge of raising seven children and harvesting the summer crops, certifying her as a determined pioneer woman. By 1854, the probate court had completed its work and Hannah remarried. Six years later, the family sold the eighty-acre farm to Jacob Doerrer. Thanks to Sandy's research, we know that Hannah, her new husband and the children moved east to Holmes County, leaving behind father Daniel and his little son, also a Daniel, whose graves are still marked by tombstones in a graveyard just over a hill from the barn. Parting must have been hard for Hannah and her children, but people had to be resilient in those days.

The farm and the 1850 barn passed through various families until the farm was split up into parcels. However, thanks to efforts of a Mr. Burgett,

the cemetery is still maintained. In 1964, the Gilmores took over the twenty-four-acre farm, the original Way farmhouse and the old barn, which they've taken good care of, re-siding the south side, adding barn doors and coating the roof, the Achilles' heel of old barns.

The Pennsylvania bank barn made a good composition, its forebay protruding, boards warping and a fence and road leading up to it. Inside, the hand-hewn timbers, harvested undoubtedly from trees on the property, testify to Daniel's ability to construct a barn that would stand the test of time. In a letter (full of stunning script penmanship) he wrote to his Illinois-based sister Maryann in December 1851, he explained his work: "During this year, I have built a barn sixty feet long and forty feet wide with two stories. By the lower story, stone and the upper story frame, it is what Ohio folks call a silo barn, but I call it a bank barn….I have a post and rail fence around the barn and barnyard and to the spring house. I built a hog stable twenty-two feet long and sixteen feet broad with an entry in it and a hen house on the top. I have built a stone spring house twenty-one feet long and one story high sealed overhead and all around." From reading this, one can sense Daniel's pride in his handiwork, done for his wife and seven children. And even though he didn't live long to enjoy it, the barn will live on in this essay and painting, safeguarding Daniel's achievements.

RICHLAND COUNTY

Bogie and Bacall

Although I had visited other barns in this farm-rich county, I chose one, long gone now but associated with author Louis Bromfield, a native of Mansfield, the county seat. After serving in World War I, he found work as a reporter in New York City and began writing novels, winning the Pulitzer Prize in 1927. He eventually wrote thirty bestselling books and moved his family to France, a country he came to love during his time there in the war. But with trouble brewing in Germany in 1938, he returned to his roots in Richland County in 1939 and bought the one-thousand-acre Herring Farm, where he built a mansion and, as the son and grandson of farmers, began farming, continuing his family tradition. By 1942 the Malabar Farm was fully operational, and thanks to Bromfield's organic and self-sustaining gardening on the farm, he was posthumously inducted into the Ohio Agricultural Hall of Fame. His

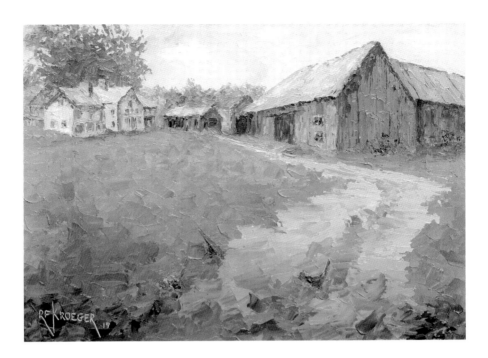

children sold the farm in 1958 to a foundation, which, faced with foreclosure, passed it over to Ohio in 1976, enabling it to become Malabar State Park. Today, it offers historical reenactments, gives tours and keeps the Bromfield legacy alive.

During the 1930s, Louis Bromfield also wrote screenplays, which often took him to Hollywood, where he became friends with many film stars. Over the years, he hosted many of them at his farm, including Errol Flynn, Edward G. Robinson and James Cagney, another farming aficionado. One of his friends was Humphrey Bogart.

If you've ever seen movies like *To Have and Have Not* or *Casablanca* or if you've ever listened to *Bold Venture*, the syndicated radio series that aired from 1951 to 1952, you can't help liking Humphrey Bogart and Lauren Bacall. He was forty-nine when he met the nineteen-year-old actress on the set of *To Have and Have Not* and asked her to write her phone number on a matchbox. That was in 1944, a year when the United States and Britain had launched D-Day. A year later, they married at Bromfield's Malabar Farm, choosing Bromfield as best man. Although Bogart died in 1957 when Bacall was only thirty-two, she treasured their marriage, even though she got only twelve years of him.

But this painting traces back long before Malabar—to *The Farm*, a novel that Bromfield published in 1933. He portrayed several generations of Ohio farmers and used recollections of his grandfather Jacob Barr, an Underground Railroad conductor and owner of the farm where Bromfield grew up. To illustrate the end pages of the first edition, an artist created a scene of a barn and farmhouses to reflect the memories that Bromfield recounted from his childhood there circa 1900. No, this farm didn't host the wedding of Bogie and Bacall, but as Hemingway once wrote in *The Sun Also Rises*, "Isn't it pretty to think so?"

CRAWFORD COUNTY

John Quincy Adams

My barn scout, the late Floyd Reinhart, and I met Norma and Ralph Shifer, owners of these two old barns, on a sunny day with clouds circling, beautiful in early June. Overhead, drafting on the wind, were turkey vultures, showing off their mighty wingspans and floating in many directions. These buzzards are the good ones, the trash removers of the bird family—drastically different from their cousins, the black vultures, the aggressive ones that can kill livestock.

The older barn, circa 1850, displays plenty of hand-hewn timbers, and the newer one, dating to around 1900, has sawmill-cut lumber. I decided that the massive silo, nearly totally engulfed in vines, needed exposure in the painting. After all, many decades ago it played a major role in this farm. Across from the barn was the location of the former Wyandot Indian reservation, now only a field where arrowheads occasionally surface.

Ralph and Norma purchased the farm in 1972, and they told us that in the years before the Civil War, the New York Central rail line came through here, making this a convenient stop on the Underground Railroad. But what was more interesting was that they still had the original deed to the farm.

Though faded, the date of 1826 was still legible, as was the signature of the president of that time, John Quincy Adams. In those early years, the president signed each land deed. This one was issued from Chillicothe, which was one of the first land offices in Ohio, and it was also the first capital city of Ohio, which lasted several years. Columbus took over in 1816.

In eastern Ohio, the city of Marietta has preserved the oldest still existing building in the state: the first official land office, a small log building built in

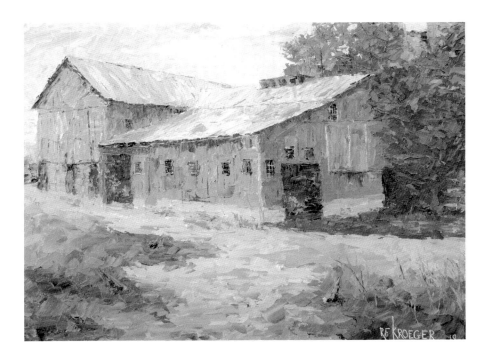

1788 as the headquarters of the Ohio Land Company. By 1800, five years after several Indian tribes gave up land in the Treaty of Greenville, Congress passed an act that established federal land offices in Steubenville, Cincinnati, Chillicothe and Marietta. Many of the land grants went to veterans of the Revolutionary War and the War of 1812, each signed by the president.

Land offices paved the way for the settlement of this land, known as the Northwest Territory, and were managed by an officer called "Register of the Land Office," a person appointed by the president with consent and approval of the Senate. Three years later, in 1803, Ohio became the seventeenth state in the Union and the first in the Northwest Ordinance. Thomas Jefferson was president. Later, land offices were started in Zanesville, Canton (later moved to Wooster) and eventually in Piqua, Delaware and Tiffin in order to keep up with the demand for the remainder of the former Indian lands.

Some twenty years after Ohio's statehood, this farm became deeded in Chillicothe. John Quincy Adams, who served as president from 1825 to 1829, signed it. This senator from Massachusetts was the eldest son of John Adams, a founding father of the United States, first vice president and second president. However, John Quincy Adams failed to win reelection, losing to Andrew Jackson, which, according to some historians, might have resulted

from his antislavery sentiment. In fact, he predicted that the slavery issue would lead to dissolution of the Union, which it almost did. Years later, the farm whose deed he signed ironically became a station on the Underground Railroad. The president would have been proud.

WYANDOT COUNTY

The Last Tribe

This farm, labeled "Heckathorn, 1827," as prominently displayed above an entrance to the barn, changed ownership in 2008 after the barn owner's grandmother passed away. Laura Wood, current owner, explained that until then it had been in the Heckathorn name. Laura's parents, Tim and Patty Wood, own the 450-acre farm, but Laura owns the farmhouse and barn. Patty is a Heckathorn descendant.

The original deed, still in the family's possession, bears the name of the patriarch John Heckathorn and is dated May 1827. President John Quincy Adams signed it. Another deed, documenting the transfer from John to Daniel Heckathorn and dated April 1836, is signed by President Andrew Jackson.

Initially, the farmer may have built a smaller barn, but he expanded when the farm began to prosper and required more storage room. The current barn's extensive hand-hewn timber and heavily-aged wood suggest a pre–Civil War era. Originally, the Heckathorns used the barn for mostly cattle and sheep. In later years, they raised hogs. Today, Tim farms a total of about eight hundred acres.

The family explained that this farm was a stop on the Underground Railroad since the nearby village of Marseilles was a significant town between Cincinnati and Detroit at that time. The enslaved people would hide in the corn fields during the day and stay inside the smokehouse at night. In those years, the Wyandot Indians also lived nearby.

According to Laura, these Indians camped near the farmhouse and across the road, but the many flint arrowheads found in nearby farm fields represent cultures long before the era of the fur traders, who introduced metal tips for the Indians' arrows. The tribe was also known as the Huron people, a name given by the French in the seventeenth century to the natives in present-day Ontario, Canada. Huron, in old French slang, connotes a "ruffian," a demeaning term, inferring that the French considered these peoples to be

essentially savages. In 1652, three remnants of tribes in Ontario fled that land to avoid adoption into the Iroquois Confederacy, according to an article in *Echoes Magazine*, a publication of the Ohio History Connection. A clan of them moved in 1748 into the Ohio country, where they became known as the Wyandot tribe.

In the same article, Lloyd Divine Jr., a citizen of the Wyandotte Nation, explained that an early writer described the Wyandots, circa 1800, as "the most abandoned and vicious tribe, having sunk in the most degrading vices such as drunkenness, lewdness and gambling." However, they tried to assimilate with the white settlers, giving up their traditional wild game hunting for farming. They also refused to join with Tecumseh during the War of 1812, for which the U.S. government rewarded them with a mill on the Sandusky River for grinding grain.

Later, Methodist missionaries converted the Wyandots to Christianity, which Mr. Divine considered the salvation of the tribe during the early 1800s when drunkenness was the norm. By 1820, the missionaries had fought hard to resist the government's efforts to move the tribe westward. They continued to live in harmony with their white neighbors and farm the land. However, in the summer of 1843, the Wyandots were finally stripped of their land. A band of 674, including 120 wagons and 300 horses, left Upper Sandusky, traveled to Marseilles—three miles from this farm—and eventually boarded steamboats on the Ohio River. They were moved to a reservation in Kansas, the last Indian tribe to leave Ohio.

MIDDLE CENTRAL

This group of eight counties lies in the center of Ohio, and as much of the state does, it contributes heavily to agricultural production. With the exception of Columbus—Ohio's capital, home of the Ohio State Buckeyes, government offices and a population of nearly 900,000—the region has many old barns, some restored but many falling apart. One of my favorites, Knox County's *Saltbox of Ohio*, a painting I've done many times, never fails to inspire me. But the one that started this Ohio Barn Project, *Granville Gray*, may not be standing by the time of this book's publication. Its sagging roof and missing boards captivated me in 2012 when I first laid eyes on it, but as a TV segment aired throughout Ohio by *Spectrum News* in December 2019 showed, its condition had worsened considerably, signaling the end.

Marion County

Seven Sisters

Kay Lamb, current owner of this 150-acre farm, explained that Joseph Kester, a traveling Lutheran minister as well as a master carpenter, built the 1850-era farmhouse where her nephew David now lives. Kester may have built a barn at the time, but it didn't last. In 1880, the Retterer family took over the farm, and David Retterer built the present barn in 1886.

He and his wife, Elizabeth, farmed the land and had eight children, the youngest of whom was the first and only boy, named Welcome. But he died in infancy. In nineteenth-century Ohio, farmers had lots of children, always hoping for sons to help with farming and eventually to assume ownership. To lose their only son must have been hard on them. Perhaps his loss represented as much difficulty as the seven sisters experienced living in a small three-bedroom farmhouse with their parents—one room for the parents and two for the girls. Seven of them in two bedrooms. Imagine that! Pioneer women were tough.

David passed in 1913, and six of the sisters married and moved away. The youngest, Hazel, remained with her mother on the farm for years. Eventually, the Ackerman family bought the farm, but they lived in town and rented it out, which often leads to neglect. Old barns and old farmhouses don't survive without a lot of care. By the time the farm was put on the auction block in 1986, the structures had deteriorated.

Kay, along with her husband, Bud, and their son, Steve, won the auction and began reconstruction, which became a labor of love. They remodeled the farmhouse, strengthened the interior of the barn and repaired the metal

David Retterer family, circa 1900. *Courtesy of Anna Lamb.*

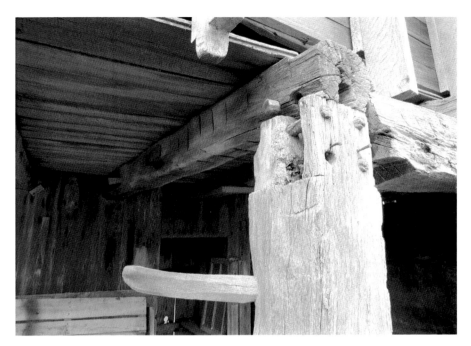

The mystery wooden spike.

roof. Unfortunately, Bud and Steve died in 2009, leaving Kay a widow and sole owner of the farm. She continues their legacy, maintaining the barn—with a recent coat of red paint—and the rustic farmhouse.

What stole the show, however, and what makes Kay sad, is the old granary that sits to the left side of the barn, as quaint an old structure as there ever was. But its days are numbered. Judging from the ancient hand-hewn marks, it probably predates the barn, possibly even to before the Civil War. Perhaps the traveling preacher built it to store corn for his livestock. Regardless, it survived nearly two centuries and still displays an interesting "mystery" of the past: two wooden spike-shaped pegs that fit perfectly into a hand-hewn beam, each about forty-five degrees from the other. What were they used for in this little granary? Harnesses for horses? Saddles? When he saw this photo, Tom O'Grady, a founder of Ohio's Friends of Ohio Barns, commented, "Mysterious. And the farmer is not around to interview and didn't leave any written explanation....Live the mysteries. They keep us coming back."

Another mystery is how seven sisters could coexist in two small bedrooms, even throughout their teenage years. I'd like to have been a fly on the wall in those days.

Union County

Defiant

The barn was old, presumably built in 1906. It was tiny, and it stood in a backyard in suburban Marysville, Ohio, stubbornly resisting the creep of brick homes and cement sidewalks. Fittingly, this county became the final piece in the Ohio Barn Project, with its little red barn, along with an identical twin in the yard next door. Yes, they were defiant.

The owner, Julie Kramer, explained that she bought the property in 2015, which is located in a tree-lined residential neighborhood. She mentioned that the house was built in 1906, a date that fits the barn as well since its beams are saw-cut and there are no mortise and tenon joints. Its small size suggests that it may have been used for carriages and horses, much like a garage of today houses cars and trucks.

Though only thirty-five miles northeast of Columbus, Marysville—with the exception of a massive Honda plant, a Nestle research facility and headquarters of the Scott fertilizer company—is predominantly rural. Its county, Union, hints at the service that so many Ohioans gave during the Civil War, but instead, it takes its name from the union of parts of counties established earlier—Franklin, Delaware, Logan and Madison.

Although not much is known about the early days of farming here, Julie, an ardent preservationist, plans to keep the barn, a rarity in suburbia. Perhaps, thanks to Julie, it will continue to stand, as a remnant of the past, in the midst of houses, mailboxes and minivans—a piece of Ohio's history, a backyard barn defiant to the end.

Madison County

The Constitution

Madison County was the last county I visited on my six-day barn trip in the spring of 2019. Without any connections, I kept my eye out for any oldies on my drive down Route 38, heading through rural farm country and on my way to I-71. As I passed the junction with Old Xenia Road, I saw a beauty—a stunningly weathered brown barn with a small add-on, possibly a corncrib. With many boards missing and holes gaping through and through,

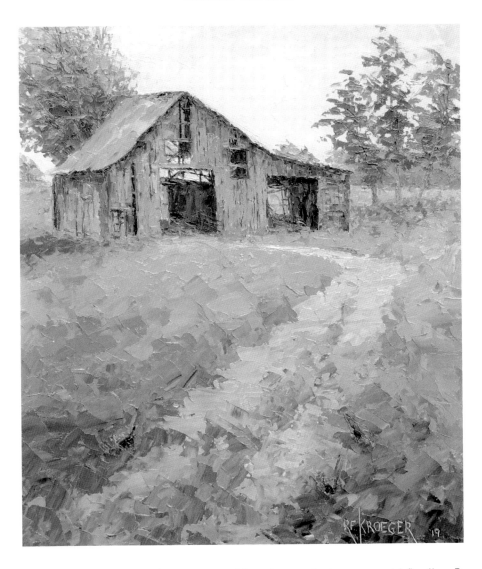

the barn's life was nearly over, something that a windstorm could finalize. It was my kind of barn.

I knocked on the adjacent farmhouse door, but no one answered. Later, I contacted the county auditor, who had trouble locating the owners. Anyway, I sent a letter, but it was never answered. So I looked to the county's namesake for a story.

Located just south of Ohio's capital city, the county is predominantly agricultural—nearly 90 percent is farmland. In fact, its soybean and corn

production ranks fourth in Ohio. Every autumn, Ohio State University hosts the Farm Science Review in London, the county seat. One of the largest agricultural trade shows in the nation, it draws more than 100,000 visitors during this three-day event. But the real story lies with James Madison.

Several Ohio counties took their names from our early leaders—Washington, Hancock, Harrison, Adams, Monroe, Hamilton, Jackson and Jefferson, many of whom signed property deeds for the Ohio pioneers. James Madison, born in 1751 in the colony of Virginia, became a lawyer and served as a delegate from Virginia in the Continental Congress during the Revolutionary War. Not yet thirty years old, he co-wrote—with John Jay and Alexander Hamilton—*The Federalist Papers*, a series of essays that laid out the basis of our constitution and the famous Bill of Rights. For this work, Madison is known as the "Father of the Constitution."

As secretary of state from 1801 to 1809, Madison, sent to Paris by President Jefferson, supervised the Louisiana Purchase from France in 1803. At a price of more than $11 million, Madison's deal included land west of the Mississippi River to the Rockies and southward to the Gulf of Mexico, in effect doubling the size of our young country and securing its western boundaries. In 1809, he was elected president and served two terms, which included the War of 1812, which began because the British navy attacked American ships that were trading with France, Britain's enemy. That war, sometimes viewed as a second war of independence, bolstered American patriotism and helped to distance our fledgling country from Mother England. Madison's protective tariff of 1816 further enhanced our freedom and was the first tariff passed by Congress, its purpose explicitly to protect American-made goods from foreign competition.

Forlorn but not forgotten, if this little brown barn—which now may be gone—could talk, it would probably have some stories to share, including why its county, established in 1810, was named after James Madison, a true patriot to whom we Americans will always be indebted.

FRANKLIN COUNTY

Rosedale

When I arrived at the Everal Barn, I couldn't tell which county it was in—Delaware or Franklin. Hoping for the latter, I asked the volunteer in the

Westerville office, formerly the 1870-ish farmhouse of the Everal family, who told me that the county line was merely a block away. So, yes, this was Franklin County.

The farm's name, Rosedale, derives from industrialist J.W. Everal's second wife, Rose, stepmother to his children after his first wife died and whom he wanted remembered when he christened the farm with her name in August 1914. Six years later, the Carpenter family bought the property, which eventually passed to the City of Westerville in 1978. Realizing its significance, city leaders kept and restored several of the buildings, creating a historical peek into life in the late 1800s. Other buildings, besides the barn and farmhouse, include a milk house, a hen house, a smokehouse and a carriage house, under which was the butcher room, where the family prepared meat for preserving.

The story began when John W. Everal was born in 1845 to immigrant parents John and Ann Everal, who married in England in 1830. They moved to Newcomerstown, Tuscarawas County, in the late 1830s and became prosperous, raising a family of seven and then eventually moving to the Westerville area.

John and his wife, Edith, along with their five children, rode horses on the banks of Alum Creek as they continued to farm the land. One day, John discovered a large deposit of clay on these banks and began making drainage tile and bricks on a kiln he built. Soon after that, with five employees and one kiln, he started the Everal Tile Company, and in 1888, his company became the Everal Tile and Brick Works, whose bricks still grace the buildings on this homestead. Everal educated farmers on the benefits of using tiles for drainage in their fields.

By 1883, he employed sixteen, and twelve years later, his twenty-three workers were producing fifteen thousand to twenty-five thousand bricks per day using six kilns. Many of today's buildings in Westerville were built with these bricks. However, when the clay deposits became exhausted in 1911, the company closed. Three years later, his son Frank started another brick and tile company, which lasted until 1929.

The showpiece of this homestead is the barn, built in Carpenter Gothic style in the late 1880s and into a bank on Alum Creek. This three-floor barn housed cattle and horses on the ground level, along with a corncrib. The second floor stored farm machinery, and the third floor was used as a hay mow, from which hay was dropped through a chute to the animals below.

But the crown jewel of this barn, helping to place it into the National Register of Historic Places, is the three-storied octagonal tower. A winding

Three-storied octagonal tower housing a one-thousand-gallon water tank.

staircase inside, impressive in itself, plays second fiddle to the former water storage tank, which once held one thousand gallons, supplying the livestock as well as the rose garden. The windmill on top of the tower drove the pump that drew water from a well.

Over the decades, the farm passed through owners and, like many old barns and buildings, fell into disrepair. When Westerville took over, city officials raised millions and not only restored the buildings but also moved the barn forty feet east, due to the widening of Cleveland Avenue. Today, the barn and other Everal buildings continue this wonderful legacy, thanks to the City of Westerville, preserving another page of Ohio's past.

DELAWARE COUNTY

The Grandfathers

Years ago, when I first laid eyes on this barn while driving north on Ohio Route 3, just outside of Sunbury, I was captivated. A morning mist hung on the ground, gentle rays of sun flickered and the weathered barn, with its rusting metal roof and five silos, almost seemed to be rising out of the fog. The scene was haunting. A mile later, I regretted not stopping to sketch it, but I didn't want to be late for my friend's wedding. I vowed to return.

When I paid a visit the next spring, I walked around, admiring the ruins of what must have been a large and prosperous Ohio farm. But now the silos were empty and the buildings unoccupied, and there was no clue to ownership or history—just a marvelous composition. I called the county auditor, who provided the owner's address and that of another barn and farmhouse down the road, but my letters to the owners didn't get a response. The historical society couldn't help either. But the barn begged to be painted, regardless of its anonymity. And there's a story too.

The word *Delaware* is often associated with the Ohio Indian tribe called the Lenapes, who became known as the Delaware Indians. Both this Ohio county and its main city take this name. But the origin goes back much further, to Thomas West, the third Baron De La Warr, who was the governor of the Virginia Colony in 1610 when Europeans first explored the large river, which they named after him—the same one that General George Washington crossed with his ragged Continental army in December 1776. In the 1600s, the Lenape tribe lived on this Delaware River, later moving westward into the Ohio country. Other northeastern Algonquin tribes called them the "Grandfathers" because they were one of the oldest tribes in this nation.

A treaty written in 1758 forced the Delawares into the Ohio country, then essentially a thick forest of towering hardwoods, where some settled along the Muskingum and others moved farther west along the Auglaize River. Once in Ohio, the Delawares became a powerful tribe, able to resist the aggressive Iroquois. But after switching allegiances between the French and the British during the fur trading wars, the tribe became divided during America's War of Independence.

Some sided with the British. Others, especially those who became Moravian Christians, living in the villages of Schoenbrunn and Gnadenhutten, maintained neutrality. Sadly, in 1782, a Pennsylvania regiment, believing

erroneously that the tribe had engaged in raids, killed about a hundred of these Christian Indians in what is now called the Gnadenhutten Massacre. Following this, the Delawares fought against the settlers and were finally defeated by General Anthony Wayne at the Battle of Fallen Timbers in 1794. In 1829, they were forced to leave Ohio for reservations in the West.

Yes, this old barn has been abandoned and may be gone and the Grandfathers may have left Ohio, but at least in this essay and painting, neither is forgotten.

MORROW COUNTY

Hole-in-the-Wall Gang

The Hole in the Wall is a remote pass in the Big Horn Mountains in Johnson County, Wyoming, where a group of cattle rustlers, known as the Hole-in-the-Wall Gang, would hide. In the late nineteenth century, this

gang and Butch Cassidy's Wild Bunch stayed here in a log cabin, built in 1883, which is now preserved at the Old Trail Town museum in Cody, Wyoming. Cassidy and the Sundance Kid, remembered in the movie starring Paul Newman and Robert Redford, eluded lawmen for years in this hideout, which was used by many outlaws from the 1860s to 1910, when it faded away into history.

Actor Paul Newman, an Ohio native, founded a summer camp for children with serious illnesses in Connecticut in 1987. He called it the Hole in the Wall Gang Camp, which quickly grew into an organization called the Serious Fun Children's Network. These individually financed and operated camps have served hundreds of thousands of children worldwide. Newman believed that children facing such terrible diseases should have a "hideout," which his camps provided.

Returning to his home state in 2007, Mr. Newman teamed with other Ohioans and toured this scenic rural property in Mount Gilead and founded another children's camp, which is called the Flying Horse Farms. Although Newman died in 2008 and didn't see the opening of this camp in 2010, his goal of another summer camp came true.

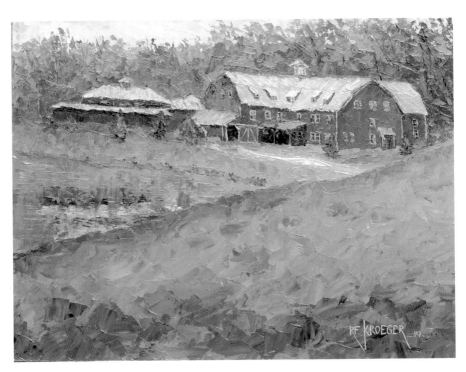

The magnificent barn, which now houses the administration center of the camp, was built in 1913 but was located elsewhere in Morrow County. Owners Mary and Tim Weiler donated the barn in 2009, and thanks to other generous supporters, Amish crews dismantled it and moved it to its present site, where they reassembled it—all in three months. Today, the century-old barn has found a new purpose: helping to continue the philanthropy started by one of Ohio's most famous actors. Butch Cassidy and the Sundance Kid would be proud.

KNOX COUNTY

The Saltbox of Ohio

There are many barns in Knox County that are larger, more interesting architecturally, older and more photogenic than this tiny barn, one that nearly touches busy Ohio Route 229. But it attracted my attention immediately. Its rusted roof had just the right amount of red and brown in it, and the occasional orange and red streaks in the siding enhanced its artistic flair. Some missing and warped boards added to its charm, as did the small window, its white paint still bright, and its haymow door, swung wide open, almost as if it were inviting strangers to come in. The roof was dramatically asymmetrical—one side was short and the other much longer, sloping down the hill.

Jeff DePolo, the barn's owner, lives nearby on DePolo Road, a street named after his father, who maintained a prominent farm here for many years. Unfortunately, after owning this little barn for thirty years, Jeff didn't know much about it, except that the nearby farmhouse was built in 1892. Sadly, since it has outlived its usefulness, the barn will be dismantled.

Jeff did point me to Larry Wise, a Knox County seventy-four-year-old who explained that Cecil Horn, the former owner, kept his horse and buggy in the barn. In the old days, the horse and buggy competed with Model Ts for room on the dirt roads. He said that they kept a few milk cows in the barn and lived on what they farmed. There isn't much more room in this small barn for anything else.

In 2017, I did more research on this interesting barn, trying to figure out why its sloped roof faced north when the prevailing wind, rain and snow come from the southwest. While the reason for that may remain mysterious, I uncovered the story of this barn—the saltbox of Ohio.

In one of my barn reference books, *The Old Barn Book*, there's a photo of a barn with a roof like this one, although it's located on Prince Edward Island, Canada. The author explained that the saltbox style of the roof "focuses the weather" on the north side of the barn. An online search revealed that the saltbox home style originated in the 1500s in England, where they were called "outshot" houses.

When English folks settled in New England, they brought this type of house with them, extended the roof and eventually gave it the name saltbox. This term came from the wooden box where salt was stored. It was important in preserving food, but it was expensive and caked up easily, which led some bright fellow to design a wooden box with a sloped lid that was hung on the wall near the hearth to keep the salt dry. The sloped lid made it easier to remove the salt when needed.

The first colonial saltbox house was built in 1638, and many others followed. Families found that they could add on to the square-shaped house with a lean-to, thereby making the roof asymmetrical, if they needed extra room for storage or for new family members. Eventually, the saltbox home was not added on; the roof was built long, sometimes to within six feet of the ground. Folklore attributed this to colonists desiring to avoid "Queen Anne's tax," a tax Mother England enforced on structures classified higher than one story. By building one level close to the ground, the saltbox was considered one level, sufficient to avoid the tax. However, Queen Anne didn't rule England until 1702, making this a quaint New England myth.

By 1750, the saltbox style had fallen out of favor around Boston, which, in those days, was the fashion hub of the East Coast. The last saltboxes were built on New England farms in the early 1800s, although farmers continued to build them in Nova Scotia, New York and New Jersey. A few, including this one, made it to Ohio.

Why Knox County? *Granville Gray*, the stimulus for my Ohio Barn Project, lies in Licking County, the county just south of Knox, where colonists from Massachusetts and Connecticut moved around 1800. These pioneers, from eastern states where the saltbox home and barn were prevalent, founded Granville and much of Licking County, and perhaps a few of them drifted north into Knox County, founded in 1808. Did a relative of one of these early pioneers learn about the saltbox barn from his or her grandfather and decide to build this one a century later? Maybe.

That might explain why the Knox County farmer pointed the sloped roof north, deciding to ignore central Ohio's southwesterly weather pattern. Maybe tradition was more important. Listen and you can hear

his grandfather's words: "Son, we always pointed the sloped side to the north." Why north? In New England, storms called "nor'easters" blow in from the ocean from a northeast direction, bringing wind, rain and snow. They can be fierce. They wreaked havoc in the 1600s, and they wreak havoc today. So the colonists made sure that the sloped roof faced north or northeast to withstand the storms. Maybe tradition played a role when this barn was built after all.

Unlike his colonial cousins, which were timber-framed—nails were expensive in the 1600s—this Ohio saltbox barn is plank-framed, with saw-cut boards nailed to one another. It probably dates to around 1900, not long after the adjacent farmhouse was built. And it's uncommon, making it a legitimate Ohio treasure.

But even though it's been around for well over a century, its days—like those of many old Ohio barns—are numbered, no thanks to the car that crashed into it years ago. Although it will be missed, it will survive in this essay and in the paintings, all framed in its own barn wood, thanks to Jeff. This will remind us of the early Ohio farmers as well as those patriots of eighteenth-century New England who started the revolution that gave us our freedom. Goodbye, saltbox of Ohio.

LICKING COUNTY

Granville Gray

This is it, the godfather of barns. This is where my Ohio Barn Project started when, in September 2012, my wife, Laura, arranged for us, on our annual anniversary "surprise" weekend, to stay at the Welsh Hills Inn, a B&B outside of Granville in Licking County. When we turned off Route 661, the main road in this area, I noticed this barn. Its quiet voice called to me.

Gray timbers had tilted from the weight of the roof, which was also buckling under the strain of approaching two hundred years. The barn's southern side had suffered the most: a missing window and several planks were gone, and many others were warped. It reeked of character. And somewhat mysteriously or even mystically, it reached inside me, awakening my inner artist. *Paint me. Don't forget me. Write about me*, it seemed to say. So I returned the next day.

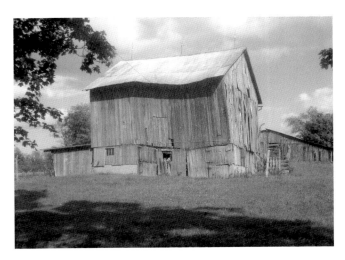

Granville Gray, 2012.

I knocked on the door, the only door actually, on the tiny farmhouse and met the farm's owner, an elderly Mr. Herbert Hall. Clad in comfortable Saturday afternoon clothes and barefoot, he was defensive at first—after all, I was a stranger—but warmed when I told him my idea. Then he let the history flow. Mr. Hall explained that the barn was probably built at the same time as this little farmhouse, about 1830, by a family named Blanchard. And what's more, this area was originally called Blanchardville. Sure enough, an 1866 plat map in Granville's history museum shows several plots belonging to the Blanchards. Mr. Hall said the early farmers owned five hundred acres. A gun shop was across the street. He explained that the beams supporting the roof were only half-cut trees, another indication of its age. The rest of the barn's timbers are all hand-hewn.

Mr. Hall, in his late seventies then, bought the farm in 1967 and, besides having a small herd of dairy cows, still raises hay in the pasture. His grandfather came to Licking County in 1905 and started farming, eventually moving to the present location. He told me that many of these plots were awarded to Civil War veterans.

Centuries before Ohio rallied troops for this bloody war, Native Americans lived here, off and on, here and there, and left behind their mark: many mounds, notably Granville's alligator effigy mound, as well as numerous ones in nearby Newark. This was their land, although they couldn't stop "progress" and yielded to the organized armies of the young United States. After General Wayne's victory over the Ohio Indian tribes in northwest Ohio in 1794, the flood gates opened: Ohio was finally safe, and the land was cheap.

The first white settlers here had Welsh ancestry. After failing to survive on rocky ground in Cambria, Massachusetts, they arrived on these hills, fertile enough to grow crops, around 1800. Hence the names the Welsh Hills B&B and Cambria-Mill Road. A few years later, colonists from Granby, Connecticut, and from Granville, Massachusetts, followed their Welsh neighbors. They paid $48,000 for land and built the town of Granville, one of Ohio's first planned communities. It was a thriving place for thirty years—farming, tanneries, distilleries, ironmaking and mills—until the town was bypassed by the National Road and the Ohio and Erie Canal. Rather than folding, Granville changed direction: education followed, and Denison University, founded in 1831, remains a bright spot.

Veterans of the American Revolution are buried in the old town cemetery, and more than one hundred houses and buildings are listed in the National Register of Historic Places. Granville is a good place to visit if you're into history.

Logs support the barn's entire roof, which is uncommon. Why? My guess is that, as Mr. Hall said, the barn was built before the Civil War and by someone who felled nearby trees, hewing them for the massive internal beams, fitted with mortise and tenon connections. However, he used whole logs for the roof, not worrying about what the inside would look like. That farmer didn't want to waste time!

Farther up the hill, not far from this true bank barn, sat an old corncrib, more of a small corn barn than a crib, its wood weathered by centuries of wind and snow. Farther down the hill was another old gray wooden building, a chicken coop. This must have been a busy place in the 1800s—with chickens running around, corn in the fields and livestock grazing.

But Father Time caught up with Granville Gray, which was featured in *Spectrum News*, created by a producer who wanted to share my Ohio Barn Project with others. Filmed in November 2019 and available on YouTube, it showed footage that revealed much deterioration. Concerned, I called Mr. Hall, who confirmed the barn's bad shape. I visited again in March 2020, hoping to get one last glimpse of the barn and say goodbye to it. Although it will be gone someday, it will always be with me, reminding me of Hemingway's reference to Paris in his book *A Moveable Feast*: "If you are lucky enough to have lived in Paris as a young man, then wherever you go for the rest of your life, it stays with you, for Paris is a moveable feast."

SOUTH CENTRAL

This section begins in the farm belt of Fayette County, where it's hard to drive anywhere without seeing fields of corn, soybeans or wheat—flat agricultural land that Interstate 71 cuts through, connecting Columbus with Cincinnati. Ross County boasts antiquity on steroids with numerous Hopewell and Adena mounds and the sprawling two-thousand-acre estate of Thomas Worthington, one of Ohio's first senators, located in Chillicothe, Ohio's first capital city. Fairfield County's charming town of Lancaster, its county seat, is not far from Pickaway County and its stunning historical Slate Run farm. Ohio's Appalachian region begins in Perry County—with its three remarkable round barns, all within a few miles of one another—and intensifies (which means there aren't many flat, straight roads) in the wooded lands of Morgan, Athens and Hocking Counties. Ohio's Appalachia, seldom visited by most suburbanites, is worth the drive.

FAYETTE COUNTY

Fayette's Corn Barn

This corn barn is one of Ohio's historical treasures. And it's got a good story too. In 2013, while driving down I-71 one day, my wife and I spied it from the highway, not far from the Washington Court House interchange. From a

distance, it looked like a round barn. The current owner, Chris Jefferies, who has lived in the area since 1979, said that he's always admired the Krieger homestead, as well as Carl Krieger's farming expertise. "Carl was one of the best farmers in the area," Chris said.

He mentioned that a larger barn sat next to this one and was once part of a huge farm, going back to the late 1800s. In the 1960s, Carl Krieger bought the farm, about one thousand acres then, but did not use this barn. Technology had changed, and small wooden corn barns were outdated. This one hadn't been used since the 1950s. So Carl built a seventy-thousand-bushel storage unit three hundred feet northwest of the barn. Carl died in 2005, and the farm was sold to a John Ackerman, an investor, not originally from Fayette County.

Born in New Jersey in 1931, Ackerman graduated from high school there and later earned a degree in engineering in 1953 from Lehigh University. Immediately after graduation, he joined the U.S. Air Force to serve in the Korean Conflict, finishing with the rank of major in 1956, the year he started working as a mechanical engineer for Pratt & Whitney. He retired thirty years later. But he had other callings: insurance agent, farm owner and

investor. John was a Renaissance man, and he apparently managed money well enough to acquire vast holdings.

John never moved to Washington Court House; he bought the Krieger farm as an investment, and he must have done well in buying and selling farmland. But when he died unexpectedly in November 2010, he had no heirs—no wife, no children, no siblings and no cousins. Why, after being an insurance agent, didn't he have a will or trust? Perhaps he thought he wouldn't die at seventy-nine, but death can come unannounced. At least that's what insurance agents preach.

So his estate, valued at $25 million, went to probate court. In an exhaustive search for heirs, required by Ohio law, the executors found two grandsons of one of his aunts who were living in California. That must have been a remarkable phone call: "Guess what? Your long-lost distant relative died, leaving you his estate."

"How much?" came the nonchalant reply.

"A big one. $25 million." The heirs, instant millionaires thanks to someone they probably never knew, disposed of the holdings, selling the farm to Chris in 2011.

So, is this a "corncrib" or a "corn barn?" Eric Sloane, in his book *An Age of Barns*, explained that the American corn barn, copied from an 1813 English plan, was not popular and gave way to the more traditional rounded corncrib, which is prevalent, either in wood or metal, on many Ohio farms. The corn barn, on the other hand—usually rectangular or square—had two doors, on either end, that were wide enough for a wagon or tractor full of corn. It was an efficient little barn.

This one is likely one of the most ornate corn barns in America. Whoever the prosperous farmer was who built it had a sense of aesthetics. The cupola and the side edging aren't simply flat boards—they're serrated, adding a whimsical flair. Its side vents also are serrated, in an almost Victorian Gothic look, typical of the late 1800s. One might assume that the large barn, previously next to it, had a similar design.

The vents helped to allow air to season the corn, which also prevented mold. And the cobs were used for oven ash (to smoke meats) and for kindling. Native Americans, especially those living in this part of Ohio in the 1700s, had even more uses for corn. None of it was wasted.

White paint overlaps a coat of red, something discovered when Chris provided barn wood to frame the painting. So I decided to do another painting in red. When Chris and I, initially thinking this was a granary, went in the barn, we discovered corn cobs, old ones, littered on the floor.

The large supporting beams were sawmill-cut, but the joints were mortise-tenons. The inside looked good—no moisture, proving that the roof had been maintained well. Chris plans to save this Fayette County gem, one of Ohio's rural heirlooms.

ROSS COUNTY

Marvelous Maxwell

Sunshine Hill Farm, a small fifteen-acre corn and soybean farmstead, is hard to miss when driving down State Route 180, just out of Kingston, thanks to this barn, a brilliant beacon of red and white, which can be seen for hundreds of yards in either direction. Its recent coat of fiery red paint and its twenty-eight-foot clerestory attract visitors, photographers and artists. This true round barn is one of Ohio's treasures.

Using trees from adjacent woods—and a sawmill for cutting—Robert P. Maxwell, the family founder and great-grandfather of Chip and his sister, Peg, built the barn in 1910 and farmed five hundred acres, keeping one hundred head of beef cattle in the barn's lower level. Over the years, the farm passed down family lines until 1978, when three families divided up the acreage. Chip Maxwell and his wife, Cherie, were the lucky ones: they got the barn and eleven acres. But as the years passed, a century of age caught up with the barn, and the silo tilted, spelling impending doom.

According to a newspaper article, Cheri said, "You cannot put a price on sentimental value." Her husband, Chip, didn't want to be on his deathbed, knowing that he didn't save the barn since his grandfather built it and his own dad cared so much for it, according to the article in the *Chillicothe Gazette*, Ohio's oldest newspaper (founded in Cincinnati in 1793). So, he put his money where his sentiments were and paid a substantial sum to the Mount Vernon Barn Company to save it. It uprighted the silo with cables and then stabilized the barn with new supports. Mission accomplished.

But after such a costly restoration, what good is the barn? It doesn't house crops or livestock. It's just a beautiful, old, non-functioning barn. However, Chelsea Maxwell, Chip's daughter, has plans. Her fiancé, Ryan Muncy, runs a well-known restaurant in Chillicothe, and his entrepreneurial spirit seems to have rubbed off, giving Chelsea ideas about transforming the barn into an event center. Across Ohio, owners are converting old barns

into wineries and venues for weddings and family reunions. They're giving old barns a new life, which is a trend that Chelsea hopes to follow, putting restrooms into an adjacent small barn, running electricity and remodeling the lower level into a refreshment lounge. She even plans to be the first to have an event here: her own wedding. After all, it would be hard to pass on a barn like *Marvelous Maxwell*.

PICKAWAY COUNTY

Living History

Although I did a painting of the county's bicentennial logo barn a few years ago, I became more intrigued with this one, an expertly restored barn in Slate Run Living Historical Farm, part of the Metro Park system of Franklin County. The many parks in this system attract nearly 11 million visitors each year, and yes, history does come alive in this one, which is well sign-posted—near Canal Winchester and just barely inside the county line.

Reenactors, dressed in period clothing, run many study programs on nineteenth-century farming and offer tours for children and adults, taking them through thirteen vintage buildings. Although Samuel Oman built this barn in 1881, it was probably not the first on the farmstead, which the Fridley family established on a 212-acre plot in 1852. When they arrived, chances are that they built a log house, then a small log barn and then in 1856 the farmhouse, which also has been restored. After Oman purchased the farm in 1867, he must have been a productive farmer, prosperous enough to afford to build this large barn, in which he might have recycled some of the hand-hewn timbers from the original barn.

When the Metro Parks acquired the farm in 1964, the workers used the barn for storage and began planning needed repairs: missing animal stalls, the deteriorating slate roof and broken boards. Eleven years later, after funding came through, they began the restoration, using historical records to realign the doors, rebuild the attractive cupola and replace lightning rods, including glass balls. They even hired a slater from New Hampshire to replace slate on the roof, maintaining the original diamond design. The result, now forty

Reenactor Harmon with antique manure spreader, circa 1870.

years later, is stunning—a beautifully restored barn from the 1880s. And they keep it full of people too. On the day I visited, a volunteer, dressed in nineteenth-century farm clothing, was taking a group of schoolchildren on a tour, and Harmon Gombash, a reenactor, was kind enough to let me take his photo while posing with an old manure spreader, circa 1870.

Thanks to the Franklin County park system for venturing into adjacent Pickaway County, Sam Oman's barn has been preserved. If he could see the many reenactors showing how farm life was in the 1880s, he'd be proud… and rightfully so. It's living history at its best.

FAIRFIELD COUNTY

The Captain

Liz Fox—along with her husband, Bob, the barn owner—was kind enough to share information about the early days of this Ohio gem, information that comes from a copy of the diary of Captain August F. Witte. In his writing, Witte explained that he enlisted in the German military when he was twenty-six, receiving the rank of corporal in the Landwehr Battalion. Within a year, he rose to lieutenant. Then he "marched with the Army of Hanover to the occupation of the Netherlands and was attached to the staff of Major General Lyon. In this way I fought against Napoleon and returned from France in February, 1816. In the year 1817 I was promoted to the rank of captain." But perhaps the aura of the New World was calling him.

In an entry dated July 29, 1829, he wrote, "Far and wide in the vicinity of Lancaster there is not one steam-mill, only water mills, which in summer frequently cannot work because of dryness. So people have to bring their grain often 10 to 20 miles to the mill and then often are forced to wait for days till they get their flour." Captain Witte saw an opportunity. The next month, he recorded, "Today the contract was closed for the purchase of the mill and distillery for $2300.00. From now everything will be done, to put the place in shape and build the structures necessary for the enterprise…it is possible to build a dwelling house of 54 foot front and 36 foot depth and a cattle barn with two floors 60 foot by 36 foot for the sum of $2500.00." Witte's plan was to grind flour, store it and sell it to locals who would not have to travel or wait. German efficiency. Why he opted for a whiskey distillery instead of a beer brewery—a German's preferred drink—remains a mystery.

In 1829, an investment of nearly $5,000 was a considerable sum, and unfortunately, it did not pay off. The distillery did not do well. Creditors forced a sheriff's sale in April 1832 to Joshua Clarke, apparently a friend of the captain's. In July, he and Witte signed an agreement, stating that Witte could buy it back in a year's time for $10,000 plus interest and "a just and fair sum" for improvements made.

Seeking a financial partner, Witte returned to Germany in the summer of 1832 and stayed there for a year. When he returned, Clarke took him on as an equal partner but still required him to pay the agreed-on $10,000. Five years later, in the financial Panic of 1837—a time when many businesses failed, banks collapsed, prices of goods declined and thousands of workers lost their jobs, which meant less money for leisure items like whiskey—the captain lost his property as well.

According to Liz, the house was given the name Concordia after the Roman goddess of harmony by Judge John T. Brasee, who purchased the house in 1858. His daughter, Alice, married George Witte, son of August Witte. As the legend goes, when George arrived on a train from New Orleans for their wedding on July 3, 1861, Alice stood out on the widow's walk atop the house and waved the Confederate flag to greet his train as it passed by the property. George and Alice took the last train out of Ohio that passed through Union and Confederate territory. They both died one year later and were buried in New Orleans a few months after the Battle of New Orleans in April 1862.

Mary Martin and her husband, Lucien, purchased the house in 1903. When a friend or visitor from the South suggested that a house as grand as theirs would be called a "hall" in the South, Mary changed the name to Concord Hall.

The Fox family purchased the farm in 1954 and began restoring the buildings. They converted the lower part—originally designed for cattle—into horse stalls since they enjoyed riding. Inside the barn, hand-hewn timbers still show the axe and adze marks of nearly two centuries ago, and the stone foundation, quarried on the property, is intact. Most of the barn siding is still original. Bob and Liz inherited the estate in 2004 and have maintained it well, staging fundraisers, celebrations and both of their children's weddings.

So, thanks to the Fox families, what the German captain left behind—a magnificent estate, manor house and timber-framed barn—are still not only surviving but functioning. In fact, the property is now listed in the National Register of Historic Places, a tribute to the wisdom and entrepreneurial spirit of "the Captain."

Perry County

The Round Barns of Perry County

After four days of touring barns in 2018, including driving through ten counties in Ohio's Appalachian region, I finally arrived in Perry County, my final stop. Four truly round barns, all within a few miles of one another, drew me here, but finding them was a challenge—going up and down gravel roads and making wrong turns, thanks to my GPS being out of range. However, I found three of them, all of which I liked. The fourth, called the Dornbirer barn, which looked intriguing from an old photo—a cupola, heavily fenestrated with windows and matching roof—was mostly collapsed. Too late.

The first barn belongs to Linda and Neil Cooperider. The original barn, built in the late 1800s, burned and was rebuilt in 1926. The owners explained that they hated to replace the roof, which had faded to a gorgeous golden color, but had no choice and installed an attractive one with brown shingles

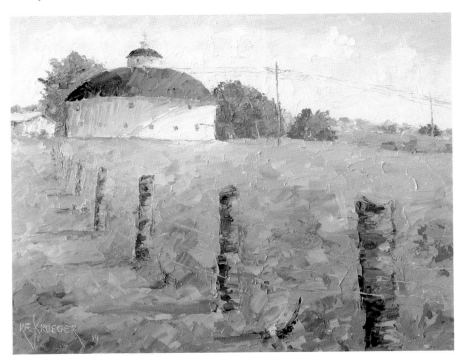

Perry County. *The Round Barns of Perry County*, Gilmore barn.

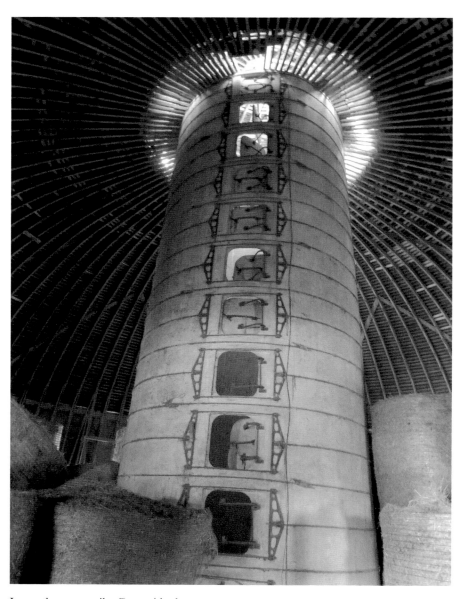

Internal concrete silo, Cooperider barn.

in 2018. And it's a working farm, raising hay on 270 acres and storing it—for beef cattle—in this beautiful round barn.

The Gilmores' was another beauty, on a farm founded by this family in 1917. As in the Cooperiders' case, this barn also burned down but was rebuilt in 1932, just as round barns were going out of style. It, too, seems to be in great condition, another Ohio gem.

But the barn I chose to represent the county, even though the others were just as worthy, is owned by John and Judy McGaughey, who acquired it in 1965. A gravel road leads up a hill and passes through a stand of trees to the white barn with its red metal roof, bleached by endless sunshine and visible for miles away. It was a composition that was difficult to ignore.

This originally was the Mott Thomas farm, dating to more than a century ago, perhaps even to Civil War times. Present owner Judy explained that this barn was built in 1909, about the time when round barns had become popular, and that the owners used it as a dairy barn, which the round barn was famous for since it could hold more stanchions than a conventional barn of similar size. Today, the family uses it for storage.

Its cupola needs help! Judy said that they can't find a repair man to climb up the roof to fix the standing seam. Perhaps by now they've found someone to solve their problem. A leaky roof has been the final nail in many an old barn's coffin. Hopefully this iconic Ohio gem won't face the same fate.

MORGAN COUNTY

The Snake Killer

Driving through Morgan County, a slice of Ohio's Appalachia at its finest, was the most adventurous expedition I had taken, topping even supremely hilly Monroe County. County Road 91—a dirt and gravel road, barely wide enough for two cars, full of hairpin turns, steep drop-offs and woods mimicking a national forest—stretched for three miles. Fortunately, no other cars challenged me on that early morning in September.

But the arduous journey was worth it, as the Farnsworth barn was a gem. After going down Richardson Lane, a private drive named after an ancestor, and then up a steep hill—making me wonder how anyone could farm here—I arrived at the 1836-built farmhouse, where I met Claire Richardson Farnsworth, along with her daughter, Grace, and her son-in-

Rare tongue-and-groove floor planks, circa 1820s.

law, Jim Gregg. After a chat, we drove down the hill and then up another one to look at the barn.

A three-story posted forebay barn, it was built in the late 1820s, a time when the typical pioneer family, building their first barn, would construct a small one, not one as large as this—sixty-six feet by forty-five feet. Another interesting feature was the construction of the floor. The two-inch-thick planks were connected via tongue-and-groove cuts, all made without power tools. Whoever the barn builder was, he had extraordinary skills—both in architecture and carpentry.

The family's history is rich in tradition, tracing back to Claire's great-great-grandfather David Smith. Over the centuries, the farm passed on to Curtis Richardson, father of Claire, the present owner. Her daughter, Grace, will be the next generation to own this farm and its well-maintained historic barn. Claire schedules an annual inspection and spent $30,000 on repairs in the 1990s. She still raises beef cattle, as the family did for years, although the barn previously housed horses and dairy cows. The third floor has two hay mows, the second floor has storage for grain and the lower level houses the livestock. The barn, now nearly two hundred years old, continues to function, another glimpse into the expertise of the builder.

But the painting's title must go to David Smith, the original pioneer, and a story about him, as reported in the *Zanesville Courier* on June 19, 1885. The writer visited the Blue Rock Quaker burial ground, only one mile north of this farm, and noticed the marble slab marking David Smith's grave: January 1864, aged eighty years, two months and eighteen days. His family were one of the first to migrate to Ohio from Chester County, Pennsylvania, and after he arrived in 1818, he stayed on the "river farm" before moving to the present location.

The writer commented on a tale about David's sense of humor. In the 1820s, this area was a wild place, booming with bears, wolves, panthers, deer and snakes both large and venomous. One of Mr. Smith's neighbors was terrified of snakes and was walking down a path where Mr. Smith had previously killed three large black snakes. Knowing that his friend would be passing by, he placed the snakes across the path and hid in the bushes. "In a short time his friend came by in a cheerful manner until he nearly stepped on snake #1. He gave a loud 'Oh' and jumped, nearly landing on snake #2. His alarm increased when he soon came on snake #3. He gave a loud scream and ran for his life. The snake killer leisurely strolled away."

Life in the pioneer days of the early 1800s involved working long days to raise crops and care for livestock, often requiring physical effort from both children and wives. Too often, folks think of those pioneer times as being all work and no play. Certainly the Smith family probably did a lot of hard work to make this hilly ground a productive farm, but thanks to this story, we know that they also had fun. Practical jokes have been around for a long time. Just ask any snake killer.

ATHENS COUNTY

Flight School

A sign titled "Red Bird Ranch" makes it hard to miss this large red bank barn, sitting on a rise adjacent to State Route 329. A large, ornate cupola, its red paint fading to gray, sits on the roof, and a tall silo stands behind it. Glenn K. Lackey, co-owner of the barn with his brothers, Ryan and Keith, and his mother, Lola Mae, said that his dad purchased the farm in 1973. These days, they farm nine hundred acres, growing soybeans, corn and hay and raising two hundred head of Black Angus cattle, housing them in their many barns.

Although this red barn formerly was home to a flock of sheep, today it's used for storage. But the farm goes back much farther, as the current farmhouse traces to 1844, probably built after the farmer became established.

The gray slate roof, though weathered and faded, still displays "G. Tedrow" and the date 1908. According to Glenn, this land baron owned the barn for more than seventy years. Even before that, there's more history here, in the form of the Miller Academy. This was the first secondary school in Athens County, started in 1841 by Amos Miller, who also built nearby cottages for those children who lived far away. According to the first volume of *Athens County* by W.E. Peters, often more than one hundred students attended. The academy continued until 1867. Many of its teachers were graduates of nearby Ohio University, Ohio's oldest, the first university chartered by an act of Congress (1787) and the first approved for the Northwest Territory (1802). The Ohio General Assembly established it in 1804, and it accepted its first students in 1809.

Although the academy represents a nice piece of Ohio history, the painting's title goes to the massive purple martin birdhouse, supported by four tall posts, that sits on a grassy bank in front of the barn. Glenn said that it contains six hundred homes for the birds. Its four pointed turrets add a bit of artistry.

Purple martins, cousins of barn swallows and colored in iridescent blue with tinges of purple, nest in man-made houses or gourds, hollowed with an opening; hundreds of years ago, the Native Americans may have made the latter to attract these birds. East of the Rockies, purple martins take advantage of such considerate bird lovers who position these houses high on stilts, hoping to encourage the martins to come back each year. Known for their predawn singing, feeding on insects, bathing in mid-air and graceful aerobatics, the birds, when approaching their houses, can descend at great speeds, tucking in their wings like a dive bomber airplane. These birds must have gone to flight school.

Glenn's father, Glenn F. Lackey, bought this fabulous birdhouse at an auction to surprise his wife, Lola, on their twenty-fifth wedding anniversary at least thirty years ago. He said it was built during the Great Depression by Lou Miller, an artisan living only a few miles away. Times were hard in those days, especially in rural areas, when this piece of art was made, reflecting the creativity and carpentry of someone trying to eke out a living. Even though Lola has never seen any purple martins reside in the house, the craftsmanship of Appalachia, as well as this old barn, remains. Who knows, maybe the birds will return next season?

HOCKING COUNTY

White Chickens

Hocking County, named for the scenic river that passes through it from the northwest to the southeast, is known for its famous Old Man Cave, majestic rock formations, gorges, cliffs and cascading waterfalls, all located in Hocking Hills State Park. On the eastern side of the county lies part of Wayne National Forest, which, with all three of its sections combined, offers more than three hundred miles of trails, covering 250,000 acres of forested Appalachia.

However, the county, despite its hills and plentiful trees, is full of old barns, many of which show their age. Barn scout Nyla, who helps run the Hocking County Historical Society, a complex of six museums, had located several old barns. The Mail Pouch barn was the most interesting.

Perched on top of a hill—as many old barns are in this county—this barn belongs to Tim and Sharon Keith, who've owned it since 2007. They raise hay and chickens on the fifty-four-acre farm and maintain the old barn, which dates to about 1900, evidenced by its saw-cut timber. Its Mail Pouch logo has faded but was probably painted by the famous barn painter Harley Warrick, who once said in an interview when asked about the nearly twenty thousand barns he had painted, "The first 1,000 were a little rough, and after that you got the hang of it." Although he officially retired in 1993, he continued painting barns, ending with the barn in Barkcamp State Park in his own Belmont County, painted in October, 2000, one month before he died.

Almost all Mail Pouch logo barns have good visibility from a main road, as this one does, which exposes the advertising message to folks driving by the barn. The only ones that didn't seem to pay attention were the chickens, which scooted by left and right as we toured the barn. Although most of the ones I see have a golden-brown color, these chickens were as white as snow and seemed to enjoy showing off their feathers, earning them the painting's title. Harley would no doubt approve.

SOUTH

These seven southern Ohio counties represent Appalachia at its best: curvy roads, hilly and bucolic scenes, crop land, livestock here and there, remains of ancient iron furnaces, covered bridges, quaint villages and, of course, countless old barns. In the 1700s, this land was a dense forest of hardwoods, a hunting ground of Native American tribes, including the Shawnees and Delawares.

For those suburbanites or urban dwellers who haven't visited these parts, southern Ohio offers a glimpse back into Ohio's early days. Four of the counties border the Ohio River, a drive that's earned a designation as an Ohio Scenic Byway, one of Ohio's twenty-seven such routes designed to teach history and provide a pleasant respite from city life.

PIKE COUNTY

The Bell

Although Pike County takes its name from Zebulon Pike, whose expeditions helped discover our western lands and whose name graces the fourteen-thousand-foot mountain in Colorado, this essay focuses on the Ohio and Erie Canal, which ran directly along the McClay farm before it was replaced by State Route 104.

The McClay family traces back to James McClay, who was born in 1829 on a ship bringing immigrants from Ireland to the United States. He fought in the Civil War as a soldier in the Fourteenth Pennsylvania Calvary, was captured and then moved to Ohio, where he began farming on this land in Pike County. But he didn't own the land, as was common in the early days; instead, he rented from the Starr family, who established the farm in the 1830s. Their family cemetery remains on the farm.

James had ten children, the youngest of whom, Orville, bought the farm in 1889 and passed it on to his son Albert. From Albert, the farm went to the fifth generation, Howard. Randy, generation number six, explained how the canalboats went past the farm and would ring a bell to announce a delivery or a pickup, which would involve crops being dropped from a platform directly onto the boat. They showed me one of the boat's bells, labeled "No. 4," which sparked my interest in this canal system.

In the 1700s, the Ohio country was a vast forest, leading one writer to claim that a squirrel, jumping from one tree to the next, could cross it without ever touching the ground. In the early 1800s, even after statehood came in 1803, Ohio wasn't much different. Farmers raised livestock and crops

Bell from an Ohio and Erie canalboat, no. 4, circa 1850.

primarily to support their families, and if they had a surplus, they'd barter for other needed goods. With the exception of a few cities like Cleveland and Cincinnati, cash was seldom used. In 1820, Ohio was a poor state. The Ohio and Erie Canal changed that.

It began close to Lake Erie in 1825, and two years later, the first thirty-eight-mile stretch between Cleveland and Akron opened. Since canal contractors paid cash to their workers, mostly Irish and Italian immigrants, many of whom died during construction, currency began to replace the barter system. In many places, the canal had to be routed past rivers and streams, requiring aqueducts to carry the canal over the water or a culvert to allow a small stream to be diverted under the canal. Completed in 1832, it connected Lake Erie with the Ohio River near Portsmouth and had 14 aqueducts, 203 culverts, 14 dams, 7 guard locks and 146 lift locks. It eventually cost more than $8 million and boosted the economy of Ohio to being the third most prosperous in the Union by 1840.

Goods from eastern ports—canals in the East preceded Ohio's canals—became accessible, and Ohio farmers could ship their farm surplus much more easily and purchase supplies at a far lower cost. Property values rose. Near the locks, Ohio entrepreneurs built gristmills, sawmills and woolen mills and founded quarries for the stone for these locks, many of which still exist. Taverns and stores came next. Realizing this potential economic gold mine, Simon Perkins founded the city of Akron in 1825, hoping that the sixteen locks along this stretch would spur development. They did. As the decades flew by, coal and iron ore made Ohio's northeast a major supplier of steel, adding industry to the agricultural face of the state.

Alongside the McClay barns, the canal, as elsewhere, stretched forty feet wide, its banks sloped at forty-five degrees and it had a depth of four feet. The first canalboat arrived in Waverly, the seat of Pike County, in September 1832. According to historian Jim Henry, James Emmitt formed a partnership with an elderly man to own a boat, buying it for $600. They added a brass bell to its deck. Try to imagine the boat captain ringing the bell as he approached the McClay barns.

The last Ohio lock, number fifty-five, completed in 1887, gave access to the Ohio River and cost $10,000. Ironically, only one boat went through it, making taxpayers wonder why it was built. By that time, improved highways and railroads had made the canal system less popular. The final blow was the great flood of 1913, which was so damaging that it effectively closed the canal.

Today, as part of the national park system, the Canal Exploration Center, located near Akron in the Cuyahoga Valley National Park, illustrates life on the Ohio and Erie Canal, preserving its rich heritage. So do the McClays' old barns and their rare canalboat bell.

SCIOTO COUNTY

Shawnee Turf

It was the land of the Shawnees, a nomadic tribe that migrated extensively along the eastern seaboard in the 1700s, following animal movement and eventually establishing what historians call Lower Shawnee Town in the early 1700s on the banks of the Ohio River near its confluence with the Scioto, a river named for the Indian word for deer hunting. By the mid-1730s, the settlement had become an important trading area with the French and the British. The great flood of 1753 wiped out the villages, which were rebuilt on the site of present-day Portsmouth, not far from this barn, located on the Ohio side of the river—on Moore's Lane—only a few miles west of the city. At that time, the Ohio country and Kentucky were thick forests, a communal hunting ground for many Native American tribes.

Levi Moore, after whom the street is named, as present-day owners Rhonda and Norma Blake explained, built this tobacco barn in 1835. However, saw-cut beam construction and lack of mortise and tenon joints, as well as a lack of venting slits, seem to indicate a date around 1900. Regardless, the Moore family were some of this region's first settlers and probably came down the Ohio on a flatboat, as many did in the late eighteenth century, a trip that involved the risk of an Indian attack.

One of the Moore clan, Philip Moore Jr., was born in Allentown, Pennsylvania, in 1761 and moved here after serving in the Revolutionary War. He built a stone house in 1797 that, well preserved, is now listed in the National Register of Historic Places and is open to visitors. Made from quarried sandstone from a nearby hill, the house served as a meeting place for Methodist circuit preachers and is known as the Cradle of Ohio Methodism. The house, located on State Route 239 and only a few miles from the Moore barn, was home to Philip's family, including one his sons, Levi, born in 1793.

According to his colossal grave marker at Portsmouth's Greenlawn Cemetery, Levi served as an ensign in the War of 1812 under a Captain

Humes and, after the war, returned to farm in Scioto County. Although he died in 1865, two of his children lasted to see 1900, a century after the family moved here. This barn's painting and essay—along with the stone house—will keep his memory alive as one of the early Ohio pioneers.

LAWRENCE COUNTY

Castle on the Hill

An article in the *Ironton Tribune* newspaper caught the attention of Kay Swartzwelder, owner of this barn along with her husband, Scott. Since hers was the most interesting response, I scheduled a trip that included my grandson Henry. Kay wrote that their farm was located close to Coal Grove, a village near the Ohio River, probably named for its coal mines, which were abundant in the nineteenth century in southern and eastern Ohio, along with numerous charcoal-fired blast furnaces, which were used to convert iron ore to iron, a significant factor in Ohio's role in the Civil War.

Since finding her farm might be difficult, we met Kay at Giovanni's Pizza—a restaurant that twelve-year-old Henry begged me to stop at—and followed her through some country lanes, finally arriving at the scene, which reminded me of the song "Castle on the Hill," written by Ed Sheeran and Benjamin Levin. We stopped at the base of the steep hill, which rises about one hundred feet, so that I could include a tall sycamore tree in the composition.

The barn was built around 1916, a date the saw-cut timbers affirm, but it wasn't until 1933, in the throes of the Great Depression, that Scott's grandfather acquired it. Eventually, the farm passed to Scott, who may someday pass family ownership to son Brandon, whom we met and who helped me select some of the barn siding, virgin poplar, for the painting's frame.

Kay came into the picture when she married Scott in 1992 and related a story about one of their horses, a beautiful Palomino mare that produced offspring every year. She was so special that she merited having her own stall, prompting the local vet to call her "Princess." She passed away a few years ago and perhaps would have been a good title for the painting if it weren't for the inspiring views from the top of this hill—miles of forests, fields and farmland, hilly enough to make one wonder how farmers could survive here in the 1800s. But they did, and they got to enjoy stunning sunrises and sunsets from this castle on the hill, a picture painted by Ed Sheeran's lyrics:

> *Found my heart and broke it here*
> *Made friends and lost them through the years*
> *And I've not seen the roaring fields in so long, I know I've grown*
> *But I can't wait to go home*
>
> *I'm on my way*
> *Driving at ninety down those country lanes*
> *Singing to "Tiny Dancer"*
> *And I miss the way you make me feel, and it's real*
> *We watched the sunset over the castle on the hill*

JACKSON COUNTY

Little Wales

Many settlers of the new state of Ohio came from Wales, either directly or from settlements in the northeastern states. One migration in 1818 brought

many Welsh families to southeastern Ohio, and another major one in 1839 brought so many that the area of Jackson and Gallia Counties became known as "Little Wales." Today, the village of Oak Hill maintains the Welsh-American Heritage Museum, the only one of its kind in the United States. And the population of families of Welsh descent in Jackson County is still a whopping 10 percent today. Who knows, perhaps a Welshman built this barn?

It sits on a hill some distance off a country lane called Sour Run Road, and it may not last long—its windows broken, siding weathered and boards missing, just perfect for a painting. When Henry and I visited the barn, we got a warm reception from an assortment of barking watch dogs, all chained, and a host of multicolored clucking chickens scattered about the path leading up the hill to the barn. On an otherwise quiet Sunday morning, they were pretty rowdy.

I considered walking up to inspect the barn, but one dog, whose chain was just long enough to allow him to block the path, didn't appear too friendly. Once in a while he'd back off, almost daring me to take a chance and hustle up the path. *No way, doggie, I prefer my pants untorn*, I thought. Instead, I looked at the barn from a distance, and judging from its appearance, I'd guess it was

built around 1900. Like many of the barns of Ohio's Appalachian region, this barn sits on a hillside, almost imploring Mother Nature to make the land tillable. Regardless of the unfavorable topography, the barn has survived, and even though it may be gone soon, it once played a part in Jackson County and its Welsh settlers.

VINTON COUNTY

The Jewels of Vinton County

Around a curve on County Road 21, also known as Shurtz Road, this large, immaculate jewel appeared almost out of nowhere. It stood there, close to the road, defying Father Time and resisting the advances of suburbia—a monument to an unknown barn builder, who constructed it in 1885, one of the earliest octagonal barns in Ohio.

I had tracked down the owner, Ronald Davis, through the county auditor and sent him a letter since he resides out of the county. He chose to respond via a handwritten letter, giving me permission to visit, paint and enter the barn, which I did. The interior was in good shape, and the saw-cut timbers—instead of hand-hewn beams, typical of barns in the 1880s—indicated that the builder had access to a sawmill close by.

Mr. Davis wrote that George and Kate Shurtz purchased the land via a government grant in 1837, possibly a Revolutionary War warrant, and established the farm. They became prominent and prosperous farmers in the region and farmed 640 acres, while a relative of theirs farmed 300 acres on adjacent land. Accordingly, the Shurtz name now graces the country lane that leads directly to State Route 93, one of the main roads in this rural county, Ohio's least populated.

The family's farming success allowed them to build a delightful Hansel and Gretel–like sandstone block cottage, which, according to Mr. Davis, who has owned the farm since 1965, had been broken into many times, once by burglars who stole all the antique furnishings. More recently, in July 2019, the cottage caught fire, most likely because of arsonists. The multicolored hexagonal slate on the roof must have been costly when the family built it in 1882. Fortunately, the white Gothic roof struts survived the fire. However, some of the roof has caved in, signaling that the end is near.

The family farmed the land, though hilly and wooded, and used the barn to house dairy cows, work horses and "buggy" horses, according to Mr. Davis. Eventually, the Shurtz sisters inherited the farm, and one of them, Minnie, a daughter of the original founder, was like a mother to Mr. Davis, who began working on the farm when he was fourteen. Since the sisters had no heirs, they gifted the farm to Mr. Davis, who had turned eighty-seven when I contacted him and who's not sure he'll be around to read about the barn in this book. "The Shurtz family were of the best quality people I have ever known. It was a pleasure to have known such nice people," he wrote.

Why does the title reference "jewels" plural? Yes, the octagonal barn is the main attraction, but it's only one of several impressive buildings. The barn across the road has a slate roof, a round steel corncrib still stands and a chicken house in the distance is well protected with a green metal roof. Sadly, the stone house, once a historic gem, is now in its last years, yet another link in this necklace of jewels—a memory of what was once a sparkling piece of Ohio history: the Shurtz family and their farm.

MEIGS COUNTY

Presidential

Courtney Midkiff, daughter of barn owner Cecil Midkiff, contacted me after reading an article about my barn project in the *Pomeroy Sentinel* newspaper. She wrote that her family has owned the farm since 1822, making them eligible soon to become a rare Ohio bicentennial farm.

After negotiating the twisting roads of Morgan and Athens Counties, I finally arrived at this simple English threshing barn, one used for hay storage and dairy cattle. The family leases out 75 of its 140 acres for hay and corn, some of whose orange- and ochre-colored stalks added to the painting's composition, as did the rustic barn siding, which Cecil supplied for the frame.

The original barn—used for hay storage, cattle and sheep—was burned by arsonists a century ago when they raided it for wool. Undaunted, the family built another barn in the 1920s, using hand-hewn beams, possibly reclaimed from the original barn, likely built in the 1800s.

Josephus Midkiff, the family patriarch, established the farm in 1822, now in its fourth generation of ownership in the form of Cecil and Millie Midkiff. Courtney and her brother are waiting their turns. She told me that many years ago, President William Howard Taft, a Cincinnatian who led the country from 1909 to 1913, visited the farm, at the time when the farm doubled as the local post office. Since the barn was rebuilt in the 1920s, Taft may have visited it then, when he was chief justice of the Supreme Court, an office he began in July 1921 and held until 1930. During his visit to the farm, according to family records, the Secret Service parked their car in the barn, honoring it and qualifying it as a "presidential" barn.

GALLIA COUNTY

Bob's Place

Nestled in the hills of another of Ohio's Appalachian counties is the Bob Evans Farm, which furnished the barn for Ohio's bicentennial logo painting and which, I thought, would be a good one for my Ohio Barn Project as well. Although I had planned a visit during the annual farm festival, which attracts thirty thousand people, I reconsidered, changing to a week earlier.

Even then, tents and trailers lined the grassy fields beneath the old barn and homestead as it prepared to host hordes of festival goers. My grandson Henry and I arrived on a sunny October morning, one with relatively few cars in the parking lot.

The farm traces back to the early 1800s, although not as far back as Gallia, the county's namesake. It's the Latin word for Gaul, as in the famous Latin phrase written by Roman Emperor Julius Caesar: *Gallia est omnis divisa in partes tres* ("All Gaul is divided into three parts"). Gaul, in Roman times, was the land where Spain and France are today. And since Frenchmen settled the county, they named it after their homeland.

In 1820, Nehemiah Wood established this farm, probably erecting a log cabin initially and then a small barn. He used clay bricks manufactured on site to build the Federal-style farmhouse in 1825; it served as the Wood family home as well as a stagecoach stop. This old barn, built in 1843, may have "recycled" some of the hand-hewn beams from the original small barn, which would have been dismantled to make room for a larger one.

The Wood family owned the farmstead for more than a century, ending when Harry Wood sold it to Rio Grande College in 1938. There the farm served as a self-help program for students, who worked on the farm to pay their college expenses. Raising crops and milking dairy cows showed them the value of hard manual labor. Bob Evans purchased the farm from the college in 1953.

Born in 1918 in Ohio's Wood County, where his father and uncle farmed, Bob Evans moved with his family when he was eleven to Gallia County to live near relatives. They settled in Gallipolis, a village on the Ohio River, where his father owned a grocery store. Apparently successful, Mr. Evans sent his son to a private boarding school, the Greenbrier Military School, from which Bob graduated with honors. He studied at Ohio State's School of Veterinary Medicine from 1937 to 1939 but married in 1940 and bought a restaurant called the Malt Shop in Gallipolis. When he entered the army in 1943, he sold the restaurant.

After serving in World War II, he returned home, where his father owned a farm. Still feeling the entrepreneurial spirit, Bob began making sausage, serving it in a twelve-stool diner he owned in Gallipolis in 1948. As he had become dissatisfied with the sausage he purchased, he began using only the best parts of the hog, which he slaughtered on his dad's farm.

After a few years of increased demand for his sausage in his little restaurant, Bob joined forces with business partners, founding Bob Evans Farms and buying the farm from Rio Grande College. His family lived in

the 1825 farmhouse, and next door, Bob built his new restaurant, another simple twelve-stool affair, which he named the Sausage Shop. Today, the restaurant seats 134, and it's busy—even outside of the annual festival.

Over the years, the company opened a total of four sausage plants to keep up with demand, and when local restaurants refused to buy his sausage, it launched its own, adopting the well-known brand of old-fashioned red and white "Steamboat Victorian" style. By the early 1970s, Bob Evans restaurants had expanded throughout Ohio, and today they're located in seventeen states—all corporately owned, ensuring consistency.

When grandson Henry and I toured the barn, a two-level bank barn, full of mortise and tenon construction, it was being used for storage. The old hand-hewn beams, probably from felled white oak trees nearby, still support this Ohio landmark. Formerly, the barn housed sheep and was used to dry tobacco, which was grown extensively throughout southern Ohio. The Ohio bicentennial logo, painted originally in 1999, sports a new coat of paint.

After our tour—with more counties to reach—Henry and I had to forego visiting the many other restored buildings on the homestead: the old farmhouse, a nineteenth-century coal mine, the working grist- and sorghum mills, the one-room schoolhouse, a rare two-story log cabin, another cabin built to house one hundred freed slaves, a few other pioneer cabins and the Revolutionary War cemetery, where veterans who settled this area are buried.

Bob Evans and his family are remembered in many ways, not the least of which are the many restaurants that bear his name. This barn, the many old buildings and the brick farmhouse called The Homestead, now listed in the National Register, is a fitting tribute to the Evans legacy. And I'm glad I had the opportunity to contribute with *Bob's Place*.

NORTHEAST

O hio's industrial northeastern tip is the state's most populated region, and though rich in tradition tracing back to the Ohio and Erie Canal, steel mills and coal furnaces, it has its share of historic old barns. But preserving them is a challenge, pitting agricultural land against industry, perhaps best illustrated in Cuyahoga County, where, despite the ever-growing metropolis of Cleveland, a piece of farming remains in the Cuyahoga Valley National Park. Thanks to the Countryside Initiative, where farmers can lease land from the national park system, several farms are alive and well. Akron's Summit County, known mostly for its iconic rubber tire production, abounds in old barns, as do Mahoning and Warren Counties, known mostly as the Ruhr Valley of Ohio. Medina, Portage, Geauga and Ashtabula Counties are quieter than their busy neighbors, with many Amish communities, maple syrup festivals, covered bridges and, of course, historic villages, homes and barns. And in Ohio's smallest county, Lake, another example of Cleveland's suburban sprawl, I was fortunate to find an old barn, perhaps the last one in the county.

MEDINA COUNTY

Longview Acres

As I drove south from Lorain County and through the northern part of Medina County, I was enthralled by the number of outstanding barns, making me hope that I'd be invited back for a full barn tour someday. David

Schmidt, a young man with a passion about his old barn, read about my project in *Ohio's Country Journal* and invited me to visit. I was glad to meet someone so young with such an interest in Ohio antiquity.

The name of this county traces back even farther than this imposing 1890s-era barn. In the early nineteenth century, New Englanders settled the area, and one of them, Elijah Borden, named the county seat Mecca but changed it to Medina when he discovered that Ohio already had a Mecca. The name Medina was taken, oddly enough, from the seventh-century Arabic town of the same name, located on the Arabian Peninsula in Saudi Arabia. A mosque in the center of the city is the burial place of the Islamic prophet Muhammad, making Medina an important Islamic pilgrimage destination, second only to Mecca.

This barn builder knew his trade, and the founding farmer wisely decided to cover the roof with slate, which proved to be a good investment. It's still there, along with the name of the farm, Longview Acres, displayed above the entrance. Massive saw-cut beams hold the barn together, and a lone cypress tree continues to watch over its flank, looking almost like a scene from Pebble Beach and its famous golf courses.

David said that the farm was formerly a dairy operation and that Richie Giachetti also owned it at one time. Richie, as you may not know, was the trainer of heavyweight fighter Mike Tyson, who polished his skills in this barn—boxing, not biting, skills, that is. David has owned the barn since 2015 and plans to save it, although this will be a long-term project since old barns require lots of work. Regardless, the original barn owner would appreciate the efforts of the Schmidts to preserve another piece of Ohio's past in Longview Acres.

SUMMIT COUNTY

Hartong's Heritage

While many old barns sit next to a road on flat land—almost featureless—others are compositions that are photographed often, such as this one, nestled in woods and fronted by a pond. Summit County, and in particular the City of Green, should be congratulated for preserving this part of its history.

It began nearly two hundred years ago when Moses Grable farmed this land. His father, Jonathan, bought it in 1839. The Grables worked the farm for twenty

years—some died and were buried here—and in 1859, they sold it to Cyrus Hartong. As many Germans did, the Hartongs moved here from Pennsylvania, where the patriarch, Jacob, was born in 1796. When Cyrus purchased the farm in 1859, his son Levi was fifteen. Ten years later, Jacob passed away.

Levi, one of ten children, was apparently a man of ambition, knowledge and fortitude. He constructed most of the buildings on this historic property, including the farmhouse and the barn, both of which date to 1883, when Levi was thirty-nine. The slate roof of the barn bears the date 1883, and a foundation stone reads, "L.J. Hartong, 1883." That must have been a good year for Levi and his family, reflecting their prosperity as farmers.

In July 2019, the *Akron Beacon Journal* reported that the City of Green was accepting proposals to allow a farmer to revitalize this historic farmstead, the first site in Green to be listed in the National Register of Historic Places. Countryside Initiative, a nonprofit started in 2015 that encourages responsible farming and offers attractive long-term leases, helped the city locate applicants for this property, including an 1883 farmhouse, summer kitchen, chicken coop and outbuildings, as well as the barn. In April 2020, the city granted a ten-year lease to a young couple, who plan to farm, live in and revitalize the Hartong estate. They'll bring the barn back to life.

And what a barn! Measuring forty-five by ninety feet, the timber-framed bank barn sits on a handsome foundation of tooled sandstone blocks. Decorative louvered vents dot all four sides. Facing eastward, the forebay allows sunlight to warm the livestock, whereas on the west side, an earthen ramp leads into the barn and its large haymow and granary. The City of Green should be congratulated on preserving this fine example of a barn built in authentic Pennsylvania Dutch traditions.

It's unlikely that Levi could have imagined that someone would paint and write about his barn nearly 150 years later, paying tribute to his skills not only as farmer but also as a businessman. Had he known, he would have been rightfully proud.

CUYAHOGA COUNTY

Tinker's Creek

The dictionary defines the verb *tinker* as to "work in the manner of a tinker especially: to repair, adjust, or work with something in an unskilled

or experimental manner." In trying to fix a watch, one tinkers with it. In trying to get the lawnmower to start again, one tinkers with it. This old barn, owned by David Wingenfeld, stands proudly above Tinkers Creek Road, which derives its name from Captain Joseph Tinker, principal boatman on a surveying party in 1796. Moses Cleaveland, head of the party and shareholder in the Connecticut Land Company, founded the city named after him, surveyed the entire region and also named a creek, the largest tributary of the Cuyahoga River, after Captain Tinker.

This barn is one of the few remaining in Cuyahoga County, which the gigantic city of Cleveland has nearly engulfed with homes, schools and businesses. Thanks to the Countryside Initiative, Dave, along with a few other farm owners, continues to farm in the historic village of Valley View in the southern tip of the county, a part of the Cuyahoga Valley National Park (with more than 2 million visits per year).

David purchased a farm, known as Swan Farm, on Tinkers Creek Road in 1975 and began organic farming, selling fresh vegetables and herbs to locals. An entrepreneur at heart, he launched a "cut your own" Christmas tree farm in 1995 and, in 2009, took a sixty-year lease on the historic Gleeson Farm, thanks again to the Countryside Initiative. This barn has become his Canal Corners Farm and Market, located down the street from his Swan Farm and not far from the Ohio and Erie Canal, adjacent to the Cuyahoga River. The Edmund Gleeson farmhouse, circa 1854, has been restored, thanks to the National Park Service, and is listed in the National Register of Historic Places.

After Dave showed me his large red barn, a Wisconsin-style dairy barn built into a natural hillside in 1905 by Edmond "Cub" Carey, the great-grandson of the farm's founders Moses and Polly Gleeson, he explained how he had repurposed the barn. Nowadays, the barn doesn't house dairy cows or their feed; it serves as an entertainment venue for a local theater group. No, the Lantern Theatre doesn't compete with the Blossom Music Center in nearby Cuyahoga Falls, but at twelve dollars per ticket for a night of family fun, it doesn't have to. Its founder, William Hoffman, coordinates production, and playwright Eric Schmiedl has written plays, including one about life on the Ohio and Erie Canal. Maybe he'll write one about Ohio's old barns someday.

Despite the rich history of Dave's farm and its buildings, the name of the road, Tinkers Creek, made me curious. The name traces back to medieval Europe, when the word described an itinerant metalworker who would travel from town to town, repairing metal pots and pans and other utensils. In

thirteenth-century Scotland and England, these folks were called "tinklers" and would make a dam out of mud or clay to cover a hole in a pot and then would pour molten solder to bind with the metal, repairing the hole. This became known as the tinkler's dam, later giving birth to the phrase, "I don't give a tinker's damn." The tinkers came to America too.

In the nineteenth century, a newspaper in Kingston, New York, reported that a local tinker known as Brandow posted a sign on the street next to his shop that described his services: "Eny 1 wantin ena thing fixt kin got it dun t' Brandows." He boasted he could fix anything, and even though his skills as a tinker were well known, one person viewed him differently: "Brandow was a necessary evil. People by no means liked his manner, but had to employ him....The tinker himself was a figure once seen, never to be forgotten.... He was a large man, dressed in whatever came in handy."

With online ordering, same-day delivery, self-driven electric cars and Internet search engines that can point the consumer to whatever he or she wants or needs, the days of such a character are long gone. Just like old barns, once essential but now nonfunctional money pits, the tinkers no longer travel from town to town. Perhaps this road was named after one. Perhaps he had a shop near the creek. Perhaps he was a robust, unkempt character like Brandow who could fix anything. Regardless, the street bears this name, a reminder of a bygone era, and that's good enough for the title.

LAKE COUNTY

Aunt Ruth's Perfume Factory

Lake County, established in 1840 and highly developed, is Ohio's smallest in land size, although it ranks eleventh in population. It's jam-packed with people, schools and businesses, and as one might guess, it also lacks the flavor of a rural county and its old barns. In fact, I had trouble finding one and finally decided to revisit *Ohio's Bicentennial Barns*, a book in which I found the barn painted in Lake County that was done in 2002. Thanks to the county auditor, I made contact with Dan and Jennifer Hearn, co-owners with Dan's mother, Nancy, and his uncle Thomas Carrig. Dan sent me a speedy e-mail reply. Yes, they were interested.

The drive north from the barn-rich country of Summit, Portage and Geauga Counties features a transition from forests, farmland and tractors

and into Lake County's suburbia—houses, buildings, hotels and, of course, Subways. This county, formed from acreage in Cuyahoga and Geauga Counties, has become a fashionable suburb of the Cleveland metropolis, Ohio's largest city.

Dan kindly took off a few hours from his work at Case Western Reserve University and couldn't disguise his enthusiasm for his barn, which still displays the Ohio bicentennial logo. When the Ohio History Connection approached Dan about the logo nearly twenty years ago, the barn was in poor condition. Although the Hearns didn't think they could repair it in time, the agent assured them that it could be done and drummed up support in the community to clear out brush and trees blocking the view, plant grass and give it a fresh coat of red paint. The church next door set up a refreshment booth in May and June for the volunteers as they revitalized the old boy. Schoolchildren got involved. Mentor, a top-notch Ohio suburb, proved that it has community spirit, finishing the cleanup a few days before the painter arrived. Scott Hagan's logo is still faintly visible.

Yes, the red paint had faded, the Ohio bicentennial logo was worn and an old add-on had collapsed, but the barn's foundation was strong and the roof, a new one added in 2011, was well maintained. Dan told me that his great-great-uncle, Frank W. Parker, and wife, Lizzie, founded the farm,

built the barn around 1912 and raised cows, horses and chickens on the tiny twenty-five acres.

Dan explained that his great-aunt, Ruth, turned the barn's upper level into her perfume shop after purchasing the business from the Grullemans, who imported fragrances from France and sold perfumes worldwide. Ruth mixed liquids, according to patented recipes, and filled imported bottles, marketing through ads in *Vogue* magazine. She also sold a variety of plants and flowers through the Wayside Gardens Catalogue. (Lake County is known for its fertile soil and is known as the Nursery Capital of the World.) So, not only was the barn fragrant with aromas of Ruth's perfume, but the yard was also a riot of colors, thanks to the many flowers and shrubs left over from the nursery business. When people would return products, instead of throwing them out, Ruth would plant them, including a sequoia and ginkgo tree.

Well, barns being barns, they smell like a barn should smell, thanks to the odors of livestock, manure and stored hay and crops. When one drives by a barn, if the wind is just right, he or she smells the familiar scent. But this one was different. Dan's gift of one of Aunt Ruth's tiny perfume bottles will accompany the painting in the fundraiser—anything to capture a piece of history. I'm sure Ruth would be proud that her barnyard perfume factory and its barn would be remembered.

ASHTABULA COUNTY

The Octagonal

Round barns—either circular or those without right angles, such as hexagonal or octagonal—are barns of the Midwest and are more predominant here than anywhere else in the United States. Unfortunately, fewer than a dozen good examples remain in Ohio. Many more can still be found in Indiana, Illinois, Wisconsin, Minnesota and Iowa, according to research in *Barns of the Midwest*, a book compiled by Allen Noble and Hubert Wilhelm. So, the few of these left in Ohio are rare gems.

Farmers initially built square- or, more often, rectangular-shaped barns to house their crops and animals, but due to articles proclaiming increased efficiency, round barns—also noticeably more aesthetically pleasing to the eye—began to flourish from the 1870s to the 1930s. In fact, a few came earlier: the first president, George Washington, designed and built a sixteen-

sided barn circa 1792–94 on his farm in Virginia. Reconstructed in 1996, the barn functions as a tourist attraction at Mount Vernon.

Another famous one still exists, the stone round barn in Hancock Shaker Village, located in western Massachusetts. Constructed in 1826, it's the only round barn built by the Shakers. Despite these two examples, this round shape didn't take hold in eastern states in the early 1800s.

The irony of the round barn, outlined in the 1853 publication *A Home for All*, was that this type of barn enclosed the most space per lineal wall of all shapes, leading one to think that it would be less expensive to build than a rectangular one. The reality, eventually discovered, was that it was more difficult for the carpenter to build and cost more than a barn of traditional shape. The author, Orson Fowler, felt that the octagonal barn design, easier to construct than a true round one, provided more space than one with square corners. More experts and writers, notably Elliot Stewart of New York State (who built one in 1874 and wrote about this novel barn), extolled the design of the octagonal barn, encouraging farmers to consider it. These publications planted the seed for such barns, and indeed some farmers began building octagonal barns in the 1870s and 1880s.

Carl Feather and Jeff Scribben, barn enthusiasts in Ashtabula County, took me here when the orange day lilies in front and alongside the barn were at their best, quietly posing for photos—a classic composition. Although we didn't meet the barn owner, we talked with a lady whose husband rents the farm from his father. They do organic gardening on one hundred acres. She agreed that the barn was special. In fact, with the exception of the restored and relocated barn in Amherst, it's the only surviving octagonal barn in northeast Ohio and the only one with original siding and in its original location.

Local legend dates the barn to 1865 and credits a Mr. Dewey for building it. The story goes that the owner imported blue glass from Belgium for the windows, with the hope that the glass would make the hay look green, thereby encouraging cows to eat it—even though hay dries to a beige color after being stored. Another theory is that the blue glass could have lessened the intensity of sunlight and helped prevent combustion of the hay and a barn fire. Today, several panes of blue glass are still evident, used instead of clear glass, which often had bubbles in it, a manufacturing defect. The bubbles could focus the sunlight—as a lens does—onto hay and ignite a fire.

Round and octagonal barns continued to thrive into the early 1930s. Even Sears and Roebuck got into the act in 1918, offering a kit to build an octagonal barn, along with other barn types, in *The Book of Barns: Honor-Bilt-Already Cut,*

a catalogue that offered fifty-six pages of barns, hog houses, chicken coops, granaries and other farm buildings. For $756, Sears provided all the lumber, pre-cut, framing timbers, hardware and paint for an octagonal barn. All the farmer needed was cement, a silo and labor.

Yes, this barn is old, but its three stories and its shingled roof are in good repair, which is the key to longevity. Once the roof leaks, look out! The farmhouse, not far from the barn, dates to 1848, hinting that this octagonal was not the first barn built here. Maybe the first one burned, as did four rectangular barns owned by New York's Elliot Stewart, convincing him to build an octagonal. However, like many other old Ohio barns, *The Octagonal* shows its age and needs maintenance, a cost that someday, sadly, may force the owners to dismantle it. Let's hope not.

GEAUGA COUNTY

Trophy Husband

Geauga County traces its name back to *Sheauga*, meaning "raccoon," a name the local tribes gave to the rivers in this part, notably the Grand River, which begins in this county and eventually empties into Lake Erie. The local historical society put me in touch with Dee Belew, an enthusiastic barn owner.

Despite April snow flurries, not heavy enough to coat the roads of Portage or Geauga Counties, I arrived on time—after all, this is northeastern Ohio, and it's known for snowing in April. The weather didn't seem to bother Dee either as she hopped down farmhouse steps to welcome me as I finished making notes in my car. While we talked, I marveled at the energy of this tiny lady, in her early seventies, who rattled off facts and figures faster than my brain could process them. She told me that there was another interesting building on their farm: a 1910 sugar house, nestled deep in forested land. Geauga and Ashtabula are the most productive counties in Ohio, which ranks fourth or fifth nationally in maple syrup production, although it had earned first place in 1840. Dee gave me some of her maple syrup.

She also shared with me that her barn, built in 1884, was used originally for dairy and livestock and probably some crop storage, indicated by the colossal concrete silo. A 2001 "Barn Again" tour included barn expert Chuck Whitney, who was impressed because the builder used an open

ramped entrance instead of an earthen bank, which is the usual approach to the top level on a bank barn. Highland County's *Hunting Mushrooms* also has an open ramp, but they're rare.

Dee and I were about to enter the barn when a head popped out of an adjacent building, a modern sugar house, where the fellow had been boiling the sap. "That's Bill, my husband," Dee said. I didn't say anything but took a closer look at this chap, clad in a winter jacket, a brown knit cap and wearing a beard, which was mostly dark brown with a few specks of gray. He looked to be in his early fifties. As I looked back at Dee, she said, "I know what you're thinking. Probably my son, right? We get this all the time. Grocery stores. Shopping malls." By this time, Bill was grinning and Dee was laughing. So I asked Bill how old he was. "Seventy-two," he said, which completely baffled me. It reminded me of Ketchum, Idaho—Hemingway territory—where many affluent seventy-year-old men have acquired attractive thirtysomethings as wives and girlfriends, colloquially known as "trophy wives." But in the Belews' case, the table had turned. So I asked them if I could take their photo for future reference in case I forgot how young Bill looked. These two lovebirds have been married more than fifty years. Refreshingly stable.

Dee showed me the inside of the massive barn, still surviving 135 years later thanks to a metal roof and hand-hewn timber framing, cut from hardwoods that once covered this land. The farmer/barn builder probably had a sawmill on the property, either rented or permanent, since, as Dee said, the previous owner passed down the story that kids used to play in the mountains of sawdust for ten years after the barn was built. Sounds like fun.

Dee and Bill Belew, barn owners.

Geauga County is full of old barns, some deteriorated and others repurposed. On my drive north, I passed Legend Lake Golf Club, which caught my attention since three massive brown-tiled silos towered over a former barn, now converted into the golf clubhouse, which made me want to return for more barns in Geauga County. It would be another reason for me to see Dee again and her "trophy husband."

TRUMBULL COUNTY

The Klondike

Every now and then, there's a barn that not only is outstanding architecturally but also has a good story to tell. This is one of them. Thanks to an article in Warren's *Tribune Chronicle*, Jeff Mathews, owner of this barn along with his wife, Bonnie, forwarded information about his barn and a story about its former owner Frank Reed.

Frank built this barn in 1885, although it may not have been the original barn since a nearby farmhouse from 1855 burned down in 1963. Anyway, Frank must have been a prosperous farmer as well as a good businessman to be able to afford to build this sixty-by-one-hundred-foot-long bank barn with a slate roof. The nearby milk house, circa 1885, also bears a slate roof. He could have used the conventional wood shakes for the roof, but Frank wanted durability, as well as a little extravagance. Perhaps flaunting his wealth, Frank put his initials, "F.H.R.," on one section of the roof, another expense, as well as putting his full name, "F.H. Reed," on another side. Life must have been pretty good for the Reeds in the 1890s…at least until Frank disappeared.

Yes, he vanished in 1898. Was he kidnapped? Murdered? No. Frank left—without telling a soul—for the famous gold rush in the Klondike of Canada's Yukon, a long journey of more than 3,500 miles. One year later, he sent a letter to his wife explaining his strange departure, telling her that he wasn't coming back and instructing her to sell the farm and keep the proceeds. Following orders, she sold it in 1900, and ten years later, Jeff's grandfather James Mathews bought the farm, two houses and the entire 240 acres for $20,000, a large sum in those days. It's been in Jeff's family ever since, but unfortunately, since its upkeep doesn't justify keeping it, Jeff and Bonnie are looking for someone to repurpose this piece of history.

Back to Frank. Why would a prosperous farmer leave his wife—and children if they had any—for a place so cold, so far away and so full of uncertainty? Was it for financial reasons? His farming business appeared to have been robust. Did he think he'd make a fortune? Or perhaps he wasn't getting along with his wife. Frank must have read the newspaper and magazine articles about such an adventure, written in romantic fashion, and might have been struck by wanderlust, that syndrome that affects many today, well documented in such magazines as *Outside*. For such an adventure to be worthy, it must involve the risk of death. Canada's Yukon qualified.

Traveling to the Yukon in 1898 involved peril. And Frank wasn't the only one lured by the thought of finding gold and striking it rich. About 100,000 people joined Frank in the hopes of instant wealth in the frozen tundra of the Klondike region of Yukon Territory. Few found it. Those who got there early had the best chance: the first gold discovery came in August 1896. When newspapers in Seattle and San Francisco reported it, the stampede of prospectors began in the following year.

But getting there was only the first hurdle. The arduous trip was so expensive that Canadian authorities required each person to bring a year's supply of food, which meant weight—sometimes nearly a ton of food and provisions, which had to be transported across rivers and over mountains. Costly. So, Frank must have known about this and must have been prepared.

Winter in the Yukon—with temperatures dipping to forty or fifty below zero—can last from September through April and May, and digging through permafrost was yet another challenge. Founded at the confluence of the Yukon and Klondike Rivers, Dawson City, the heart of the gold rush, had a population of five hundred in 1896. By the summer of 1898, the year Frank disappeared, it had thirty thousand residents and a host of new buildings—saloons, roadhouses, hotels, stores and even brothels. One old photograph shows a line of hundreds of men waiting to get into the post office. Was one of them Frank, preparing to mail his letter of instruction to his wife? Thousands of letters would arrive in a single shipment; with one person sorting them, this meant that people would have to wait in line for days.

Despite the temptation of instant wealth, only about one-third of the 100,000 ever reached Dawson City. Many turned back, out of money for the trip; some died on the way; and others moved on to new gold fields, such as the one in Nome in western Alaska. Others got rich, either by transporting prospectors or supplying miners with goods, which were priced high—a one-pound bag of salt commanded $28 ($760 in today's dollars), a can of butter sold for $5 ($140) and a single egg cost $3 ($81) in the spring delivery

of 1898. It was a classic case of supply and demand. The Yukon's gold rush fizzled in 1899, and gold was last mined there in 1903.

No one in Ohio ever heard from Frank Reed again, and even though his famous letter has been lost, the story has been passed down from one generation to another, each reminded of this fascinating farmer by his initials still branded on the barn's roof. Jeff mentioned that some of Reed's relatives from Texas visited the farm in the late 1980s to see the barn, and they verified the tale.

Jeff told another story, this one involving the Great Depression. In those bleak years, a railroad line ran directly behind the barn. From time to time, hobos would hop off the train, looking for food and shelter. Jeff's grandfather, a kindly man, would look after them, but not before taking their cigarettes away. If they stayed, they had to work on the farm. One did stay: Lee Yippy, who worked on the farm for twenty-five years before leaving in 1960.

The barn and its outbuildings are impressive. Slate covers the many roof lines of the main barn, the milk house and the octagonal silo, built

Bonnie and Jeff Mathews, barn owners.

by the Mathews patriarch in 1915. Few silos have a hexagonal slate roof. The decorative cupola is more than just showy; it accommodates the pulley system for large hay forks. The track and trolley are still in the peak of the barn. The lumber, both hand-hewn and sawmill-cut, continues to defy Father Time, still supporting the barn, whose days are numbered if no one comes forward to salvage this beauty.

Inside, forty-two stanchions for dairy cows as well as other stalls for young livestock and horses hint at what was farmed here. Jeff raised beef cattle until 2015. He and Bonnie also showed us a wooden model of their barn made by an artist in Tennessee, which means that even if the barn is dismantled someday, they'll have this replica, this painting and this essay to keep the memory alive. Surely Klondike Frank would approve.

PORTAGE COUNTY

The Portage Path

Leianne Heppner, director of the Summit County Historical Society, spotted this photogenic beauty and provided contact information about the owners, Lynne and her husband, Ronald Bensinger, who bought the farm in 1999. When asked why they chose a rural setting, Lynne said, "It seemed like a good place to raise five kids." After observing the benefits of raising children on a farm, I'd have to agree with that.

The scene was one that photographers dream about: a road winding up and curving toward the farmhouse, a pine tree to the left and a tilted wooden fence to the right of the road, an old water wheel and two silos towering over the barn, its weathered red paint streaked with gray. All old barns deserve such charming compositions. The weather was another matter.

For April, the day was chilly, one with snow flurries and a wind chill well below freezing, but Lynne was gracious enough to provide some history. She said that they don't know much about the original owners except that house was built in 1900, as was the original barn, which burned down in 1920 and was rebuilt. Inside, the timber is saw-cut, and there's a basketball hoop, probably reserved for play time after farm chores were done.

But the area goes back much further. The county takes its name from the famous Portage Path, which connected two rivers, the Tuscarawas and the Cuyahoga, a trail that the Native Americans used extensively before settlers

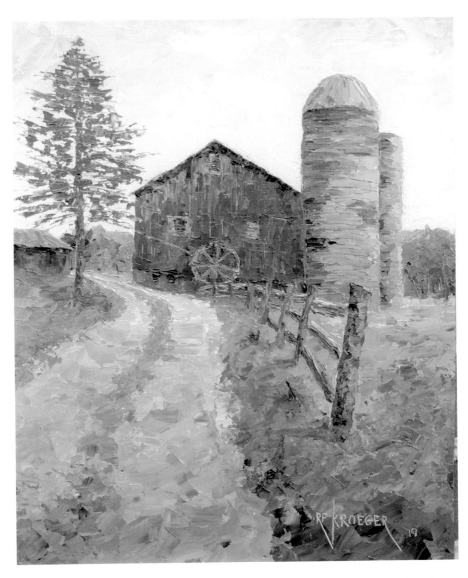

arrived. Indians would carry their canoes from one river to the other, hunt and camp along the way and pass by a large gray sandstone rock, called Standing Rock, which juts out and rises twenty feet above the Cuyahoga River. The Seneca, Ottawa and Chippewa tribes lived and hunted here and would hold meetings at this sacred place, which they called "Council Rock." Indian families, in passing, would construct a small ladder to the top of the rock and place a piece of bark, indicating the direction they took.

Initially, the French occupied the land, but when the French and Indian War ended in 1763, they ceded this territory to the British. Later, it became part of the Connecticut Western Reserve, which the Connecticut Land Company purchased in 1795. Portage County was created in 1807.

Even though the county bustles with homes, businesses and a well-known university, its name will always reflect the image of breech-clad Native Americans carrying their birch-bark canoes, moving from river to river, in search of food and shelter, on feet covered only with moccasins.

10

MIDDLE EAST

O hio's middle eastern region combines a host of cultures, ranging from the Amish lands of Wayne and Holmes Counties—one of the largest such settlements in America—to the open-hearth furnaces of Youngstown's eerily quiet steel mills. Farther south, Appalachian Ohio begins with the rolling hills and wooded forests of Columbiana, Carroll and Jefferson Counties. Regardless of the diversity of economic engines, this section of Ohio abounds in old barns—from early Ohio pioneers to one recent repurposing, a conversion of an old barn, now renamed the Yellow Butterfly Winery, a task undertaken by none other than a former mayor of Cleveland.

HOLMES COUNTY

The Hayrakers

Everyone works hard on a farm in the Amish community. And that often means doing something the old-fashioned way, without modern machinery—like cutting hay fields in mowing machines pulled by draft horses.

Two Amish ladies, standing on top of mowers and holding the reins of handsome draft horses, zigzagged left and right as they cut the field of hay adjacent to their large barns. One dressed in yellow and one in blue—both dresses made by hand—lending a pastel-like atmosphere to the scene. The

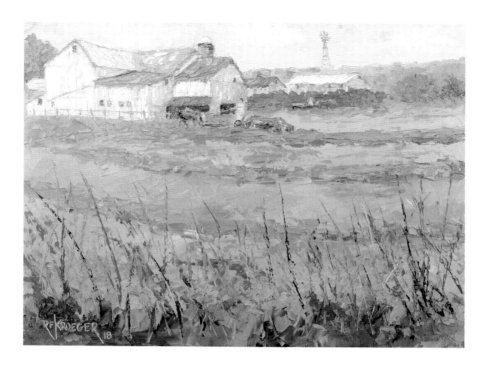

mother in blue must have thought that it would be a good idea to have her son along—as he stands behind her on the wagon—to show him the "ropes" of haycutting, a task he might soon be doing.

Holmes County, a tourist destination in Ohio, draws hundreds of thousands of visitors each year and shows that a life of old-fashioned living has its advantages. Visitors are guaranteed to see Amish and Mennonites dressed in traditional garb, sitting in black horse-pulled buggies and talking in a German or Swiss accent. Lots of them.

Although Lancaster County, Pennsylvania, initially held the lead in raw numbers in Amish communities in America, Holmes and surrounding Ohio counties—Portage, Geauga, Medina, Stark, Tuscarawas, Coshocton and Wayne—have far surpassed it. And being good businessmen, the Amish have built many facilities to entertain, house and sell their wares. It's a popular destination, although many don't realize the sacrifices Amish ancestors made centuries ago.

Spurred by religious persecution, Mennonites immigrated to America as early as 1683 and settled in Pennsylvania, courtesy of the Quakers. William Penn, a wealthy Englishman and a Quaker, traveled to America in 1681 to take possession of a large tract of land that King Charles II awarded to pay

the king's debts to Penn's father. He planned the city of Philadelphia—a combination of the Greek words *philos* and *delphos*, meaning "brotherly love"— and established the colony of Pennsylvania. He invited fellow Quakers from England to join him in the New World, as well as those from other faiths who were likewise persecuted. The Anabaptists—the Mennonites, Amish and Brethren—followed. Others came in the early 1700s, although the journey was perilous, often beginning with rafting along the Rhine River, sailing from a port city such as Rotterdam and finally reaching a coastal town in England, ten days to a month later. Crossing the Atlantic took much longer, sometimes up to twelve weeks, and strong storms and winds, coupled with cramped living quarters, took their toll: 50 percent of children under seven died. However, the lure of religious freedom kept them coming. And with them, they brought their superb timber-framing skills, felling tall hardwood trees and hewing them to erect barns and farmhouses, many of which are still standing two hundred years later.

At first, in British America, they could not own land and became tenant farmers, although landownership changed after the American Revolution. In time, the Amish moved west. In 1809, Jonas Stutzman, the first of the Amish to arrive in Holmes County, built a log cabin and began farming. An Ohio historical plaque marks the spot.

Other families followed, and many of the present-day Amish in Holmes County can trace their lineage to names such as Troyer, Miller, Yoder, Hershberger and Shrock. They continue to maintain their traditional life, keeping a deep sense of community, and they never forget the sacrifices made by their European ancestors. "The Hayrakers" shows one aspect of their non-electronic lifestyle, eschewing a modern tractor for a horse-pulled mower. Another look into Ohio's past.

WAYNE COUNTY

Johnny's Legacy

In the spring of 2018, I visited the Blue Barn Winery. It was pouring again. *No problem*, I thought, *the rain would give me a chance to chat with the owner*. Brett Urian greeted me in the parking lot, offering an umbrella as we escaped the rain inside the farmhouse. It was "a pioneer house," as declared by a metal plaque on the brick wall—"More than 100 years old, 1834, Wayne County

Historical Society." Another plaque, not far away and also awarded by the society, reads, "County Historical Landmark, Blue Barn, 1868." It was nice to see historical preservation being recognized.

Brett and his wife, Marcia, have worked magic in this old farmhouse, bringing out its charm and keeping its rustic flavor but not modernizing it too much. Although the original farmer remains unknown, according to records that Brett found in the county office, the blue barn was present in 1868, not long after the end of the Civil War. Perhaps they painted it "Union" blue, a highly unusual color for a barn, to honor the many Ohioans who gave their lives in that bloody conflict.

Brett, who owns an environmental cleanup company, moved here to escape city life and relax in the peace and serenity of rural Ohio. He and his wife also liked the idea of restoring an old barn and farmhouse, goals that they have accomplished. In 1999, when they purchased the farm, the bank side of the barn had caved in, requiring major work. But unlike many old barns, this one didn't require a new roof. In fact, the roof may be the original, made of tin shingle plates, which rarely last more than one hundred years, unless painted on a regular basis. Thomas Jefferson advocated this type of interlocking tin shingles and used it on his mansion, Monticello, which he began building in 1769 and finished in 1808.

Inside, there's evidence of local sawmills—all the beams are saw-cut—somewhat unusual in an Ohio barn this old, when hand-hewn timber was the norm. Brett guesses the barn may have been used for dairy cows, crops and hay. The livestock were kept downstairs, and grain was threshed upstairs.

Even though neighbors remember the barn always in blue, when Brett had it repainted, he found white paint underneath the original blue. Some of the old-timers said that it was painted blue as a symbol of patriotism around the time of World War I. So, perhaps this barn honored both the Civil War vets and those of the First World War.

A few years after the Urians moved in, a neighbor, Andy Troutman, suggested that they turn their barn into a winery. Brett told me that he hesitated, not wanting to compete with Troutman Vineyards, a short jog down the road. But Andy reassured him, believing that two wineries would attract more tourists than one could, and that would mean better business for both. So, Brett studied, took classes and became a winemaker, planting the vineyard in 2008 and turning "old blue" into a vibrant scene, one with live music on most weekends. The Blue Barn Winery has given an old barn a new purpose!

Today, they have five labels—Barn Dance Red, Barn Dance White, General Wooster Red, Lady Wooster White and Rumspringa. The last one,

named in honor of Brett's Amish friends, conjures up the time when Amish young people are given a chance to "taste" life outside the community before deciding to join. The two Woosters, whose name was taken for the Wayne County seat, revive the memory of Major General David Wooster, a 1738 Yale grad and a hero in the American Revolution, the only American general to lose his life in the war. His wife, Mary, daughter of the president of Yale, may have been a spy for General Washington after the death of her husband. Possibly because of this and because her husband had won victories, in 1779 British troops attacked New Haven, targeted Mary's home, abused her and destroyed her furniture. Actions like that spurred Connecticut Loyalists to enlist on the American side. Even though in her later years she became destitute and had to appeal for relief aid, she is remembered in the Mary Clap Wooster Chapter of the Daughters of the American Revolution, which was organized in 1893 and is based in New Haven.

Although the wine labels honor the past, the real story, as related to me by Brett, involves a fellow who probably walked here—passing the farmhouse—in the early 1800s, preferring walking to riding, showing his love for his fellow creature, the horse. The dirt path, today's Ohio Route 3, was formerly an Indian trail, and the farmhouse was originally a trading post. This fellow was Johnny Appleseed, a real person—not a folklore legend like Paul Bunyan, Pecos Bill or John Henry. And yes, he might have walked here in front of Brett's farmhouse, barefoot.

John Chapman, his real name, born in 1774 in Massachusetts, was a child during the American Revolution. He died in Fort Wayne, Indiana, in 1845. After his father served in the war, he brought his family of twelve children to Ohio in 1805. John was thirty-one then, but he started his life's work much earlier, working as an apprentice in an apple orchard, which is how he learned the trade of nurseryman.

Popular image depicts Johnny, barefoot and raggedly dressed, tossing apple seeds along the roads wherever he walked. Close, but not quite right. Using his knowledge from working in an orchard, he planted trees in nurseries, put fences around them to protect the plantings from livestock and deer and left them in care of a local, who sold the trees on a sharecropper basis. Johnny returned every year or two to tend the nursery, which he owned. According to Brett, he also allowed the sharecroppers to live, rent-free, as long as they would care for animals, notably the horses that he rescued. Johnny was not only an early environmentalist but an animal rights person as well.

He started his nursery business in Warren, Pennsylvania, a small village founded in 1795 alongside the Allegheny River and bordering today's

Allegheny National Forest. From Pennsylvania, he moved to Ohio, starting nurseries in Ashland, Richland and Columbiana Counties. Along with seeds of apple trees, Johnny also spread the gospel of the Swedenborgian church both to white settlers and to Native Americans, who respected him, feeling that he was someone who had been touched by the Great Spirit, according to Jeffrey Kacirk in his book, *Forgotten English*.

By the time John died in 1845, even though the financial crisis of 1837 had affected his tree business, his sister received, in his will, 1,200 acres of nurseries in Ohio and Indiana. According to Brett, the sharecropper of some of the nurseries often was able to buy the land by paying the taxes owed.

It's fun to think that perhaps two hundred years ago, Johnny Appleseed stopped in at this trading post on the old Indian trail, preached a little and, in return, got a hot meal and a room for the night. Anyway, Brett and Marcia continue the tradition by caring for horses and donkeys that have been rescued—saving them from the glue factory and honoring Johnny's legacy. Even though he's long gone, his spirit lives on.

STARK COUNTY

Espana in Ohio

Driving north on Route 62, leaving Holmes County, entering Stark County and heading toward the village of Navarre, I spotted two old forebay barns, both alongside the road and only a quarter mile away from each other. They appeared so similar, making me wonder if they were built by the same person.

Oddly enough, Ohio's Navarre takes its name from a city in Spain, the home of the Basque Spaniards, the ones who continuously yearn for independence. They've always been tough people, going back to the seventh century, when neither the Franks nor the Visigoths could conquer them.

Located in northern Spain on the southern slopes of the Pyrenees, Navarre is probably best known for its capital of Pamplona, home of the annual running of the bulls, which dates to 1592. This festival commemorates Saint Fermin, a third-century bishop native to the region who was martyred by being dragged through the streets of Amiens in France by a bull. Today, daring young Basques continue to show their bravery by dashing down the city's narrow streets while the bulls charge.

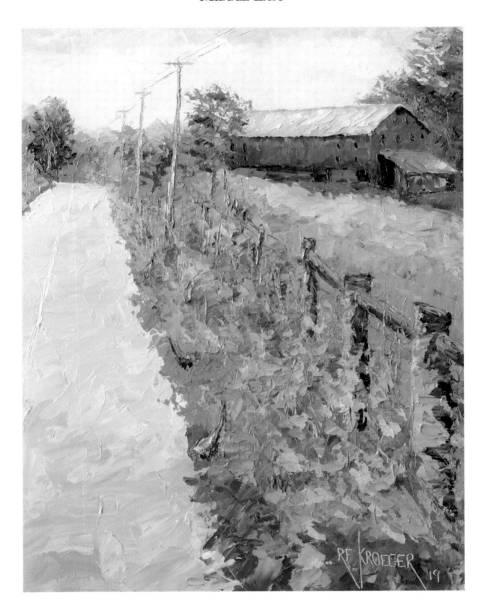

A missionary, Reverend Christian Frederick Post, built the first dwelling in this area in 1761: a log cabin, not far from the banks of the Tuscarawas River. And later, in the mid-1800s, three small villages merged into Navarre, although the person who named it after its Spanish sister city has long been forgotten. In the 1830s, immigrants built the Ohio and Erie Canal, a

waterway that brought prosperity to Ohio and one that has been resurrected from parts north to Cleveland and throughout this region.

The two forebay barns almost touch the road, as many old barns do today, which made it easy for farmers to load their wagons and proceed onto the dirt road for deliveries. A gent mowing his grass across the road said that the Bowers family owned the barn for many years, but it had recently changed ownership. Its intact slate roof and construction suggest that it was built around 1900. The forebay design, a German innovation, protects windows, doors and farm animals in inclement weather, as well as provides additional storage for hay. No, there weren't any bulls in the pasture.

MAHONING COUNTY

Peter Pan, Wendy and Tinkerbell

Old barns sometimes tell a compelling story. However, once in a great while, the barn reveals multiple looks into the past, as this one does, the one I've come to call "the Peter Pan barn."

This barn, located many miles from Youngstown's once-famous steel mills, lies in the southern part of Mahoning County, where farming was the main economic engine, as it was in the adjacent Appalachian county of Columbiana. Sandra Ciminero, current co-owner and resident of this farm, told me that her grandfather Ralph E. Elser purchased the farm around 1921, although the farm traces back into the 1800s, as evidenced by a pile of hand-hewn beams scrapped from an older building. According to a 1925 Elser reunion notice, a century earlier George Elser, the farm's founder, traveled here with his family in a covered wagon drawn by two oxen.

Ralph, one of George's ten children, became the school superintendent of Mahoning County Schools and, for some reason, decided to take up part-time farming in the 1920s, building this barn with red oak taken from trees in the adjacent woods. The beams are saw-cut, indicating there probably was a sawmill on the grounds. For many years, he farmed his thirty acres, raising grain, horses, sheep and Berkshire hogs that grew rapidly, weighing more than 230 pounds after only six months.

Even though Ralph spent his weekdays in school, he was a proficient and committed farmer, proved by a notice that Sandra provided. It advertised a public auction in June 1945, a short three months before the end of the war,

Sheriff Ralph Elser and his prize hogs, 1940s. *Courtesy of Sandra Ciminero.*

and it included many items for sale. The midsize barn, which Ralph built during years of the Great Depression, was not large enough to hold two seasons of crops and livestock, making such annual farm auctions practical.

By 1935, Ralph must have grown restless again, winning election to Mahoning County sheriff, a post he held for fourteen years. His first challenge was one of Youngstown's most serious problems: the Mafia. During the late nineteenth century, Italian immigrants flooded northeast Ohio and, with them, a small percentage of Sicilian mobsters. They flourished during the Prohibition years in Youngstown, possibly motivating Mr. Elser to run for sheriff.

As many know, decades of corrupt Youngstown public officials—including police chiefs, mayors, county prosecutors, sheriffs and even a U.S. congressman—helped to bestow on Youngstown the moniker of "Crimetown U.S.A.," a title penned by John Kobler in his March 1963 article of the same name published in the *Saturday Evening Post*. However, Sheriff Elser wasn't one of those gangsters. He resisted the mob's bribes and political contributions and won election after election. Online archives reported that as early as 1936, only after a year in office, the sheriff sent deputies on raids

PUBLIC SALE On Ralph Elser Farm
Sharrott Road, North Lima

SATURDAY, JUNE 2, 1945

Beginning at 1:00 P. M.

HOGS
18 BROOD SOWS.

HOGS
60 SMALL PIGS

Horses -- Cattle -- Sheep -- Farm Machinery -- Grain

Ralph E. Elser, Owner.

Paul E. Wright, John S. Morris, Bert E. Durr, Auctioneers.
W. O. Troyer and Ray Elser, Clerks.

Sale notice, 1945. *Courtesy of Sandra Ciminero.*

to Youngstown nightclubs and bars to close down gambling. His policemen conducted one such raid at 2:15 a.m., arresting Dominic Prato and Victor Fusillo. Apparently, the sheriff was determined, even though one day he was shot at when leaving the farm. Luckily, the shooter missed.

But a much more violent problem came a year later in 1937, when, as the country was emerging from the Great Depression, steelworkers and their unions wanted a bigger slice of the pie and weren't afraid to use force. It was called the Little Steel Strike of 1937—the "little" referring to small steel companies like Youngstown's Republic Steel, Sheet and Tube and Inland Steel. A larger strike began earlier in Chicago at the Republic plant, where a skirmish broke out between picketing workers and police, ending with ten protestors dead and many more injured, including thirty-five police. It became known as the Memorial Day Massacre.

Meanwhile, in Youngstown, striking steelworkers continued to picket and confront policemen. On the evening of June 9, 1937, Sheriff Elser, not one to back away from conflict, became involved. Angered that a food truck escorted by police had breached the picket line and entered the steel plant, about five hundred strikers rushed to the scene and attacked the fifteen police guarding the gate. Quickly they sent word to Sheriff Elser, who was only a few blocks away. He responded at once, bringing fifty of his deputies in armored trucks and firing tear gas, which dispersed the crowd. For actions like this, the sheriff earned the title "Strikebreaker."

However, the strike continued, more were killed, the governor intervened and eventually President Roosevelt became involved, ordering the National Guard into action. Dealing with steel strikes, along with Mafia problems, was how Ralph Elser began his career as sheriff. Farming undoubtedly took him away from such troubles and provided some peace and quiet.

Ralph Donald Elser, the sheriff's son, took over the farm in the late 1940s and raised four daughters, one of whom, Sandra, provided the story that earned the painting's title. In 1955, Sandra, around five years old; her eight-year-old sister Jeanne; and their sister Patricia, who was twelve—all budding actresses—put on plays in the barn. Patricia took on the role of Peter Pan and, grabbing a rope hanging from the rafters, swung through the air, as Wendy, played by Jeanne, and Sandra, as Tinkerbell, looked on. Sandra said that her parents were the audience: "Sure, they liked to watch us put on plays." But they never saw the two oldest daringly walking along the high beams. No safety nets in those days.

These enterprising girls also performed circus acts under a maple tree near the barn, entertaining neighbors and raising money for UNICEF. Patricia was the ring master, and Sandra was a lion. And they must have been pretty good since two of them went on to become actresses. Sandra, also captivated by the arts, earned degrees in art, studied at the Art Institute of Chicago and became an art teacher, a job she still loves. The fourth sister, Paula, who came along later, became the most involved in acting, still playing roles in movies.

Over the years, Sheriff Elser's descendants have maintained the barn well, including rebuilding a section of the foundation and, more recently, installing buried logs attached by steel cables. Thanks to these efforts, the barn, now nearly a century old, can continue to hold decades of memories, not only of the barn builder and the Mahoning County sheriff but also of three young girls—aspiring Hollywood starlets, flying through the air, walking along the high beams, enjoying their childhood and basking in the Neverland of youth. James Matthew Barrie would be proud.

COLUMBIANA COUNTY

Harvey's Heritage

The Firestone family moved to Columbiana County in 1828 and built a two-story brick farmhouse and a large bank barn. They were German farmers

and knew how to work the land, growing oats, hay, corn and wheat and relying on a large flock of sheep for their wool, the family's cash crop. They continued to farm this land throughout the nineteenth century, but one of their children, Harvey Samuel, born in 1868, decided to leave the family farming business not long after this barn was built in 1880.

He attended business school but dropped out to become a bookkeeper. Not satisfied with that occupation, he worked as a salesman for a buggy company in Detroit, where he made friends with Henry Ford, who was experimenting with cars and was fascinated by speed. But Harvey lost his job when the company folded in 1896. Without a job but not without an idea, he embarked on a project to replace steel-rimmed buggy wheels with rubber tires. It was an opportunity, like so many at the turn of the century, that could turn a simple farm boy into a millionaire. He just had to sell the concept.

With one worker, he started a rubber tire company in Chicago, and as it grew, he sold it for $45,000, a fortune in those days. Still not satisfied, Harvey left Chicago and moved to Akron, Ohio, using his newly made fortune to start the Firestone Tire and Rubber Company in 1900. He convinced his friend Henry Ford to try his pneumatic tires, which Ford liked since they increased car speed. Ford tried them on three models in 1903 and produced 1,700 cars—all with Firestone's tires.

Success followed success, and by 1910, Harvey's company had manufactured more than 1 million tires. The Ohio farm boy had become an industrialist, rubbed shoulders with President Warren Harding, another former rural Ohioan, and went camping with Thomas Edison and Henry Ford. He had become an Ohio legend. Today, after a merger with Bridgestone, Firestone is the world's leader in tires.

Then, in 1983, for some strange reason, Harvey's two surviving sons, both in their seventies, donated the original 1828 family farmhouse and a large Pennsylvania-style barn to the Greenfield Village complex in Michigan, allowing Ohio history to leave the state. Another Firestone treasure, an Italianate-style home built by the family in 1880, well before Harvey struck it rich, was lovingly transported to a new location in 2011. But vandals burned it.

One of only two buildings left from the Firestone legacy, this old barn was built in 1880, as its slate roof testifies. In June 2015, Tom Mackall, owner of the barn and a local entrepreneur, decided to preserve the barn and moved it several hundred yards to a new foundation near a ten-acre retention lake—an incredible feat that can be viewed in a YouTube video. That the barn could be transported in one piece testifies to its construction:

solid hand-hewn oak beams and mortise and tenon joints. If only its builder could have watched the move!

Tom plans to renovate the barn to function as a Firestone museum that will feature farm machinery and perhaps a brewpub. Thanks to Tom, one last piece of Ohio history will be preserved, not only in this barn but also in this painting, framed with original Firestone barn siding, something that would have made Harvey smile.

JEFFERSON COUNTY

The Surveyors

Most people don't know that General George Washington, our first president, began his career as a land surveyor. In his travels in the Ohio country in the mid- to late 1700s, he might have been near where this small red barn (not built at that time) still stands. It sits in Ohio's Appalachian Plateau, next to State Route 43, just east of Amsterdam.

When he was sixteen, Washington accompanied two prominent surveyors for work in the Blue Ridge Mountains of Virginia, not far from his family farms, which he and his brother inherited when their father died. One year later, in 1749, he was appointed the official surveyor for Culpeper County in Virginia. This led to an appointment as a lieutenant colonel in the Virginia Regiment in the French and Indian War in the 1750s. His war service earned him land grants in the Ohio River Valley, which motivated him to explore the area in 1770. He and others took a canoe trip from present-day Pittsburgh down the Ohio River and found the land ideal for settlement. In fact, he purchased land in Ohio and West Virginia and surveyed it, keeping accurate records. Overall, out of 199 surveys attributed to Washington, 75 still exist, showing his penchant for studying maps before he made strategic decisions in both the French and Indian War and the War of Independence.

When the Revolutionary War ended in 1783, Washington awarded land grants to veterans in the Ohio country, which at the time was still predominantly Indian territory. To facilitate this process, the first federal land office was established adjacent to Fort Steuben in 1801, not far from this barn in Jefferson County. The fort took its name from Major General Baron von Steuben, who was Washington's chief of staff in the final three years of the war.

Farther down the river in Marietta, General Rufus Putnam, a close friend of Washington's and also a surveyor, formed the Ohio Company with others and laid out the town of Marietta in 1788, along with building a log home and a land office, the two oldest surviving buildings in Ohio. This company purchased land from Congress, which desperately needed funds, and granted plots to war veterans as well as to other settlers in what is now southeastern Ohio. Putnam's log house and the Ohio Company's land office have been preserved in Marietta in the Campus Martius Museum complex. The first federal land office has also been maintained in Steubenville. The barn and its proximity to Fort Steuben keep memories of these early surveyors alive and well.

CARROLL COUNTY

Serendipity

The dictionary defines *serendipity* as the occurrence and development of events by chance in a happy or beneficial way, which is exactly what happened when I passed this magnificent scene in Carroll County on an

early September morning. A drive along Route 9 into this region shows off its rolling hills, Mennonite churches and road signs for Amish buggies. The countryside is far from flat: curved and hilly roads being the norm. Once in a while, there's a straight patch of asphalt. It's Appalachia at its best.

Mary Hawk, barn owner along with her husband, Jeff, talked about their barn. She said that although the farmhouse dates to 1854, the original barn, which burned, was probably hand-hewn timber-framed as well. She revealed that Quakers from Pennsylvania started the farm, as happened elsewhere in eastern Ohio. Most of them were abolitionists and offered their homes and barns as rest stops on Ohio's Underground Railroad. Who knows? Maybe enslaved people stayed here too.

Mary said that the present barn was built in 1905 and that Jeff's grandparents bought the farm in 1969. Mary and Jeff took over in 2011. They raise beef cattle and farm soybeans, corn and hay on 175 acres.

Long ago, Mary continued, a road passed behind the barn and its two adjacent buildings—one a blacksmith's forge and the other a cobbler's shop, where one day Mary and Jeff discovered the shoemaker's original wooden shoe lasts. All buildings have the original slate roofs, testifying to the affluence of the farmer as well as to the value of such an investment—a century of protection against rain, snow and wind.

Without any prior connections on this county visit, I was finally in the right place and at the right time to be able to capture this piece of Ohio history. Truly, it was serendipity.

TUSCARAWAS COUNTY

The Yellow Butterfly

Barn scout John Ourant, after giving me a tour of the local historical museum in Newcomerstown, took me to the converted barn at the Yellow Butterfly Winery, which he told me would be tough to find on my own. He explained that a former mayor of Cleveland owned the barn, triggering my curiosity. Why would a mayor of such a large city be interested in living on a rural farm, buried in such winding hills?

The barn sits in a valley beneath Blue Ridge Road, a curving stretch that is aptly named—with forested hills in the background and rolling meadows closer to the barn. Michael White, who owns the barn, winery and alpaca

farm with his wife, JoAnn, told me that the original barn burned, probably in the early 1900s, and that this one was rebuilt in the 1920s. The saw-cut interior framing and construction would confirm this date. Over the years, the barn changed hands, and when the Whites purchased it, the roof was sagging and support beams needed replacing. "It took thirteen months—with only eight days off—to restore the barn," Michael said. But let's start from the beginning, by answering the question why a mayor of such a metropolis would choose a life of hard manual labor in the country.

The story began when thirteen-year-old Michael, growing up in eastern Cleveland, set two goals for himself: to be mayor of Cleveland and to own a farm. He accomplished both and in grand fashion. But why a farm?

For four of his formative teenaged years, Michael worked for Dr. Johnson, a PhD in agriculture, and he learned how to raise crops on a five-acre farm in urban Cleveland. Dr. Johnson taught him a love for the land and farming, sowing seeds for farm ownership in young Michael. Off to Ohio State University, he earned a degree in education along with a master's degree in public administration in 1974.

Upon his return to Cleveland, Michael served as an administrative assistant in Cleveland City Council, then as a city councilman from the

Glenville district and finally as a state representative. Next, he won the race for mayor and served for three four-year terms, from 1990 to 2002, the second African American mayor, the second youngest and Cleveland's longest-serving mayor. He had work to do: the owner of the iconic Cleveland Browns football team threatened to move, and Cleveland was facing the same urban crisis as Detroit. But Mayor White, with the help of citizens and businesses, saved his city.

The football team left for Baltimore, but Cleveland retained the Browns name, constructed a new stadium and got a new franchise. Under the mayor's leadership, the Rock and Roll Hall of Fame and the Great Lakes Science Center were built, encouraging tourism. Businesses and people began to repopulate Cleveland's lakefront. The city was reborn. But after three terms, Michael announced his retirement and began his second career: farming. Years later, in 2017, the city awarded Michael the prestigious Cleveland Heritage Medal, well earned and well deserved.

In the late 1990s, Michael and JoAnn visited Tuscarawas County and bought a forty-five-acre farm they named Seven Pines. Next they built a house and, by 2002, were raising alpacas, smaller cousins of lamas and known for their soft fiber. And then, following in the footsteps of Johnny Appleseed, he took money from his $1 million campaign fund to build a nonprofit refuge for abused horses, calling it the Seven Pines Foundation. Johnny would be proud, given his own love of animals.

And then came the winery. "My wife bought me a class on winemaking after I retired," Michael said. So he learned to make wine, drinking it, sharing it with friends and giving it away. In 2009, the Whites bought an adjacent thirty-five-acre farm, complete with an old, run-down barn. The seeds that Dr. Johnson had sown were growing.

After a year's worth of shoveling manure and hard labor, the winery, its wine bar and outside seating—offering a tranquil view of the hills and woodlands—opened for business. Today, the vineyards, planted in 2009, are producing, and the winery offers more than a dozen varieties, as well as Saturday evening dinners from spring to fall. Events can be held in the barn's lower level, and a live music series offers more entertainment. All of this provides jobs—running the farm, maintaining the old barn, harvesting and bottling the wine and operating the retail wine shop. Most importantly, just as he did for Cleveland, Michael White has given an old barn new life, a second chance to be functional again. I'm sure that if it could talk, the Yellow Butterfly barn would voice its appreciation.

11

SOUTHEAST

Ohio's southeastern counties represent the best of Ohio's Appalachian region and offer some of Ohio's most scenic country, along with many old barns. Harrison County's red sixteen-sided barn lies in a spectacular setting, one that's hidden from mainstream roads, making its discovery even more exciting. Belmont County, home of Harley Warrick, the last of the iconic Mail Pouch barn painters, and his disciple, Scott Hagan, is represented by a Mail Pouch barn in a state park. Muskingum County's barn wins a prize for most photogenic, followed closely by barns in Coshocton and Noble Counties. The "barn" in Guernsey County might be a misnomer, but its story is priceless. Monroe County, represented by its famous stone Kindelberger barn, offers winding roads that motorcycle clubs refer to as challenging, which is a modest way to describe them. Finally, this book ends, perhaps appropriately, with a county named after George Washington, our country's first leader, and home to Ohio's oldest buildings—safely preserved in the Campus Martius Museum.

MUSKINGUM COUNTY

Pristine

Dawn was beginning to break, its early morning glow casting shadows and highlighting hay bales in the field, far below this old barn, which sits on

a ridge overlooking acres of the McDonald farm. It was a scene that any photographer would kill for.

Susan McDonald, a local attorney and farmer, owns it. Susan's family roots trace back to 1858, when Samuel Culbertson established the farm, along with a store and a post office. During the Civil War, according to the family, Confederate general John Hunt Morgan passed by here on his raid into Ohio, although this time he paid for provisions after noticing a Freemason sign on the property—shades of the movie *The Man Who Would Be King*.

When I visited on a crisp autumn morning, I met Susan, one of her sons and also her mother, the lively eighty-seven-year-old Dorothy Montgomery, who inherited the farm from her father, Fred, who in turn got it from his father. Dorothy, full of life, explained that she was a former county commissioner—in addition to raising a family, teaching school and volunteering as a 4-H advisor, a task she's maintained for more than sixty years. Busy lady.

Three sides of this 240-acre farm border the Wilds, a 10,000-acre tract of reclaimed strip mining land that's been converted into a safari ranch—with zebras, rhinos, giraffes, antelopes and camels. Many area farmers, coming out of the Great Depression and cash-poor, sold mineral rights to coal companies in the 1940s and eventually sold their entire farms. But Fred Culbertson refused, as Dorothy recalled: "There was no way that company was going to get his land." In the 1980s, the Central Ohio Coal Company donated more than 9,000 acres for this game preserve, a noble gesture that has meant millions of tourist dollars for this county.

The original barn was made of logs, common in pre–Civil War days, but it didn't last. The family built the current one in the 1920s using logs from trees on the farm, cutting them in a nearby sawmill. Inside the large barn are saw-cut timbers, lots of hay and goats below. On the outside, the wording "Twin Maple Stock Farm" refers to two large maple trees that fronted the farmhouse, which, now gone, have been replaced with new trees.

Over the years, the farm has been productive, raising crops and livestock, including Percherons, Herefords, hogs and Broad Breasted Bronze turkey. Go ahead, try saying that ten times in a row quickly. Today, John McDonald and his wife, Susan, the sixth generation, are continuing the tradition, raising beef cattle, honey bees and goats, along with growing hay, pumpkins, corn and soybeans. And they've taken the farm into the twenty-first century with a festival in autumn, featuring a corn maze—

A pristine morning in Muskingum County.

where, as their flyer states, getting lost means finding fun—plus bonfires, private parties, agricultural exhibits, a petting zoo, a pedal tractor track and more. It's a great way for city slickers to see what Old McDonald has on his farm, if you'll pardon the pun.

While all these family-friendly activities are wonderful, as is the twenty-six thousand square feet of greenhouse, used for raising annual and perennial plants, the view of this barn—its grayish white contrasting dramatically against dark green foliage on a cool September morning, the distant tree line shrouded in haze and sun rays sneaking through and around the hay bales—was priceless. In fact, it was pristine.

COSHOCTON COUNTY

Whitewoman

Located north on State Route 16, a highway that passes from Muskingum and into Coshocton County, the barn sat on top of a wooded hill—its silo silhouetted against a deep-green background, a nice composition. A narrow road led up to it.

Coshocton County, formed by parts of adjoining Muskingum and Tuscarawas Counties in 1810, takes its name from the Delaware Indian language meaning "union of waters" or "black bear crossing." And if you venture into the county's most historic town, Roscoe Village, and walk down its main street, you may be curious about its name: Whitewoman Street. It goes back to Mary Harris.

Mary was the first known European to live in Ohio, although it wasn't exactly her choice. In 1704, when she was about nine, Mary and about one hundred others were captured by the Caughnawaga Indians and French soldiers in their raid in Deerfield, Massachusetts, a battle known as the Deerfield Massachusetts Massacre. The Indians marched them three hundred miles north into Canada.

In the 1700s, American Indians would often capture children and adults to replace deceased members in their tribe and would adopt them, regardless of their race. Mary became a servant in her Indian village and eventually married a Mohawk brave in a small community of Jesuits and Indians living outside Montreal. In the 1740s, Harris and her family came to Ohio and settled near the Walhonding River, which takes its name from the Delaware Indians, although it became known to white settlers as "Whitewoman Creek," and the village became known as "White Woman's Town."

A French map published in France in 1746 shows the name of this river as *Riviere des Femmes Blanc* (River of the White Women). Years later, the main street of Roscoe Village was named Whitewoman Street simply because it was the road leading to White Woman's River, which was the American name of the Walhonding River in the early nineteenth century. The Indian name was always the Walhonding, as it is called today.

Christopher Gist, a British colonial explorer and one of the first surveyors of the wild Ohio country, was forty-five years old when he visited Mary Harris in 1751 while she was living in her village about seven miles up the Walhonding River. Mary Harris gave her name and a brief background to Gist, who, during the 1750s, twice saved the life of George Washington.

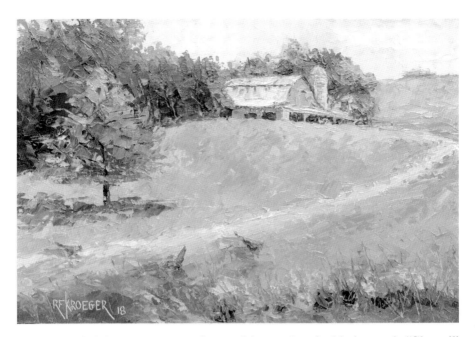

Gist recorded her comments about white settlers in his journal: "She still remembers they used to be very religious in New England, and wonders how the White Men can be so wicked as she has seen them in these Woods."

In 1755, Mary, aged sixty, returned to Canada during the French and Indian War, where she provided lodging for English prisoners and was remembered as being very kind. That same year, English-language maps labeled the name of the river and town as Whitewoman's, a fitting tribute to an early pioneer woman, a legacy honored in today's Roscoe Village.

GUERNSEY COUNTY

Labor of Love

A lot of old barns feature the Harley Warrick Mail Pouch logo, but it's rare to find it on a covered bridge. So, when venturing out of Muskingum County and passing through a thin slice of Guernsey County, I was surprised by this oddity. Even though I had already captured a barn in this county, I had to stop for a look. *Yes*, I pondered, *this is not a barn, but it's still an Ohio treasure—a covered bridge with Harley's trademark.*

Susan McDonald, whose family barn in Muskingum County is less than fifteen minutes from here, provided the contact information of the owners, Mary Lou and Audley West. Mary Lou said that her husband was not feeling well enough to chat, but she knew the story.

Her husband had always wanted a covered bridge, and when the Ohio Coal Company—the same one that donated nine thousand acres to form the wild animal preserve—put barns on this property up for sale, Audley bought three of them. These were probably old timber-framed barns, housing lots of great lumber that originally belonged to farmers who sold their land to the coal company for cash after the Great Depression.

Audley used the wood to build his covered bridge, finishing it in the late 1970s, but he wasn't done. He wanted the Mail Pouch logo. So he hired Harley Warrick to paint it, which he did in 1982 and then again several years later. But although Harley always did a good job, the ravages of snow and rain took their toll, and years later, the barn needed repainting. Audley sent a deposit check to Harley, but unfortunately he became sick and returned the check. He died soon after that.

Determined to have his bridge look good, Audley assembled a team of his four children, in-laws and grandchildren; made stencils from Harley's work;

and repainted it. Voila! A brand new coat for the bridge and a happy Audley. Word spread south to McConnelsville, the county seat of rural Morgan County, where a Mr. Goss became interested in having the Mail Pouch logo on his barn as well. After being asked to paint it, Audley declined, but after thinking about the offer, he mentioned that he had a few grandsons who'd do just about anything for a buck, according to Mary Lou. So, Audley broke out the stencils, bought the paint and took his grandsons with him for this grandfather-grandson project.

Yes, even though this piece of Ohio history is not an old barn, its compelling story merits inclusion in this book. After all, its boards, taken from nearby vintage barns, still bear the imprint of the famous barn painter Harley Warrick. Nowadays, once again, Ohio weather hasn't been kind to this little bridge, and its paint has begun to fade. Perhaps the family will soon unearth those stencils and put a new coat on Audley's dream come true. After all, it was a labor of love.

HARRISON COUNTY

Workley's Wonder

The Harrison County Visitor Center thinks enough of this round barn to put its striking photo in its brochures, as well as in those of other Ohio counties. Originally, I discovered it on the Dale Travis website on Ohio round barns. Yes, it's worthy of being in brochures, but it's not easy to find.

Fortunately, the historical society provided the contact information of the barn's owners, Judy and Ollie Workley. Judy, seventy-eight, had just celebrated sixty-one years of marriage to Ollie, who, she said, also made picture frames out of barn wood. They were interested in being included in the Ohio Barn Project.

In her directions through eastern Ohio's Appalachian Plateau, a section of Ohio where a straight road is rare, Judy advised me not to follow the GPS, which would lead up a nasty gravel road. Thanks to her, I found Skullfork Road, navigated the hills and forests and arrived safely, finally emerging from dense woods. Almost magically, the bright-red barn appeared, perched on a hill like a lighthouse beacon shining in the sea. It was stunning.

Judy, Ollie and their daughter, Tracy, explained that they'd be going to the annual Barnesville Pumpkin Festival soon. I'm glad I got there before they left. The barn was worth it.

According to Judy, the original owner, John B. Steward, built the house and barn in 1921. His two sons fought in World War I and presumably helped their dad farm the hilly land. Over the years, unfortunately, the farm fell on hard times and had deteriorated by the time the Workleys bought it in 1971. Thankfully, they felt so strongly about preserving Ohio history that they began to restore the barn, even adding a fresh coat of red paint recently. The matching mailbox, a miniature of the barn, showed their pride in this Ohio gem.

Actually, the barn is not round—it's sixteen-sided and, as Judy proudly proclaimed, the only sixteen-sided barn in Ohio. Each side is twelve feet long, the barn is sixty feet high and it stretches sixty feet wide. Its sandstone foundation, quarried on the farm, mimics the Kindelberger stone barn in nearby Monroe County. The attractive cupola sits on top of a round silo, which, according to Judy, was filled only once. Removing the corn took too long.

The tools: Gary holds a crandall, and Marge holds a stone pick. *Courtesy of Marge and Gary Baumberger.*

These days, Gary and Marjorie still work the farm. After decades of raising dairy cows, they now tend to chickens (a buyer stops by every day to pick up eggs), forty beef cattle, a dozen dairy goats and three horses. Gary handles the hay business—taking some to the silos and some to the main barn, which sounds simple but it's not. On the first day, he cuts the hay. On the next, he picks up the hay in a "chopper," which blows it into a wagon, which Gary unhitches and takes to the silo. This continues until the silo is full. But there's more hay on the land. So Gary cuts this hay, allows it to cure in the field, rakes it and round bales it and then hauls it to the barn the same day for storage until winter feeding. Whew! Meanwhile, not to be outdone, Marge drives their ATV back and forth to milk the goats every day. They're both in their seventies. Hard physical work keeps them young. Kindelberger farming continues.

In 1980, the National Register of Historic Places listed this spectacular barn, an honor it deserves not only because of its unique architecture but also because it has stood the test of time. Ohio is lucky to still have these important barns, which it will have for many more years to come.

NOBLE COUNTY

Junior and the Nuns

On a drive along State Route 78, a striking blue barn appeared, almost volunteering to be the county's representative. And the bonus was that Leianne Neff Heppner, the Summit County Historical Society's guru who grew up in this county, knew a story about it.

The road signs read "Woodfield Rd" and "Zwick Rd," the latter leading toward the barn and farmhouse. Leianne explained that the farm was owned for a long time by "Junior" Zwick and his wife and that the Zwick family still owns it.

Leianne related a memory from her childhood involving the Zwicks. One winter during a heavy snowstorm, a group of nuns was stranded in their car. When Leianne's dad, Ken Neff, happened to see the disabled car, he picked up the nuns and took them home. Later, Ken called his friend who opened up his grocery store, closed during the fierce storm, so that Ken could get some food for the sisters. Ken, as the funeral director in nearby

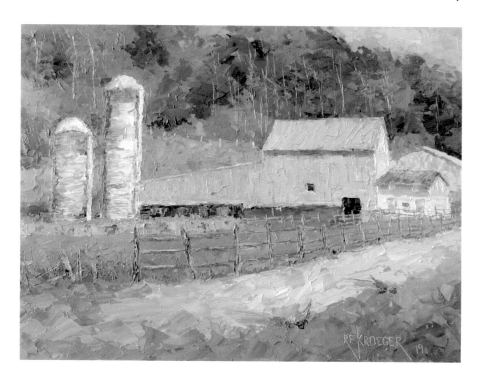

Summerfield, was regarded as being only slightly more important than the town doctor. Kindly, her dad took in the nuns, giving up his bed and those of Leianne and her sister so that the nuns would have sleeping quarters for the night. Leianne got to sleep in dad's funeral home. Hmm.

The next morning, the owner of the blue barn, Junior Zwick, along with another farmer, Jim Warner, returned the nuns to Woodsfield in his four-wheel-drive truck. The nuns thanked the family profusely and shared that they didn't sleep a wink, choosing instead to spend the time praying for this generous family. At that, Leianne's first thought was that since they didn't sleep, one of the nuns could have spent the night in the funeral home, allowing Leianne to sleep in her own bedroom. As you might guess, the funeral home was frigid. But such sacrifices are common in rural Ohio counties, where hospitality is still in vogue, offering valuable lessons for all of us. Just ask Leianne how cold that bed really was.

WASHINGTON COUNTY

A Barn for Basketball

This old red barn, with "HOME" painted under the front eave, goes back to the late 1800s. With doors loosening from their hinges, missing and slanted siding and an array of vines and bushes slowly creeping up its walls, the barn is on its last legs. No matter—it has a story to tell.

Its current owner, Tanya Wilder, a professor of Spanish at Washington State Community College, formerly directed the Evergreen Arts & Humanities Series there while a teaching adjunct at Marietta College. Tanya said that the original owners, the Apple family, used the barn for dairy cows, eventually selling the farm where it stands to the Stage family. They, in turn, sold to the Orders family, who last used the barn for farming in the mid-1970s. Tanya was the next to own it. She said the barn served her family for barn dances and parties, but not for any farm activity.

Since the barn once was used as a makeshift gym for the local school down the road, a basketball hoop remains on one of the major beams, slightly tilted and rusted. It is with this hoop that the story begins.

Today's parents often drive their children from one sporting event to another and pay for expensive sports equipment, team dues and practice facilities, not to mention the travel expenses when tournaments are far from

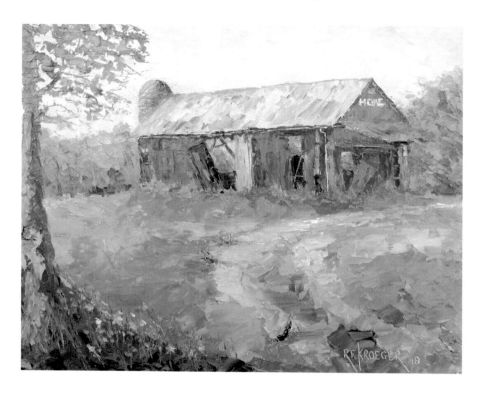

home. After all, they know their kids will either become a pro or at least earn an athletic scholarship to college. Right. So, this athletic entitlement has become a birthright, at least for many children raised in the suburbs. But that wasn't the case at this barn, back in the 1930s, '40s and '50s.

James Naismith grew up on a farm in Canada, was orphaned and, though not a gifted student, was a good athlete. In 1891, he moved to Springfield, Massachusetts, and became a physical education teacher at the local YMCA. Winters in that state can be brutal. One year, such cold conditions prompted his boss to order him to invent an indoor game that would keep the youngsters in shape. So, with only two weeks to fulfill this command, he invented basketball and organized the first game in December 1891 at the YMCA gym. Naismith was thirty then and, as time passed, saw his new game catch on, first in America and then throughout the world. The Olympics adopted it in 1904, and it became an official Olympic event at the 1936 games in Berlin.

Returning to Washington County, in the 1930s, kids would walk to school, do chores on the farm and then finish their homework. Their day was full, but kids being kids, they liked to socialize. And this barn was a good place for

that. The owners, realizing that this could be a source of cheap labor and, feeling a sense of community pride, installed a basketball hoop inside their barn. Bingo: instant gym. After school and on weekends, the boys would migrate here to "hang out" and play basketball. But there was a catch. In exchange for use of this "gym" time, they would milk the cows and perform other work around the barn. No problem. No entitlement. What a great lesson that was—teaching young people that there's no free lunch! Even though this old beauty will someday no longer be with us, its memory and its story will survive, thanks to Ms. Wilder.

AFTERWORD

I didn't keep track of all the miles I drove in my quest to find an old barn in each of Ohio's eighty-eight counties. It could have been worse: Iowa—with its dozens of fascinating round barns—has ninety-nine counties. Some roads I traveled were flat and as straight as an arrow, such as Route 127 on Ohio's western border. On the other end of the spectrum, Ohio's eastern Appalachian counties offered spectacular scenery, taking me up and down hills and around curves continually, with few stretches of the flat and straight.

I also didn't record the number of nights spent in hotels, where I often ended the day by making notes and sketches of barns I'd visited during the tour. Occasionally, I stayed with locals, which always was enjoyable, allowing me to get to know the people a bit better. One recent visit was with Susan Spinelli and Brian Blair, who own a vast tract of forestland in Hocking County. Ardent environmentalists, they also have preserved a magnificent red barn, now surrounded by towering hardwoods, with hundreds of trees that have overtaken what was farmland decades ago.

As I acknowledged earlier, I was blessed to have been given tours by many thoughtful barn scouts, who took the time to find these old barns, locate their owners and dig up history about them. This often led to understanding different cultures—like the Amish of Holmes County, where we were treated to the sight of "hayrakers."

After *Spectrum News* did a wonderful mini-documentary on my Ohio Barn Project, which aired on Spectrum Cable TV in December 2019, I became curious about "Granville Gray," the old barn that inspired me in 2012. The

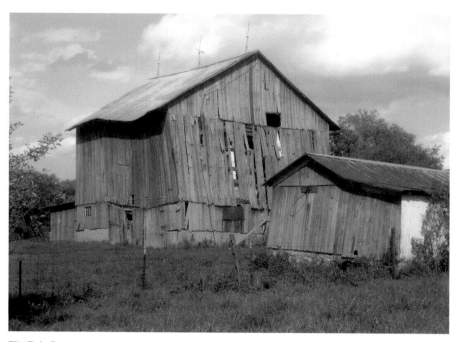

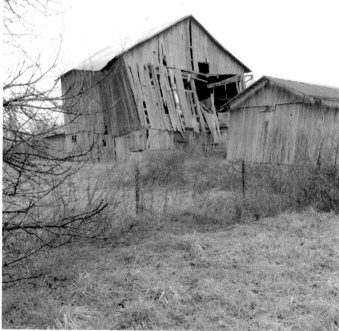

Granville Gray in
2012 (*above*) and
in 2020 (*left*).

producer decided to drive to Licking County to film it, which convinced me to visit it again. I called the owner, Herbert Hall, who admitted, "It's in pretty bad shape."

After touring Hocking and Fairfield Counties, I drove north to see it and was shocked. When asked about plans for his barn, Mr. Hall replied, "Well, I really haven't thought about it." At eighty-six, his days are numbered, although he may not have to worry about the barn's future. A strong wind could take it down. How different it looks today compared to when I first saw it in 2012. It symbolizes the plight of many timber-framed barns of the 1800s.

On the brighter side, West Chester Township, a suburban farming community in Butler County, just north of Cincinnati, will host a celebration of these old barn paintings in May 2021. The iconic Muhlhauser barn, an example of a most impressive dismantling and reassembling of an old barn, will feature all the barn paintings in this book, raising funds for local nonprofits. The Muhlhauser barn, once on a farm where grains were grown for nineteenth-century beer breweries in downtown Cincinnati, represents a flavorful portrait of early German heritage in the Queen City.

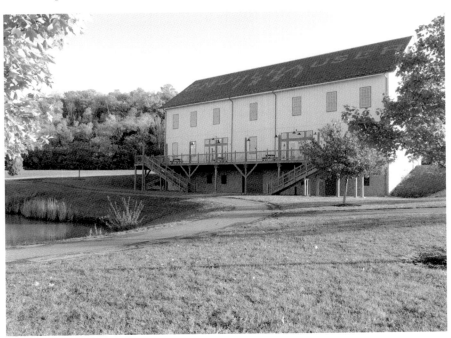

Muhlhauser barn. Built in 1881, moved and restored in 2008.

The barn's spacious interior, with original oak beams.

What now? With my Ohio Barn Project completed, I will embark on another adventurous plan to capture round barns, one that will involve visiting several other states. However, I will continue to seek out barns in Ohio and Indiana, hoping to preserve them in paintings and essays, as well as using them to raise not only funds for nonprofits but awareness of the importance of the old "money maker." If a nonprofit—such as a historical society or 4-H—has an interest in taking me on a tour of old barns in its county, I can be reached via the contact page at www.barnart.weebly.com. I also do an occasional commission, if time allows.

As I continue on barn tours, I pass many old barns whose days are numbered. Thoughts pop into my head: *Who built them? What are their stories? Why are they falling apart?* Perhaps their stories, along with their lumber, will be lost forever. *So, quickly*, I tell myself, *Stop! Capture it…before it's too late.*

ABOUT THE AUTHOR

D r. Robert Kroeger, a native of Youngstown, graduated from Ohio State University's College of Dentistry and served four years of active duty in the U.S. Navy, ending with the rank of lieutenant commander. He and his late wife, Brenda, moved to Cincinnati, where they raised five children and where Dr. Kroeger practiced general dentistry from 1977 to 2010, when he retired. He and his wife, Laura, also live in Cincinnati, where they enjoy spending time with eight grandchildren.

Dr. Kroeger is a second-generation artist, although unlike his father, Francis, who held an art degree from Notre Dame, his professional art career blossomed later in life. Although he did not immediately follow in his father's footsteps, Robert's career as a dentist allowed him to study color values and facial aesthetic principles in smile design.

In writing, Dr. Kroeger has published two books on dentistry, a book on vitality and seven books on golf in Scotland, England, Wales and Ireland, including *To the 14th Tee*, *The Links of Wales*, *The Golf Courses of Old Tom Morris*, *Golf on the Links of Ireland*, *Golf on the Links of England*, *Complete Guide to the Golf Courses of Scotland* and *The Secrets of Islay*. This is his first book on old barns but hopefully not his last. He can be contacted via the website www.barnart. weebly.com.

Visit us at
www.historypress.com